Poussin to Seurat  *French Drawings from
the National Gallery of Scotland*

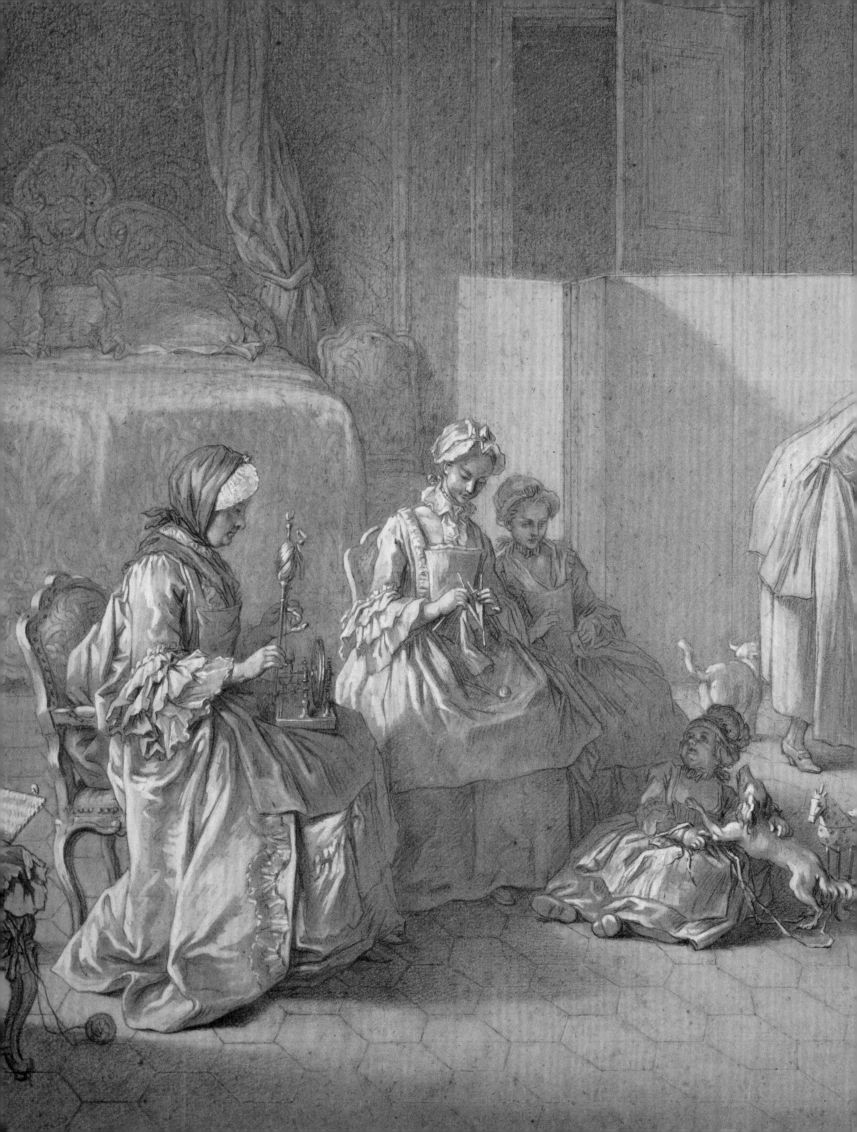

# POUSSIN to SEURAT

## French Drawings
## from the National Gallery of Scotland

MICHAEL CLARKE

National Galleries of Scotland

EDINBURGH · 2010

Published by the Trustees of the National Galleries of Scotland
to accompany the exhibition, *Poussin to Seurat: French Drawings
from the National Gallery of Scotland,* held at the Wallace
Collection, London, from 23 September 2010 to 3 January 2011
and at the National Gallery Complex, Edinburgh, from 5 February
2011 to 1 May 2011.

Text © the Trustees of the National Galleries of Scotland
ISBN 978 1 906270 31 5

Designed and typeset in Dante and Corbel by Dalrymple
Printed on Gardapat 150gsm by Conti Tipicolor, Italy

Front cover:
Nicolas Poussin, *A Dance to the Music of Time* (cat.no.49)
Back cover:
detail from Louis Roguin, *Jewish Woman of Algiers* (cat.no.51)
Frontispiece:
detail from Etienne Jeaurat, *Family in an Interior* (cat.no.38)

The proceeds from the sale of this book go towards supporting
the National Galleries of Scotland. For a complete list of current
publications, please write to: NGS Publishing at the Scottish
National Gallery of Modern Art, 75 Belford Road, Edinburgh,
EH4 3DR or visit our website: www.nationalgalleries.org

National Galleries of Scotland is a charity
registered in Scotland (no.SC003728)

# Contents

Directors' Foreword  7

Preface  9

Catalogue Note  11

CATALOGUE

Aligny, Claude-Félix-Théodore Caruelle d'  12

Bellange, Jacques de  14

Béranger, Antoine  16

Bernard, Emile  18

Boisselier, Antoine-Félix  20

Boissieu, Jean-Jacques de  22

Boucher, François  24

Cabat, Louis-Nicolas  26

Callot, Jacques  28

Caron, Antoine  30

Cazin, Jean-Charles  32

Claude Gellée, called Le Lorrain  34–7

Cochin the Elder, Charles-Nicolas  38

Corot, Jean-Baptiste-Camille  40

Dagnan-Bouveret, Pascal-Adolphe-Jean  42

Dauzats, Adrien  44

Decamps, Alexandre-Gabriel  46

Delacroix, Eugène  48

Delaroche, Paul  50

Deshays de Colleville, Jean-Baptiste-Henri  52

Dughet, Gaspard  54

Dulac, Charles-Marie  56

Fromentin, Eugéne  58

Gérard, Marguerite  60

Girodet de Roussy-Trioson, Anne-Louis  62

Glaize, Auguste-Barthélémy  64

Gros, Antoine-Jean, baron  66

Gudin, Jean-Antoine-Théodore, baron  68

Guérin, Pierre-Narcisse  70

Harpignies, Henri-Joseph  72

Hébert, Ernest  74

Hesse, Alexandre-Jean-Baptiste  76

Hoin, Claude  78

Huet, Paul  80

Ingres, Jean-Auguste-Dominique  82–5

Jeaurat, Etienne  86

Lancrenon, Joseph-Ferdinand  88

Mandevare, Nicolas Alphonse Michel  90

Meynier, Charles  92

Millet, Jean-François  94

Patel, Pierre-Antoine  96

Pérelle, Gabriel  98

Pesne, Antoine  100

Pillement, Jean-Baptiste  102

Pils, Isidore Alexandre Augustin  104

Pissarro, Camille  106

Poussin, Nicolas  108

Regnault, Henri Alexandre Georges  110

Roguin, Louis  112

Saint-Aubin, Gabriel de  114

Sand, George  116

Scheffer, Ary  118

Schnetz, Jean-Victor  120

Seurat, Georges  122

Valenciennes, Pierre-Henri de  124

Watteau, Antoine  126–31

Wille, Pierre-Alexandre  132

Zix, Benjamin  134–5

# Directors' Foreword

This is the second exhibition on which the National Galleries of Scotland and the Wallace Collection have collaborated. The first, of paintings and drawings from the National Gallery of Scotland, was held in 2003–4 to mark the hundredth anniversary of the National Art Collections Fund (now called The Art Fund). This second exhibition does not celebrate an anniversary but is a timely reminder of the riches of the drawings collection in Edinburgh. It also provides a seductive taster to the major catalogue of all the French paintings in the National Gallery of Scotland which is currently being written by Michael Clarke and Frances Fowle.

These drawings have been chosen not only to demonstrate the breadth and quality of the collection in Edinburgh but also to complement the outstanding array of French paintings at the Wallace Collection. Thus, for example, visitors will be able to see the only known preparatory sketch for Poussin's *A Dance to the Music of Time*, one of the greatest French paintings at Hertford House, and they can also enjoy excellent drawings by other artists magnificently represented in the Wallace Collection such as Claude, Watteau, Boucher, Delacroix and Delaroche. No less interesting will be the opportunity to see works by painters such as Jeaurat, Valenciennes, Girodet, Pissarro and Seurat who for various reasons did not attract the acquisitive eye of the 4th Marquess of Hertford and Sir Richard Wallace.

We are delighted that the happy precedent of 2003–4 is being repeated and that once again our two institutions are working together. For this credit is due above all to Michael Clarke, Director of the National Gallery of Scotland, who has chosen the drawings (many of which he acquired for the Gallery), compiled the catalogue and throughout driven the project forward with immense enthusiasm. At the Wallace Collection the administration and presentation of the exhibition has been most ably overseen by Stephen Duffy and Christoph Martin Vogtherr.

DAME ROSALIND SAVILL
*Director, The Wallace Collection*

JOHN LEIGHTON
*Director-General, National Galleries of Scotland*

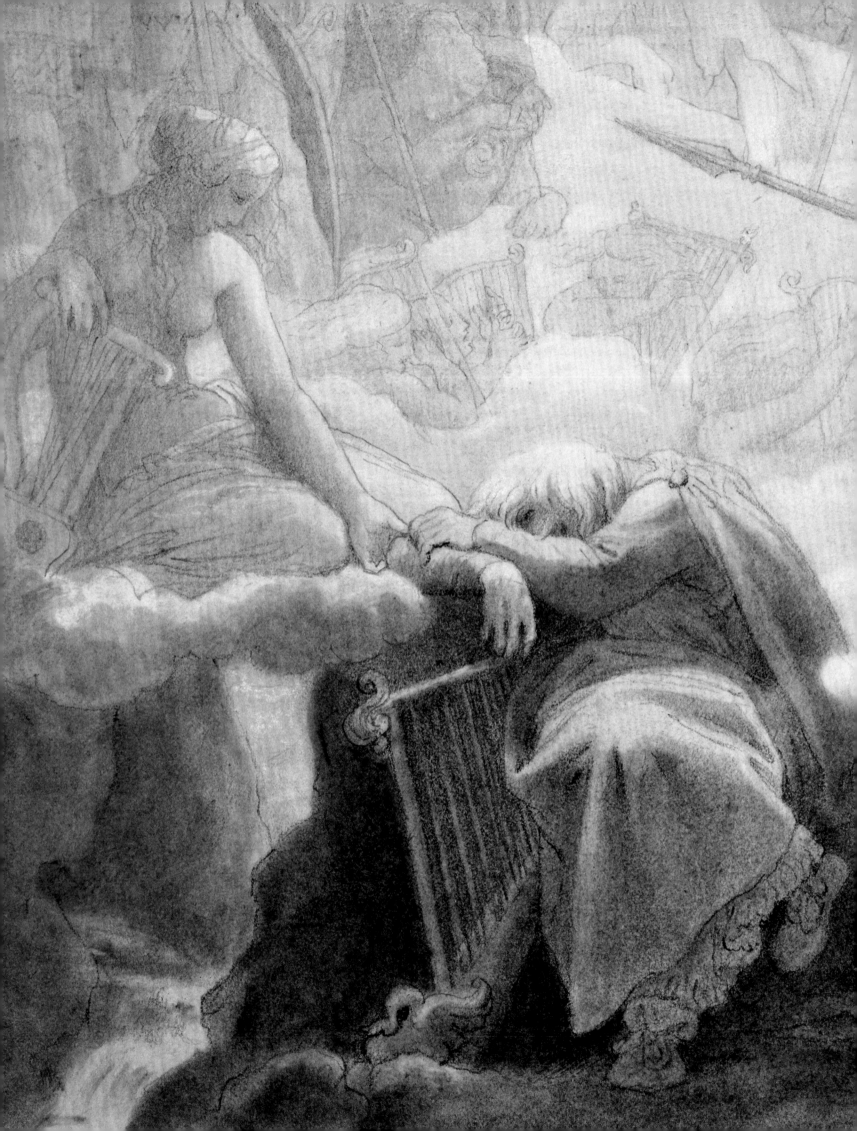

# Preface

Of all the major European schools of drawing the French is one of the richest and most fertile. Its variety, as demonstrated in this exhibition book, embraces the refined elegance of the School of Fontainebleau, the playful sensualities of the Rococo, the corrective rigour of Neoclassicism, the Romantic freeing up of technique in the early to mid-nineteenth century, and the stylistic and formal innovations of Impressionism and Post-Impressionism. Underlying this vigorous evolution was a constant delight in the possibilities offered by the medium.

If the Italian Giorgio Vasari, author of the *Lives of the Artists*, was the first serious collector of drawings – assembled and mounted to chronicle the achievements of the great masters of the Italian Renaissance – it was the French who, in many respects, later refined the collecting of drawings as an art form. Perhaps none surpassed the scholarship and achievement of Pierre-Jean Mariette (1694–1775), whose magnificent collection of around 9,000 drawings is now being reconstructed and published in a marvellous project led by Pierre Rosenberg. Appropriately, Mariette at one time owned our wonderful preparatory drawing by Nicolas Poussin for the painting *A Dance to the Music of Time*, now in the Wallace Collection.

The intimate knowledge and consummate connoisseurship that informed Mariette's collecting were qualities that can also be found in abundance in later collectors. In the nineteenth century, for example, there were the Goncourt brothers, with their delicate passion for the refinements of the *dix-huitième*, and the Marquis de Chennevières, who aptly summarised the ambition of any serious collector as 'acquiring one [drawing] which has no equivalent, which is pre-eminent'.

In our own time there are, happily, many distinguished collectors of French drawings and at the National Gallery of Scotland we have been privileged to show selections from three such collections: *Dessins français de la collection Prat* XVIIe–XVIIIe–XIXe *siècles* (1995); *Mastery and Elegance. Two Centuries of French Drawings from the Collection of Jeffrey E. Horvitz* (1999); and *Raphael to Renoir. Drawings from the Collection of Jean Bonna* (2009).

In a recent interview with George Goldner, Jean Bonna revealingly commented: 'I think when you are a collector, it's a "disease" that is very difficult to cure, and I was born a collector.' This is a malady that, with respect to French drawings, fortunately continues to afflict a number of museums in the United Kingdom. One thinks principally in this respect of the Ashmolean Museum and the British Museum and, in Scotland, of our own efforts in this area. Our collection of French drawings is not large, just over 750 in total, but we have endeavoured in recent years, with the modest funds at our disposal, to add to existing holdings with judicious purchases, particularly of the eighteenth and nineteenth centuries. Here one is aided by the very prolificacy of the French School. Mainstream art history tends to overlook the fact that there were many regional academies in France, in addition to the great Parisian institutions, and there was a profusion of decorative projects; private, state and religious. Drawing played a crucial role in this vast range of activity and we are fortunate that fascinating examples, both major and minor, continue to appear in the auction houses and at the specialist dealers. Since 1992, there has been the annual pleasure of the Salon du Dessin, held in Paris every March, where not only do the participating dealers succeed in assembling enticing fare for visitors and collectors alike, but there is also a charming intermingling of all those who love drawings and crave that *intimité*, that close acquaintance with an artist's act of creation, that drawing provides perhaps better than any other medium.

The scholarly cataloguing of the drawings collection in the National Gallery of Scotland really began under our first Keeper of Prints and Drawings, Keith Andrews (1926–1989). In addition to various exhibition catalogues, he produced

Jean-Auguste-Dominique Ingres, detail from *The Dream of Ossian* (cat.no.37)

three exemplary permanent collection catalogues of the Italian (1968), Netherlandish (1985) and German (1991) Schools. We currently have a number of other cataloguing projects in progress and over the next few years intend to publish catalogues of our English drawings and a supplementary volume of all the Italian drawings acquired since 1968. This present catalogue, which begins the task of cataloguing our French drawings, comes about as the result of the kind invitation of the director of the Wallace Collection, Dame Rosalind Savill, for us to participate in that institution's ongoing series of guest exhibitions of French drawings from public collections. We are delighted to be following in the footsteps of such distinguished predecessors as the Ashmolean Museum, Oxford (2002), the Musée du Château, Versailles (2006–7) and Waddesdon Manor (2007–8). Our selection from our own holdings is intended to mirror the range of French artists represented in the Wallace Collection.

At the Wallace Collection we are pleased to acknowledge the valuable encouragement of Stephen Duffy, Jeremy Warren and, above all, Christoph Martin Vogtherr, who has also kindly written four of the catalogue entries. Colleagues at the National Galleries of Scotland have been enormously helpful, in particular Hannah Brocklehurst, Kerry Eldon, Frances Fowle, Valerie Hunter, Christine Thompson and Aidan Weston-Lewis. In Paris I have been fortunate to enjoy the wonderful study facilities in the Departments of Graphic Arts and Paintings in the Musée du Louvre. Christophe Leribault was unfailingly kind and supportive during my all-too-brief Parisian sojourn. Other friends and colleagues who have assisted my research in one way or another include Bertrand Gautier, James Mackinnon, Laure de Margerie, Joelle Marty, Olivier Meslay, Stephen Ongpin, Louis-Antoine Prat and Carel van Tuyll.

There are two special debts to acknowledge. A number of years ago John Lewis OBE, a former chairman of the Trustees of the Wallace Collection, made a donation to the National Gallery of Scotland for research travel and it was this fund which kindly supported my month's stay in Paris. The exhibition itself would have been very difficult to mount without a most welcome subvention from the distinguished collector Jean Bonna. I am extremely grateful to both these generous and enlightened benefactors. Finally, I would not have been able to undertake this project, and intermittently absent myself from my directorial duties, without the understanding of our director-general, John Leighton, and the selfless support of my deputy director, Christopher Baker.

MICHAEL CLARKE
*Director, National Gallery of Scotland*

# Catalogue Note

Dimensions are given in centimetres, height before width.

The entries for cat.nos. 14, 45, 58, and 59 have been written by Christoph Martin Vogtherr. All other entries are by Michael Clarke.

The following abbreviations are used:

EDINBURGH 1961
*Fifty Master Drawings in the National Gallery of Scotland*, National Gallery of Scotland, Edinburgh, 1961

EDINBURGH 1976
*Old Master Drawings from the David Laing Bequest*, National Gallery of Scotland, Edinburgh, 1976

EDINBURGH 1991
*Saved for Scotland: Works of Art Acquired with the Help of the National Art Collections Fund*, National Gallery of Scotland, Edinburgh, 1991

EDINBURGH 2001
*From the Madonna to the Moulin Rouge. Drawings Recently Acquired for the National Gallery of Scotland*, National Gallery of Scotland, Edinburgh, 2001

EDINBURGH 2005
*Choice. Twenty-One Years of Collecting for Scotland*, National Gallery of Scotland, Edinburgh, 2005

EDINBURGH / LONDON 1994
*From Leonardo to Manet, Ten Years of Collecting Prints and Drawings*, National Gallery of Scotland, Edinburgh, and Hazlitt, Gooden and Fox, London, 1994

EDINBURGH / LONDON 2003–4
*Many Happy Returns. The National Gallery of Scotland celebrates One Hundred Years of The Art Fund*, National Gallery of Scotland, Edinburgh, 2003, The Wallace Collection, London, 2004

EDINBURGH / NEW YORK / HOUSTON 1999–2001
*The Draughtsman's Art. Master Drawings from the National Gallery of Scotland*, National Gallery of Scotland, Edinburgh, 1999, subsequently shown at The Frick Collection, New York and the Museum of Fine Arts, Houston, 2000–1

L
F. Lugt, *Les Marques de Collections de Dessins & d'Estampes*, Amsterdam, 1921, *Supplément*, The Hague, 1956. A new, revised and updated version is avalable online: http://www.marquesdecollections.fr

LONDON 1966
*Old Master Drawings. A Loan Exhibition from the National Gallery of Scotland, in Aid of the National Art Collections Fund*, Colnaghi, London, 1966

LUGT
F. Lugt, *Répertoire des catalogues de ventes publiques*, vols I–III, The Hague, 1938–64, vol.IV, Paris, 1987

WASHINGTON / FORT WORTH 1990–1
*Old Master Drawings from the National Gallery of Scotland,* National Gallery of Art, Washington and Kimbell Art Museum, Fort Worth, 1990–1

# 1

## Claude-Félix-Théodore Caruelle d'Aligny
### *View at Amalfi*

CHAUMES (NIÈVRE) 1798–
1871 LYONS

After studying with Regnault and Watelet, Aligny first exhibited at the Salon in 1822. In the same year he met Corot in the studio of Jean-Victor Bertin. He was in Italy 1824–7 and while in Rome, he associated particularly with Corot and the German Nazarenes. On his return to France, he travelled widely in that country. He was in Italy again from 1834 to 1835 in the company of Edouard Bertin, and in Switzerland in 1842, the year he was awarded the Légion d'honneur. The following year he travelled to Greece, Turkey and Albania. Although one of Aligny's paintings entered the state collection at the Musée du Luxembourg, Paris, in 1851, his art was attracting considerable hostile criticism by that date. In 1861 he was appointed director of the Ecole des Beaux-Arts at Lyon.[1]

This drawing dates from Aligny's second trip to Italy during which, in the summer of 1834, he undertook a concerted campaign of sketching in the environs of Naples – Amalfi, Sorrento, Corpo di Cava and Capri. Aligny's drawings from this trip have an assured quality in what had become his characteristic manner, developed over the preceding decade, in which form and construction are achieved by mainly linear means and shading is boldly indicated in a schematic manner. Horizons are raised and, as in his drawings of other areas such as the Forest of Fontainebleau, the artist exhibits a particular fascination with large rocks set into the landscape, through whose depiction he is able to achieve a purity of form. Indeed, his highly original drawing style remains of considerably greater interest than the often insipid quality achieved in his finished paintings (as opposed to his often impressive oil sketches). Comparable drawings in style and dating include: *View of Corpo di Cava*, dated 18 July 1834 (Louvre, Paris);[2] *Ravines of Sorrento*, dated 22 August 1834 (with W.M. Brady, New York, 2003);[3] *Ravines of Sorrento*, dated 18 August 1834 (Musée Fabre, Montpellier);[4] and *Capri*, dated 12 September (Louvre, Paris).[5]

D 5408
Pen and brown ink · 33.3 × 48.5
Signed, lower right: *Th.Aligny* and inscribed, lower left: *à Amalfi le 23 Juillet 1834*; also dated, verso, lower left: *à Amalfi ce 23 Juillet-1834–(no.16)*

PROVENANCE
W.M. Brady, New York; from whom purchased 1995.

EXHIBITED
*Master Drawings 1790–1900: A Selection of Recent Acquisitions*, W. M. Brady, New York, Spring 1995 (9).

NOTES
1. The standard work on Aligny is M.-M. Aubrun, *Théodore Caruelle d'Aligny 1798–1871: Catalogue raisonné de l'Oeuvre peint, dessiné, gravé*, Paris, 1988.
2. Aubrun 1988, cat.no. D 165.
3. *Master Drawings*, W.M. Brady, New York, January-February, 2003 (22). Aubrun 1988, cat.no. D 163.
4. Aubrun 1988, cat.no. D 171.
5. Aubrun 1988, cat.no. D 176.

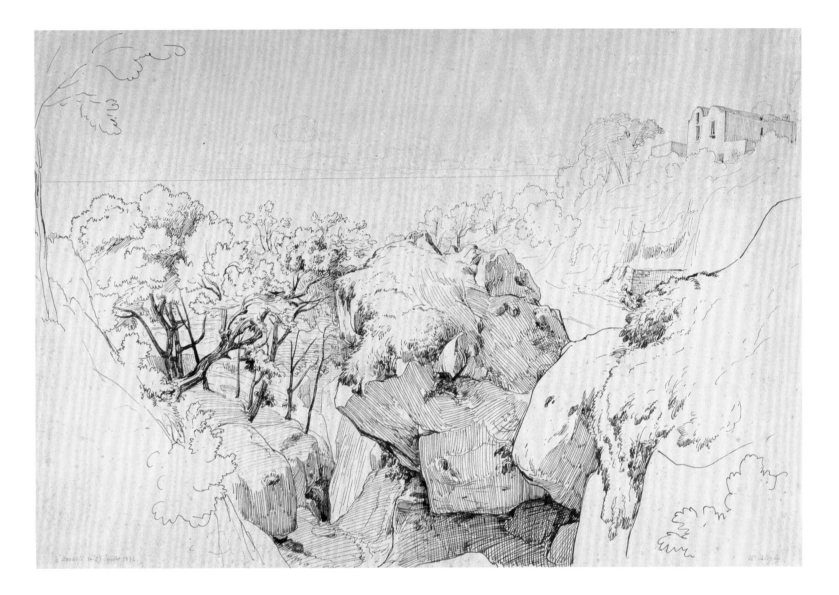

# 2　Jacques de Bellange  *Madonna and Child, with Saint James the Great Quenching the Fires of Hell*

ACTIVE 1595–1616 NANCY

Bellange was one of a number of famous seventeenth-century masters who came from Lorraine: other major figures include Jacques Callot, Claude Lorrain and Georges de La Tour. Of his career relatively little is known. He contracted in 1595 for an apprentice in the city of La Mothe (destroyed during the Thirty Years' War). He is recorded as a painter of portraits and wall decorations and served as court painter to the Dukes of Lorraine from 1602 until his death. Claude Deruet became his apprentice in 1605, he was in France in 1608, and in 1612 he married a young woman aged seventeen. There is uncertainty as to his exact name: he was given the honorary title of *Sieur* in 1606 and is sometimes known as Jacques de Bellange. He may have visited Italy at some point in his career.

Although identified as a painter in his own lifetime, today about forty-eight etchings and around eighty drawings by Bellange are known. On the evidence of a photograph, F.-G. Pariset, the pioneering scholar of art in Lorraine, described this drawing in a letter of June 1950 (now in the National Gallery of Scotland files) as *à la manière de Bellange*. The majority opinion, however, has been that this ambitious sheet is by him. Cited as characteristic are the upturned heads of the putti and the struggling figures below, their contorted forms pressed against the surface of the paper. In the opinion of Sue Welsh Reed (cited in the Washington / Fort Worth 1990–1 exhibition catalogue) this sheet should possibly be classified as a presentation drawing, to be approved by a patron. Saint James the Great can be identified by the scallop shell on his left shoulder. The strange iconography, perhaps expressing some local dogma, remains unexplained. In the catalogue to the monographic exhibition at Rennes devoted to Bellange, catalogue by Jacques Thuillier, the subject is given as *Souls in Purgatory* and the attribution to Bellange is rejected, the young Claude Deruet (*c*.1588–1660) being proposed instead.[1]

RSA 225
Pen and brown ink with brown, yellow, and mauve washes on blue paper · 55.1 × 41.6
Various inscriptions incorporating letters and figures in two distinct contemporary hands inscribed on the verso

PROVENANCE
E. Peart; David Laing Bequest to the Royal Scottish Academy; by whom placed on loan in 1966.

EXHIBITED
*Drawings by Old Masters*, Royal Academy, London, 1953 (370); *Between Renaissance and Baroque*, City Art Gallery, Manchester, 1965 (261); Edinburgh 1976 (7); Washington / Fort Worth 1990–1 (67).

NOTES
1. *Jacques de Bellange*, Musée des Beaux-Arts, Rennes, 2001, pp.337–8.

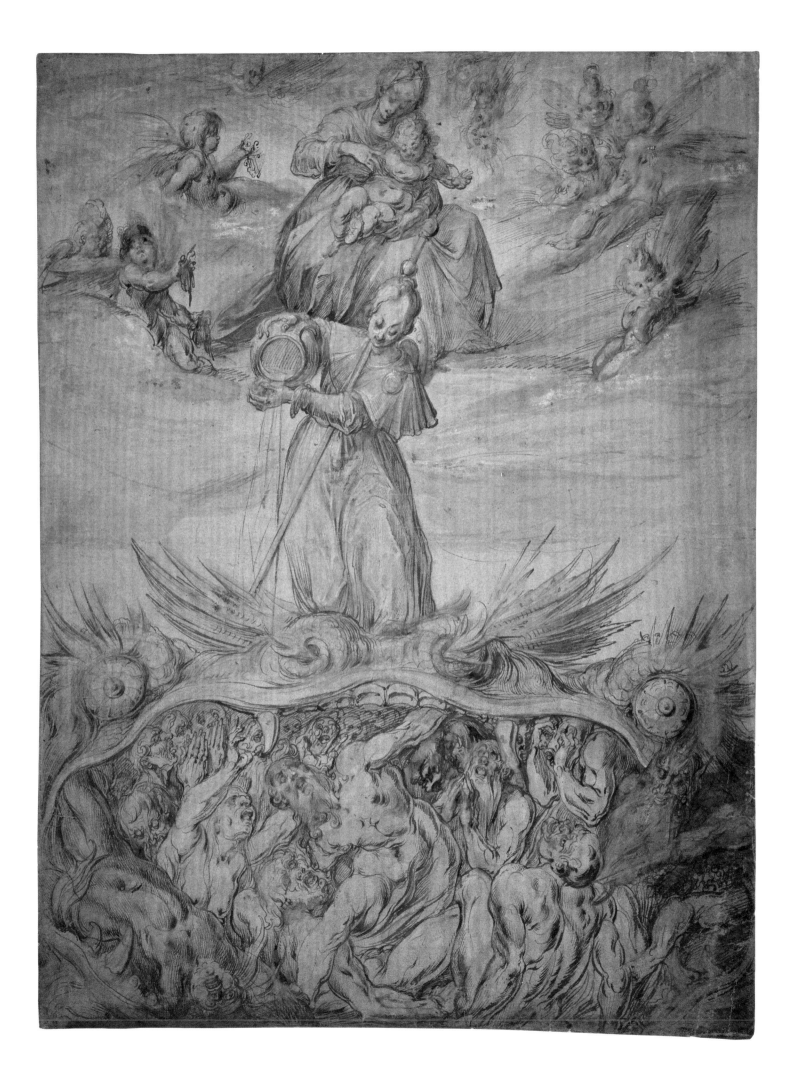

# 3

## Antoine Béranger
## *The Conjurer (L'Escamoteur)*

PARIS 1785–1867 SEVRES

Béranger was a painter who exhibited at almost every Salon from 1814 to 1859. After studying with various masters he concentrated on history and still-life painting. He later worked for the Manufacture Nationale de Sèvres and was one of its principal porcelain painters.[1] Among other activities he executed the preparatory studies on board for the stained-glass windows for the chapels of Dreux and the Trianon, and he was also well known as a lithographer.[2] His daughter, Susanne Estelle, worked in watercolours and enamels, as did both his sons, Charles and Emile.

This charming drawing includes many well-observed figures, from the man on the right smoking a cigar to the sensuous costume and upswept hair of the lady holding a child, whose attention is distracted by the extravagantly uniformed soldier. In the centre a group of children is held in thrall by the magician on the left. Another drawing by Béranger, *Study of Children Playing a Game*, in a similar style and technique, reminiscent of Louis-Léopold Boilly (1761–1845), was with Kate de Rothschild in 2001.[3]

D 5522
Pen and brown ink and wash, heightened with white, over black chalk on brown paper · 21.2 × 28.7
Mounted with a drawn trompe l'oeil label below: *Antoine* BERANGER / *1785–1867* / *L'Escamoteur*

PROVENANCE
Georges Haumont, curator of the Musée de Sèvres 1926–42; by descent; Hôtel des Ventes de Béziers, 23 September 2000 (Maître Abraham); Day and Faber, London, from whom purchased 2001.

EXHIBITED
*European Drawings 1570–1870*, Day and Faber, London, 2001 (17); Edinburgh 2001 (20).

NOTES
1. Two drawings by Béranger sold at Christie's, Monaco, 2 July 1993 (93, 94), both preparatory studies for the medallions in the great Etruscan-style vase (on rollers) *L'Education physique des anciens grecs* (Musée National de Céramique, Sèvres) demonstrate, even in this last great classical commission undertaken by Sèvres, Béranger's playful empathy in his depiction of children. Béranger's activity at Sèvres is further documented in G. de Bellaigue, *French Porcelain in the Collection of Her Majesty the Queen, London*, 2009; see, in particular, his involvement (first recorded in September 1810) in the decoration of the *Table of the Grand Commanders*, designed by Brongniart, no.2634, pp.2062ff.
2. See J. Laran, *Inventaire du fonds français après 1800*, vol.II, Paris, 1971, pp.232–4.
3. *Master Drawings* , Kate de Rothschild, London, 8–13 July 2001 (24), ex-sale catalogue Laurin, Guilloux, Buffetaud, Paris, 24 November 1993 (97).

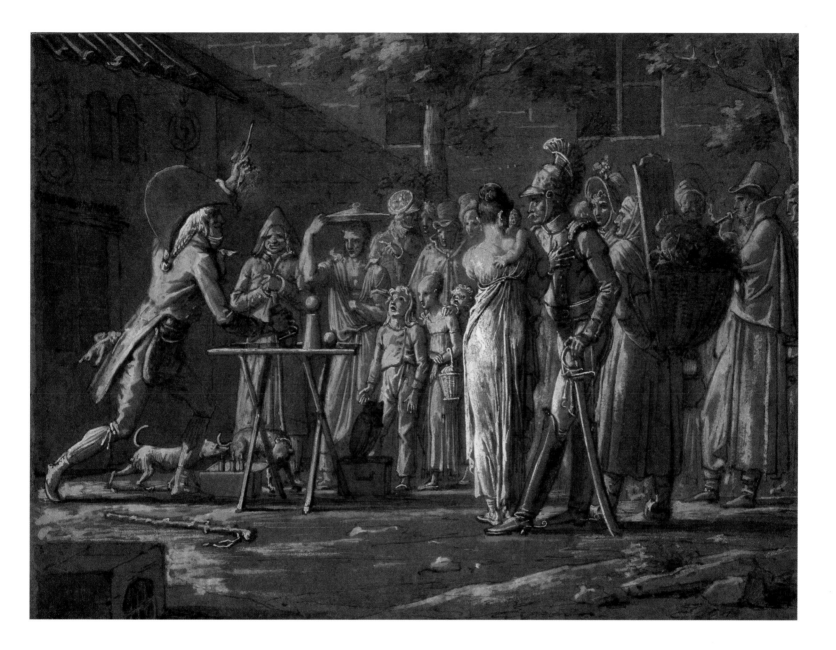

# 4 Emile Bernard
## *Young Breton Woman*

LILLE 1868–1941 PARIS

Bernard first studied at the Atelier Cormon in Paris but was expelled for insubordination. His fellow students included Van Gogh and Toulouse-Lautrec, as well as Louis Anquetin, with whom he developed the use of flat areas of colour contained within strong outlines which led to Cloisonnisme. This style greatly influenced the older Paul Gauguin, whom Bernard had first met in 1886. Both men were in Pont-Aven in 1888, each producing their seminal paintings of Breton life: Bernard his *Breton Women in the Meadow* and Gauguin his *Vision of the Sermon* (National Gallery of Scotland, Edinburgh). Relations soured between them as each claimed primacy in the invention of Synthetism and, although they both exhibited at the group show organised by their friend Schuffenecker at the Café Volpini in 1889, the definitive split came in 1891. Thereafter Bernard exhibited widely: at the Salon des Indépendants; with the Nabis at Le Barc de Bouteville; and at the Salon de la Rose + Croix. In addition to visiting Italy, Greece and the Near East, he settled in Cairo 1893–1904. In 1905 he founded the journal *La Révolution artistique*. His later work embodied an expressive classicism, inspired by the old masters.

Dating from the crucial year of 1888, this strikingly bold watercolour of a seated young woman is illustrative of the costume studies Bernard made at Pont-Aven in southern Brittany where, like many of his artistic colleagues, he lodged at the Pension Gloanec. The model for this study may well have been one of the pension staff. She wears traditional Breton costume with a *coiffe* and a sober outfit with black velvet sleeves. Bernard was evidently unhappy with the head and redrew it on a piece of paper, which was then stuck down on the main design. In type and physiognomy she is particularly close to the figures found in Bernard's *Breton Women in the Meadow* (fig.4.1) of 1888.

D 5624
Black chalk and watercolour · 39 × 19.9
Signed and dated, lower left: *Emile Bernard / 1888*

PROVENANCE
Talabardon et Gautier, Paris; from whom purchased 2008.

EXHIBITED
*Le xixe siècle*, Talabardon et Gautier, Paris, 2007 (26).

Fig.4.1 Emile Bernard, *Breton Women in the Meadow*, Private Collection

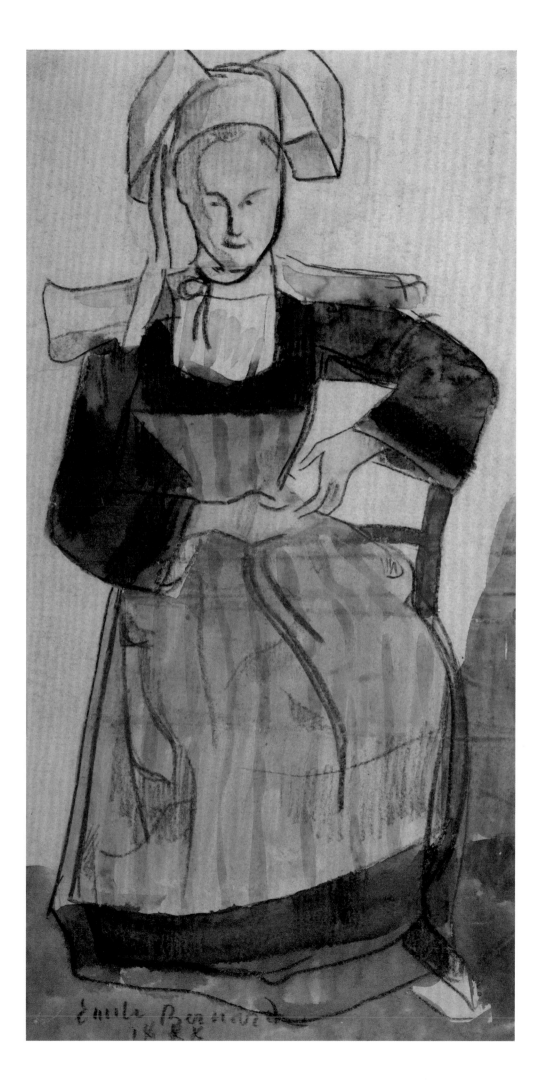

# 5

# Antoine-Félix Boisselier
## *Narni*

PARIS 1790–1857 VERSAILLES

Boisselier studied first with his brother, Félix, a history painter and winner of the Prix de Rome in 1805, and then with the landscape painter Jean-Victor Bertin. He was with his brother in Italy from 1807 until the latter's suicide in 1811. It is probable that he visited Italy on several occasions throughout his career. After returning to Paris, in 1817 he won the second prize in the competition held that year for the inaugural Grand Prix du Paysage Historique for his *Democritus and the Abderites*. The winner was the highly gifted Achille-Etna Michallon, first teacher of Corot. In 1819 Boisselier received a government commission for several landscapes for the decoration of the Galerie de Diane at Fontainebleau. He had first exhibited at the Salon in 1812 and continued to do so until 1853. He also exhibited widely outside of Paris. In 1830 he was appointed professor of drawing at the Ecole militaire at St-Cyr and thereafter resided at Versailles.[1] He was awarded the Légion d'honneur in 1842.

Narni, best known today perhaps through Corot's early Salon painting of 1826–7 *View at Narni* (National Gallery of Canada, Ottawa), had been a popular subject with landscape painters since the later eighteenth century. This was principally on account of the Roman bridge built across the river Nera by Augustus, which forms the centrepiece in Corot's celebrated painting. The town was also famous for its cathedral and other ancient monuments and Pierre-Henri de Valenciennes, in his seminal treatise on perspective and landscape first published in 1800, had recommended that painters should come and work in this region.[2]

This drawing, which depicts part of the town rather than any specific monument, comes from an album of fifty-three drawings by Boisselier, with a vellum cover, sold at Christie's, Monaco, in 1995. Each of the drawings was titled below. The album was broken up and sold after the 1995 sale, but its list of contents reveals a conventional choice of sites in and near Rome such as Tivoli, Subiaco, and Civita Castellana. None of the drawings is dated so it is not possible to be absolutely sure from which of Boisselier's trips the album originates; however its scope and locations suggest it comes from the first, certain, Italian sojourn of 1807–11. Such albums would have been typical of landscape artists who visited Italy and then used these visual compendia as source material throughout their careers. Together with the collection of Boisselier's drawings at the Musée de Senlis (donation Docteur Moreau) this album is of primary importance for studying the evolution of Boisselier's drawing style.

D 5412
Black chalk · 34.5 × 25.5
Inscribed in ink, lower centre: *Narni*
Boisselier's collection mark (L 3064, but in blue-grey ink), verso, lower left

PROVENANCE
Christie's, Monaco, 30 June 1995 (120, no.31); Galerie de la Scala, Paris; from whom purchased 1996.

NOTES
1. The most thorough biography of Boisselier is by V. Pomarède in the exh.cat. *Paysages d'Italie*, Paris / Mantua, 2001, p.138.
2. P.H. de Valenciennes, *Elémens de perspective pratique à l'usage des artistes …* , Paris, 1800, p.601.

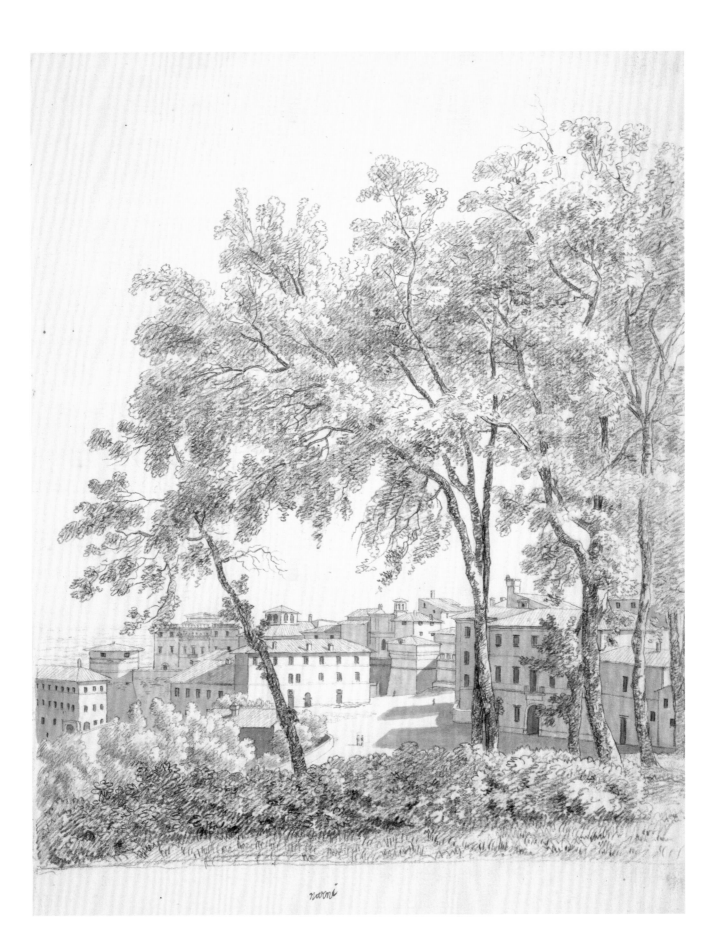

narni

# 6

## Jean-Jacques de Boissieu
### *Portrait of a Man*

LYONS 1736–1810 LYONS

Boissieu was one of the most prolific, diverse and successful of all draughtsmen working mainly in the French provinces in the eighteenth century.[1] He trained in his native Lyons, at first with an artist named Lombard, then with the history painter Jean-Charles Frontier, director of the Ecole de Dessin there. After a tour of the Rhône valley, he was in Paris in 1762 where his circle included Greuze, Wille (who encouraged his interest in printmaking), Vernet and Soufflot, as well as the collectors Mariette and Watelet. In 1765 he was invited by the young Louis-Alexandre, duc de La Rochefoucauld, on a tour of Italy and made numerous landscape drawings there. On his return to Rome in 1766 he sought employment as an etcher.[2] The following year he travelled round the Auvergne accompanying the scientist Nicolas Desmarets who was studying the natural history of the region. After a second stay in Paris he obtained, in 1771, an official post in Lyons – Trésorier de France – and he settled there for the rest of his life. Though based in his native city, he remained known in the capital and during the Revolution he enjoyed the protection of Jacques-Louis David. In his graphic work and in his relatively few paintings he displayed a consistent debt to seventeenth-century Netherlandish art:[3] in this respect he can be grouped with other neo-Dutch artists of the later eighteenth century such as Louis-Léopold Boilly, Marguerite Gérard and Martin Drölling. Boissieu was also an important figure in the establishment of a Lyonnais school of painters and advised artists such as Grobon, Révoil, Richard, Berjon, Duclaux and Epinat.

In addition to his numerous landscape drawings, Boissieu was a fine portraitist with a particular empathy for distinguished heads of old or middle-aged men that, in their painstaking realism, are reminiscent of Dutch seventeenth-century character studies or *tronies*. They are carefully drawn from the model in a rather distinctive, naive manner that confers a degree of monumentality upon the subject. One can also discern a certain similarity to the drawn portraits of his contemporary and mentor Jean-Georges Wille (1715–1808). The strong contrast of light and dark in his portraits and genre scenes are reminiscent of seventeenth-century Dutch artists such as Bega and Van de Velde. The majority of Boissieu's portrait drawings may date from later in his career when the vicissitudes of age discouraged extensive travelling and observation of landscape. His drawings and etchings were particularly appreciated from an early date by German collectors.[4]

D 5501
Brush and grey wash, heightened with white, over black chalk on blue-grey paper · 31.6 × 23.5

PROVENANCE
Galerie de Bayser, Paris; Mrs John J. Ide, San Francisco; by descent; Thomas Williams Fine Art Ltd, London, from whom purchased 2000.

EXHIBITED
Edinburgh 2001 (22).

NOTES
1. Significant groups of his drawings are in the Louvre, Paris, the Musée des Beaux-Arts, Lyons, and the Hessisches Landesmuseum, Darmstadt.
2. The catalogue raisonné of Boissieu's prints was published anonymously in 1878 by his grandson Alphonse de Boissieu: *Jean-Jacques de Boissieu, Catalogue raisonné de son oeuvre*, Paris, 1878. This was revised, with a new commentary, by Pérez: M.F. Pérez, *L'oeuvre gravé de Jean-Jacques de Boissieu, 1736–1810*, Geneva, 1994.
3. On the Dutch influence on his landscapes see V. Kaposy, 'Influences néerlandaises sur les dessins français du XVIIIe siècle (J.J. de Boissieu et A.T.H.Desfriches)', *Actae Historiae atrium Academiae Scientiarum Hungaricae*, vol.XXIII, 1977, pp.315–28.
4. M.F. Pérez, 'Les dessins de Jean-Jacques de Boissieu (1736–1810) conservés au cabinet des Dessins de Berlin-Dahlem' *Jahrbuch der Berliner Museen*, 1986, pp.84–91; M.F. Pérez, 'La Diffusion en Allemagne des gravures de Jean-Jacques de Boissieu (1736–1810) d'après sa correspondence', *Nouvelles de l'estampe*, 57, May / June 1981, pp.4–13.

# 7

## François Boucher
### *The Rape of Europa*

PARIS 1703–1770 PARIS

By the middle of the eighteenth century Boucher had become the dominant figure in French painting. He had originally trained with his father Nicolas, a master painter in the Academy of Saint-Luc, and then studied briefly with François Lemoyne at some time between 1721 and 1723, after which he may also have trained with Louis Galloche. He won the Prix de Rome in 1723 with his *Evil-merodach Releasing Joachim from Prison* (location unknown), but there was no room for him at the time at the French Academy there. He finally travelled to Rome at his own expense in 1728 but was back in France by November when he was *agréé* at the Academy, being *reçu* in 1734 with his *Rinaldo and Armida* (Louvre, Paris). From the 1730s onwards he received an increasing number of commissions, not only for paintings but also for tapestry designs for the Beauvais and Gobelins manufactories, porcelain designs for Sèvres and sets and opera designs for the Opéra and the *Théâtre la Foire*. His reputation spread rapidly abroad, and in 1748 he declined the position of *premier peintre* to the King of Prussia. With Madame de Pompadour's installation as *maîtresse en titre* to Louis XV in 1745, his commissions for the Crown increased, including work for the royal châteaux at Choissy and Fontainebleau, and for Madame de Pompadour's own château at Bellevue. Boucher was named *premier peintre du roi* in 1765 on the death of Carle Vanloo, prompting the acid observation from Diderot 'Well, my friend, it's at precisely the moment Boucher has ceased to be an artist that he's appointed first painter to the king.'[1] In his later years Boucher mainly painted variations on his favourite theme of the pastoral.

This drawing was first identified by Alistair Laing[2] as Boucher's *première pensée* for *The Rape of Europa* (fig.7.1)[3] painted for the special *concours* of 1747 devised by Charles Lenormant de Tournehem, recently appointed *Directeur général des Bâtiments du roi*. This competition was intended to encourage the French school of painting, the quality of which had been perceived to be in decline by many critics at the 1746 Salon. Ten history painters, whose names were supplied by Charles-Antoine Coypel, *premier peintre du roi*, were invited to treat subjects of their choice in 'whichever genre they were inclined by genius and inspiration'. The hope was that history painting would be revived by new subjects chosen from different countries and periods. It was therefore deemed disappointing by some that Boucher should choose a subject well known in European art and already popular with eighteenth-century painters. The account of the rape of Europa is taken from the second book of Ovid's *Metamorphoses* and tells how Jupiter, in the guise of a bull, abducted Europa, virginal princess of Tyre. Boucher depicts the beginning of the story in which the courtship takes place on dry land amid frolicking nymphs strewn with flowers. His rather traditional and decorative choice of subject may be partially explained by the fact that his competition entry was also intended as a tapestry design for the series *Les Amours des Dieux* (Loves of the Gods), commissioned by the Beauvais manufactory in 1747 and completed in 1752.

A number of drawings for the composition have already been identified in the literature on Boucher,[4] a testimony to the care, which he exercised in this particular instance. None of them, however, is for the whole composition. In the Edinburgh *première pensée* Boucher would appear

to have taken as his initial source of inspiration Veronese's well-known treatment of the same subject (Palazzo Ducale, Venice),[5] there being some similarities in the grouping of the main protagonists, most notably those on the left of the composition. Several features of this drawing recur from Boucher's own earlier 1734 treatments of this theme: the bull turning its head up to gaze at Europa is found in the brown grisaille sketch at Amiens,[6] and the basket of flowers occurs in the Wallace Collection picture.[7] In the final painting, however, Europa has moved to the centre, and Jupiter, in the form of the bull, has adopted a more passive role. The summary, schematic figure style in this drawing can be found in other drawings by Boucher, particularly those of the 1740s.[8] Surviving *premières pensées* by Boucher are rare and Laing has drawn attention to that for the *Death of Adonis* of 1730.[9] Boucher must have executed many such drawings, only to discard them once the projects were completed.

D 5351
Red chalk · 28.3 × 44.1 · Watermark of D & C Blauw[10]

PROVENANCE
Garrigues family, La Rochelle; by descent; Phillips, London, 16 December 1992 (125 unsold); purchased through Phillips, 1993.

EXHIBITED
Edinburgh / London 1994 (11); Edinburgh / New York / Houston 1999–2001 (44).

NOTES
1. 'Salon de 1765' in Seznec and Adhémar (eds), *Diderot Salons*, Oxford, 1960, vol.II, p.77.
2. As noted in the Phillips sale catalogue, see provenance.
3. A.Ananoff and D.Wildenstein, *François Boucher*, Lausanne / Paris, 1976, vol.II, no.350. For a full discussion of the painting, see C.Bailey, *The Loves of the Gods. Mythological Painting from Watteau to David*, exh.cat., Paris / Philadelphia / Fort Worth, 1991–2 (47).
4. Ananoff and Wildenstein, vol.II, p.51, nos 2–7; *François Boucher*, exh.cat., New York / Detroit / Paris, 1986, pp.238–9, nos 1–6.
5. T.Pignatti, *Veronese*, Venice, 1976, vol.I, no.216, II, figs 522–5.
6. Ananoff and Wildenstein, vol.I, no.103.
7. *Ibid.*, no.104.
8. For example, Paul Prouté, Paris, 1987, nos 30–1, and the *Bacchus and Ariadne: Design for a Fan Leaf* in the National Gallery of Canada (A.E. Popham and K.M. Fenwick, *European Drawings in the Collection of the National Gallery of Canada*, Toronto, 1965 (223).
9. Phillips catalogue entry: the drawing was exhibited by Patrick Perrin, Paris, 1988 (3).
10. The Dutch papermaking firm of Dirk and Cornelis Blauw began trading in 1621 and continued in various guises for a further 250 years.

Fig.7.1 François Boucher, *The Rape of Europa*, Musée du Louvre, Paris

# Louis-Nicolas Cabat
## *View of the Villa Belvedere, Rome*

PARIS 1812–1893 PARIS

First apprenticed in 1825–8 as a painter on porcelain at the Gouverneur factory in Paris, Cabat then studied with the landscape painter Camille Flers and, through the dealer Mme Hulin, probably met the landscape painters Bonington and Huet. He worked in the environs of Paris, and then in 1831 in Normandy and in the following year in the Berry in the company of Jules Dupré (whose style strongly influenced his early work). He was a frequent visitor to the Forest of Fontainebleau but he also travelled to Italy, the first and most important visit lasting from 1836 to 1839. In the mid-1830s, he broke away from the naturalistic style of landscape painting, then dominant in France, to develop a highly individual mixture of classicism and religiosity (he was a Catholic convert and at one stage considered becoming a Dominican). Cabat was a regular exhibitor at the Salon from 1830 until his death. In 1847 he married a native of Troyes, Emilie Bazin, through whose paternal grandfather he became particularly attached to the village of Bercenay-en-Othe in the department of the Aube, which he visited regularly and where he established a studio in the Bazin family house. Cabat was elected to the Institut de France in 1867 and from 1878 to 1885 was director of the French Academy in Rome. His regime there was criticised for being too lax and he was replaced by the allegedly more rigorous Hébert.[1]

As Carol Richardson has convincingly demonstrated,[2] this imposing view (formerly thought to show the Villa Medici, Rome) depicts the Villa Belvedere, Pope Innocent VIII's late-fifteenth-century retreat from the nearby Vatican palaces. Comparison of the drawing with a modern photograph confirms that the two 'towers' are in fact the lateral view of Bramante's apse rising above the Belvedere courtyard and the Cortile della Pigna. Furthermore, Cabat's drawing, far from showing an imaginary landscape, is topographically accurate. The view shows, to the left, the defensive wall constructed in the sixteenth century from the Castello to the bastion under the Belvedere; more specifically, in the left foreground of the drawing the wall is depicted from just before the Porto Castello running along to the Belvedere.

Such a grand and structured composition, with a bowed figure approaching along a zigzag road, is broadly reminiscent of Nicolas Poussin's heroic landscapes of the late 1640s. Even before Cabat's first visit to Italy in 1836–9 (punctuated by a brief return to France in 1838), contemporary critics had noted his predilection for the work of the seventeenth-century master.[3] Of Cabat's *View of the Gorge-aux-Loups, Forest of Fontainebleau*, exhibited at the 1835 Salon, the critic of *L'Artiste* observed, 'To be sure, he dreams of Poussin as he used to dream formerly of Flemish landscapes; … there are all these great landscapes by the author of Diogenes (for example, Poussin, whose painting of *Diogenes* is in the Louvre, Paris) which pass ceaselessly in front of his eyes and which interpose themselves between the real point of view and the painter.'[4] Again, in 1841, W. Tenint in his Salon review referred to Cabat as having been 'seduced by the severe school of Poussin to the extent of having sacrificed his own free will to him'.[5] However, around 1834–5, Cabat had deliberately turned towards the art of artists such as Claude and Poussin in his desire to achieve a harmonious idealism in his art, very different from the northern realism of his early work. He was not alone in this idealising tendency, and other French landscape painters who can be mentioned in this context include the Benouville brothers, Caruelle d'Aligny and Paul Flandrin. However, the catalyst in Cabat's case for such an abrupt change in style was provided by his conversion to a devout and liberal Catholicism under the guidance of his spiritual mentor, the Abbé Lacordaire,[6] with whom

he founded the 'Société de Saint-Jean', which was concerned with reinstating the Christian application of art.[7] The evidence of the landscape drawing now in the Louvre inscribed *Rome 20 Novembre 1836* (fig.8.1), and bearing a number of stylistic similarities to the Edinburgh drawing, seems to suggest that the Italian visit of 1836–9 provides the most likely dating for this drawing, though Pierre Miquel suggested around 1850.[8] Large in size, executed on three pieces of paper joined together, it has to be classed as one of his most ambitious drawings and one intended for display or exhibition. As Richardson also suggests, the choice of subject, essentially of Christian rather than Classical Rome, must have been influenced by Cabat's profoundly held religious beliefs.

Fig.8.1 Louis-Nicolas Cabat, *Roman Landscape*, 1836, Musée du Louvre, Paris

D 5414

Pencil, pen, brown ink and wash · 43.5 × 77.5

PROVENANCE

Pierre Miquel, Cannes; from whom bought by Galerie Brame et Lorenceau, Paris; from whom purchased 1996.

EXHIBITED

Edinburgh / New York / Houston 1999–2001 (55).

NOTES

1. The most detailed published biography of Cabat is to be found in P. Miquel, *Le paysage français au XIXe siècle 1824–1874*, Maures-la-Jolie, 1975, vol.III, pp.482–531. The most recent exhibition of his work was *Louis Cabat (1812–1893)*, Musée des Beaux-Arts, Troyes, 1987.

2. C. M. Richardson, 'A Cabat for the National Gallery of Scotland: The true identity of Louis-Nicholas [*sic*] Cabat's Villa Medici', *Apollo*, March 2000, pp.48–51.

3. On the interest in Poussin at that time, see R. Verdi, 'Poussin's Life in Nineteenth-Century Pictures', *The Burlington Magazine*, vol.CXIII, 1969, pp.741–50.

4. Miquel 1975, p.490.

5. *Ibid.*, p.500.

6. Henri Lacordaire (1802–1861), a leading ecclesiastic in the Catholic revival in France following the Napoleonic period.

7. P. Dorbec, 'Louis Cabat', *Gazette des Beaux-Arts*, vol.1, April 1909, p.328.

8. Letter from Sylvie Brame, 11 December 1998, National Gallery of Scotland files.

# 9

## Jacques Callot
### *Ecce Homo*

NANCY c.1592–1635 NANCY

Jacques Callot is best remembered as one of the most prolific of all printmakers. He produced more than 1,400 etchings and engravings, which were very popular across Europe both during his lifetime and later. He was apprenticed to a goldsmith in Nancy. Sometime between 1608 and 1611 he left for Rome where he continued his education with the engraver Philippe Thomassin. He moved to Florence in 1611 and was employed by Cosimo II de'Medici, Grand Duke of Tuscany. A brilliant series of engravings followed, especially those depicting public festivities. On the death of Cosimo in 1621, Callot returned to Nancy. He undertook commissions for the Infanta Clara Eugenia and also for Cardinal Richelieu, for whom he made the spectacular etching depicting the breaking of the English blockade off the Ile de Ré, near La Rochelle (1630). His last great work, *The Miseries of War*, reflects the horrors of Richelieu's invasion of Lorraine in 1633.

This is an excellent example of Callot's draughtsmanship and has been dated to around 1620–30.[1] His style of graphic reportage was brilliantly suited to capturing the drama of a scene such as this: the eloquent gestures expressed by the hands of the protagonists, and the shorthand used to describe the huddled groups in the lower left corner. Although it may have been drawn as an idea for an engraving, no related print is known. Religious subject matter was of great importance to Callot, his family being particularly devout Catholics. Four brothers and one sister belonged to religious orders and Callot himself is reported to have attended Mass every day and left a substantial bequest to the church.

D 4907
Red chalk with traces of black chalk and brown wash
21.1 × 16.5
A.A. De Pass (L 108a) and Royal Institution of Truro (L 2014e) collection marks on separate piece of paper, presumably removed from a previous mount.

PROVENANCE
A. A. de Pass; by whom given to the Royal Institution of Cornwall, Truro; Christie's, London, 30 November 1965 (132); purchased from Colnaghi's, London 1966.

EXHIBITED
London 1966 (39); Washington / Fort Worth 1990–1 (64).

NOTES
1. K. Andrews, 'Recent Acquisitions at the National Gallery of Scotland' *Master Drawings*, vol.v, Edinburgh, 1967, p.381, no.17, pl.18.

# Antoine Caron
## *Water Festival at Fontainebleau*

BEAUVAIS 1521–1599 PARIS

A major figure in the development of French Mannerism, Caron began his long career in his native Beauvais where he provided cartoons for stained-glass windows. But it was at Fontainebleau that he received his most important training and where he was profoundly influenced by the Italian artists who worked there, Francesco Primaticcio and Niccolò dell'Abate. Thereafter, he pursued a successful career at the French court where he was extensively employed as a designer of cartoons for tapestries and as a painter of decorations for festivals and triumphal entries.

Fig.10.1 *Water Festival at Fontainebleau*, tapestry, woven in Brussels 1582–5, Uffizi, Florence

This is one of a series of six surviving drawings by Caron that formed the basis for a slightly later series of eight Valois tapestries, the so-called *Valois fêtes*, now in the Uffizi, Florence.[1] The tapestries, which were commissioned by Catherine de' Medici,[2] glorify the period of Henri III and of the duc d'Anjou. They were made in Brussels around 1582–5 and designed by Lucas de Heere. In them full-length figures, some of whom have been identified as members of the family of Catherine de' Medici, are superimposed on the foregrounds of the Caron compositions as if looking in on the events taking place therein. As Frances Yates has so aptly put it: 'The Valois tapestries are thus the result, not of a collaboration between two artists, but of a total revision and reinterpretation of the designs of one artist by another.'[3] The tapestries were rediscovered in 1866 from the boxes in which they had been stored since the late sixteenth century in the palace of the Grand Duke of Tuscany, who in 1589 married Christine de Lorraine, grand-daughter of Catherine de' Medici. Five of the Caron drawings represent festivals at the French court that took place between 1562 and 1573 during the reign of Charles IX. The Edinburgh drawing was the earliest of the series to come to light and at the time it was shown in the Royal Academy in 1949/50, Yates observed that the composition appears in the background of one of the Valois tapestries. Five more drawings by Caron, all of roughly the same dimensions and likewise numbered and relating to other tapestries in the series, subsequently appeared and were offered for sale by Colnaghi's, London, in 1955. Probably sketches for cartoons, they are now distributed as follows and, like the Edinburgh drawing, are numbered:

*The Castle of Anet*, Louvre, Paris

*The Garden of the Tuilerie*, Fogg Art Museum, Cambridge, Mass., formerly Winslow Ames Collection, Springfield, Missouri

*The Sirens and the Marine Monster*, Pierpont Morgan Library, New York

*Carrousel of Breton and Irish Knights*, Courtauld Institute Gallery, University of London[4]

*Game of Quintain*, Courtauld Institute Gallery, University of London

Yates, on the basis that the latest actual event / fête shown is that for the entertainment of the Polish ambassadors in 1573 (the drawing in the Fogg), has suggested that all the works may date from around then.[5] The two Valois tapestries for which no drawings by Caron are known are *The Combat at the Bar* and *The Assault on the Elephant*.

In this drawing boats filled with warriors attack an island defended by others with lances. The oriflammes or banners fly to the left, but this is reversed in the tapestry. Such reversions are apparently frequent with low warp tapestries.[6] The setting is clearly identifiable as Fontainebleau. In the tapestry relating to the Edinburgh drawing Henry III and his queen, Louise of Lorraine, stand on the right of the composition with the water fête organised by Catherine de' Medici in 1564 in the background (fig.10.1). The sailors in one of the boats now have Turkish costumes, doubtless reflecting Admiral Doria's great naval victory over the Turks at Lepanto in 1571.

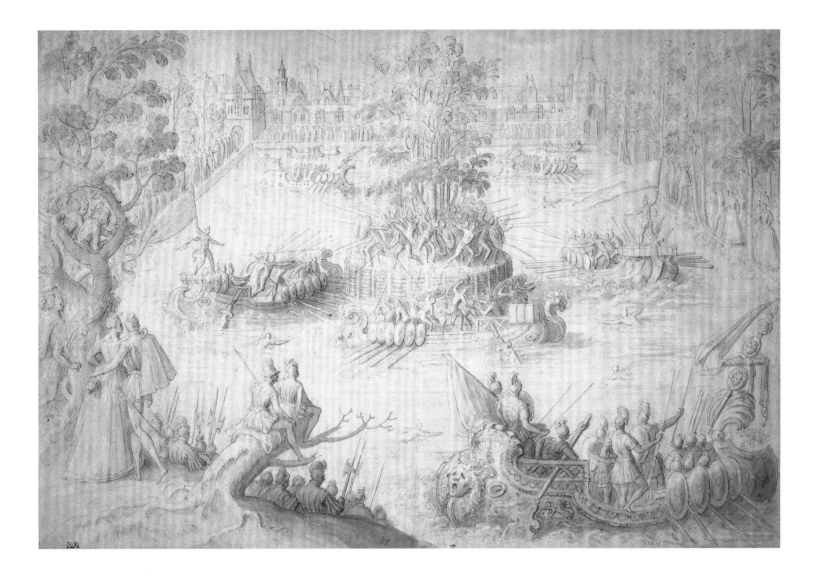

RSA D 767
Black chalk with pen and brown wash, heightened with white · 31.6 × 46.5
Inscribed in a contemporary hand in ink, lower centre: 2
Collection marks of Royal Scottish Academy (L 2188), lower left and National Gallery of Scotland (L 1969f) lower centre. Verso collection mark of National Gallery of Scotland (circular, not in L), lower left and unidentified (seventeenth-century?) paraphe in brown ink, centre.

PROVENANCE
David Laing Bequest to the Royal Scottish Academy; transferred 1910.

EXHIBITED
*Landscape in French Art*, Royal Academy, London, 1949 (525); *De Triomf van het Manierisme; de Europese stijl van Michelangelo tot el Greco*, Rijksmuseum, Amsterdam, 1955 (183); Edinburgh 1961 (9); *Between Renaissance and Baroque. European Art 1520–1600*, City Art Gallery, Manchester, 1966 (292); London, 1966 (31); *L'Ecole de Fontainebleau*, Grand Palais, Paris, 1972 (43); Washington / Fort Worth 1990–1 (50).

NOTES
1. F.A. Yates, *The Valois Tapestries*, 2nd edn, London, 1975; J. Ehrmann, *Antoine Caron*, Paris, 1986 pp.189–200; L. de Groër, 'Les tapisseries des Valois du Musée des Offices à Florence', *Hommage à Hubert Landais*, Paris, 1987, pp.125–34.
2. There was a large and sophisticated market for tapestries in sixteenth-century France, led by the French crown. There was also a precedent for Catherine de' Medici commissioning tapestries based on designs by Caron in the set of tapestries honouring the classical widow Artemesia based on designs by Caron created for a manuscript of 1562. For a broader discussion of Renaissance tapestries in northern Europe see T. Campbell, *Tapestry in the Renaissance, Art and Magnificence*, New Haven and London, 2002, pp.263–85.
3. Yates 1975, p.5.
4. For the two Courtauld drawings see *French Drawings XVI–XIX Centuries*, Courtauld Institute Gallery, London, 1991 (8,9).
5. Yates 1975, p.3.
6. J. Ehrmann, 'Drawings by Antoine Caron for the Valois Tapestries in the Uffizi, Florence', *Art Quarterly*, Spring 1958, pp.47–65.

# Jean-Charles Cazin
## *A Village Street at Evening*

SAMER 1841–1901 LE LAVANDOU

An artist whose unexpectedly complex style defies easy categorisation, Cazin worked primarily as a landscape painter. In Paris he studied at the Ecole Gratuite de Dessin under Horace Lecoq de Boisbaudran, whose two tenets of studying closely from nature and of painting and drawing from memory had a fundamental influence on him. On his teacher's recommendation he was appointed director of the Ecole de Dessin and of the museum at Tours, and it was there that he also became interested in the industrial arts. In 1871 he moved to London and worked primarily in the field of ceramics. In 1874 he returned to France settling in Equihen near Boulogne-sur-mer. He also resumed painting, inspired by the often windblown dune scenery round Boulogne, concentrating on both historical and religious subjects in which the protagonists were portrayed in modern settings in a style partially influenced by his friend Puvis de Chavannes and admired by both Odilon Redon and Maurice Denis. Cazin exhibited at the Salon from 1876 and with the Société Nationale from 1890. He was awarded the Légion d'honneur in 1882 and in 1900 he received a Grand Prix at the Exposition universelle. Although some of his work was destroyed during the First World War, enough survives for a proper appreciation of his very individual synthesis of various stylistic currents in later nineteenth-century French art.

This highly atmospheric pastel is illustrative of the haunting sense of melancholy which Cazin could conjure up in his best work. In nocturnal scenes such as this he appears far closer to the Symbolists of his era than to the successors of Barbizon or Impressionism. Given the relatively flat topography of this scene it may well be that it depicts a village in Seine-et-Marne[1] rather than one of the steeply sloping villages on the Channel coast near Boulogne.

D 5582
Pastel · 56 × 52
Signed, lower right: *J.C.CAZIN*

PROVENANCE
Jules Claretie,[2] his sale, Hôtel Drouot, Paris, 8 May 1914 (75 as 'Rue de village-Effet de nuit'); Galerie de La Scala, Paris; from whom purchased 2005.

NOTES
1. For example, *A Village Street*, The Metropolitan Museum of Art, New York, acc.no.25.110.53, described by L.Bénédite, *Jean-Charles Cazin*, [c.1901], p.25, illus. as *Village de Seine-et-Marne*.
2. Jules Arsène Arnaud Claretie (1840–1913), writer, critic and director of the Théâtre Français. His major work of art criticism was *L'art et les artistes français contemporains. Avec un Avant-propos sur le Salon de 1876*, Paris, 1876.

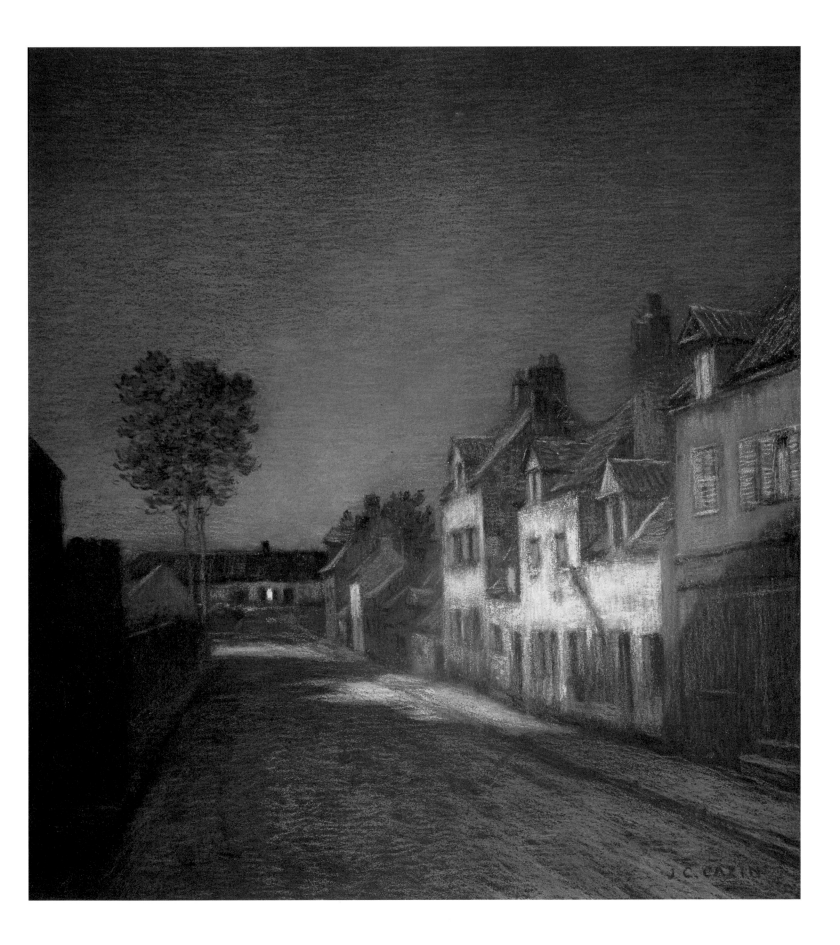

# 12

## Claude Gellée, called Le Lorrain
### *Pastoral Caprice with the Arch of Constantine and the Colosseum*

CHAMAGNE 1604/5?–1682 ROME

Generally considered the founder of the classical landscape tradition in painting, Claude was born in the then independent duchy of Lorraine. He arrived in Rome around 1617–18, where he was based for most of his career. He trained with both Agostino Tassi and initially, for a period of up to two years, with the German painter Goffredo Wals in Naples. In 1625 he returned to Lorraine for a year to work as Claude Deruet's assistant. His early work in Rome included mural landscapes. In about 1633–4 he was one of a number of artists commissioned to make landscapes for Philip IV's palace of Buen Retiro near Madrid. He gradually attracted a wide range of European patrons including popes, cardinals and princes. In order to protect against forgeries he compiled his *Liber Veritatis* (*Book of Truth*), comprising drawn records of all his major compositions. This is now housed, disbound, in the British Museum, London (which holds the greatest collection of his drawings). Claude's paintings were particularly collected by the British in the eighteenth and nineteenth centuries and were extremely influential on the Picturesque movement and on landscape painting and country house park design.

This drawing was formerly attributed to the eighteenth-century Scottish painter John Runciman (younger brother of the more famous Alexander) until correctly identified by Keith Andrews.[1] It is a study for a picture formerly at Houghton Hall, Norfolk, which was sold at Christie's in December 1989 (80) (fig.12.1).[2] The painting, datable to 1648, is recorded in drawing no.115 in Claude's *Liber Veritatis*.[3] A later well-known variant is in the Duke of Westminster's collection.[4] According to Roethlisberger,[5] the Edinburgh drawing, despite the impression of having been done from nature, was almost certainly executed in the studio. Kitson, writing in the entry for this drawing in the 1969 Hayward Gallery exhibition catalogue, observed that the 'squaring with diagonals' represented Claude's method of marking up a drawing for transferring a design to canvas:

*In this case he must have begun with the horizontal and vertical lines which intersect at the upper edge of the arch. This was the focal point of the design. The diagonal from top left to bottom right was probably added next, with the diagonal at the bottom left ruled parallel to it. The whole of the rest of the pattern would then have followed, consisting of six roughly equal squares (in fact they are not all equal, nor are they exact squares, nor is the main horizontal half way up the sheet). By using this system Claude was enabled to reproduce the main features of the composition in the same relative positions on the canvas.*

In Claude's day the Arch of Constantine was still partially embedded in the ground due to the accretions of centuries and it is so depicted both in our drawing and in the final painting. The conceit of transplanting the Arch and the Colosseum into a fanciful Campagna setting has led Roethlisberger to suggest that the patron of the composition might have lived abroad rather than as a resident of Rome.[6]

RSA 217

Brush with brown ink and red washes, and black chalk
18 × 24.7
The composition is divided into squares by a system of black chalk lines ruled vertically, horizontally, and diagonally. Inscribed in an (?) eighteenth-century hand on the recto, bottom right corner, in ink: *29* and on the verso, in ink: *Claude G ... ee*, visible through the paper on which the drawing has been laid down.

PROVENANCE
David Laing Bequest to the Royal Scottish Academy; by whom placed on loan in 1966.

EXHIBITED
*The Art of Claude Lorrain*, Hayward Gallery, London, 1969 (83); Edinburgh 1976 (19); Washington / Fort Worth 1990–1 (72).

NOTES
1. K. Andrews, 'Recent Acquisitions at the National Gallery of Scotland', *Master Drawings*, vol.v, 1967, p.381.
2. M. Roethlisberger, 'The Houghton Hall Claude', *Apollo*, May 1990, pp.300–3.
3. M. Kitson, *Claude Lorrain: Liber Veritatis*, London, 1978 pp.124–5. The *Liber* drawing is inscribed: *faict pour monsieur p.r.*, transcribed in the first index (1682 or soon after) as *Piniez*.
4. M. Roethlisberger, *Claude Lorrain: the Paintings*, vol.i, London, 1961, pp.288–90.
5. M. Roethlisberger, *Claude Lorrain: the Drawings*, vol.i, Berkeley and Los Angeles, 1968, no.656a.
6. Roethlisberger 1990, p.301.

Fig.12.1 Claude Lorrain, *Pastoral Landscape with Ruins*, formerly at Houghton Hall, Norfolk

## 13 Claude Gellée, called Le Lorrain
### Roman Landscape with a Gatehouse

Dated by Roethlisberger to around 1635,[1] this
drawing was correctly attributed to Claude
by Keith Andrews shortly after it was placed
on loan to the Gallery in 1966. A nature study
– possibly begun out of doors and finished in
the studio – it is characteristic of Claude's early
wash drawings which, in style, are indebted to
the example of Dutch artists working in Rome
such as Bartholomeus Breenbergh and his circle.
It depicts, on the right, one of the ancient gates
in the Aurelian walls of the city: the most likely
candidate, according to Roethlisberger, being the
Porta Salaria or, less probably, the Porta Latina.
The subject was doubtless chosen because it was
picturesque, a partially ruined building at the
meeting point of city and country. Such a motif
would have been potentially useful to Claude as
he devised his imagined recreations of the ancient
and biblical worlds.

RSA 19
Black chalk, pen, brown ink and brown wash · 11.4 × 14.4
Inscribed, lower centre: *Cl. le Lorrain*
Collection marks lower centre, Royal Scottish Academy
(L 2188) and, lower right, Jonathan Richardson Senr (L 2184).
On the mount recto, lower right, John Barnard (L 1419); verso,
centre right, John Barnard (L 1420 *J.B.No:788. / 10¾ by 7¾*),
centre left, William Sharp (L 2650); unidentified (A library
classification?) *Fa.64. / J.*

PROVENANCE
Jonathan Richardson Senior; William Sharp; John Barnard;
David Laing Bequest to the Royal Scottish Academy, by whom
placed on loan in 1966.

NOTES
1. M. Roethlisberger, *Claude Lorrain: The Drawings*, vol.I,
Berkeley and Los Angeles, 1968, no.146a.

# 14 Attributed to Charles-Nicolas Cochin the Elder after Watteau
*Love in the Italian Theatre*

PARIS 1688–1754 PARIS

Charles-Nicolas Cochin first trained as a painter with his father Charles in Paris, but around 1712 became an engraver. *Agréé* in 1729, he was received as a member by the French Academy in 1731. Cochin's fame rested on his prints after Watteau, Jean-François de Troy, Jean-Siméon Chardin and other leading artists of his time. He became one of the best engravers in France in the first half of the eighteenth century and some of his sheets are among the masterpieces of eighteenth-century printmaking.[1] His son Charles-Nicolas Cochin the Younger (1715–1790) was one of the most prolific and important draughtsmen of the following generation in France and excelled as a designer for court celebrations and as an illustrator. His fame later far outshone that of his father.

This drawing had long been classified as an anonymous copy after Antoine Watteau. It reproduces a well-known painting in the Gemäldegalerie, Berlin, *Love in the Italian Theatre*, in the exact size of the original (fig.14.1). The painting, a rare night scene in Watteau's œuvre, depicts an outdoor gathering of male and female characters, some of them clad in costumes of the Italian Commedia dell'arte. It is paired with *Love in the French Theatre*, a day scene featuring several characters in costumes from the French stage. Both titles go back to the so-called *Recueil Jullienne*, a series of prints after Watteau's paintings by different engravers published between 1726 and 1739 by Jean de Jullienne, director of the Gobelins factory, textile producer, art dealer and collector. In 1734, when both paintings were engraved by Cochin for the *Recueil*, they were part of the collection of Henri de Rosnel in Paris.[2]

On stylistic grounds the two paintings have often been dated some years apart. Recent art-historical and technical examination has, however, revealed that they are likely to have been painted at the same time, around 1715–17. Slight changes to *Love in the Italian Theatre* made by Watteau reflect an attempt to match the work more closely to its pendant. Both paintings are among the very rare examples in Watteau's work of a one-layered, bright grey priming.[3] It is thus likely that the paintings were created as pendants. The combination of Italian and French comedy characters and of night and day scenes makes them a perfect pair. They were published together for Jullienne's publication and announced in the *Mercure de France* of May 1734.

The recent examination of the Berlin painting has unexpectedly provided a clue for the attribution of the drawing in Edinburgh. It is exactly the same size as both Watteau's painting and of Cochin's print. A slight squaring in graphite of 1.3 centimetres is visible on the sheet, a standard device to transfer a composition to another work. Close inspection of the Berlin painting revealed traces of needles or thin nails all around the edges of the painting at the same distance. These nails probably served to hold a grid of thin threads which helped to produce an exact copy of the original. A similar grid was then drawn on a sheet of paper and Watteau's composition copied onto the paper. This technique required direct access by the printmaker to the painting. On 24 April 1734, Henri de Rosnel, the owner of the painting, was granted royal privilege for the prints. He was obviously involved in their production although they appeared as part of the *Recueil Jullienne*. It is thus likely that Cochin was able to use this technique on the originals. The sheet in Edinburgh probably served as the first copy after Watteau's painting. The drawing was therefore executed by the engraver himself or at least for him. A consecutive drawing or counter-proof must have shown the composition in reverse. Cochin's print is in the same orientation as the painting which means that the scene must have appeared in reverse on the copper plate.

D 1800
Grey and red ink and grey wash, squaring in graphite
36.3 × 48.7

PROVENANCE
David Laing Bequest to the Royal Scottish Academy; transferred 1910.

NOTES
1. On Cochin the Elder, see M. Roux, *Inventaire du Fonds Français. Graveurs du xviiie siècle. Bibliothèque Nationale. Département des Estampes*, vol.4: *Cathelin-Cochin Père (Charles-Nicolas)*, Paris, 1940, pp.594–5.
2. E. Dacier and A. Vuaflart, *Jean de Jullienne et les graveurs de Watteau au xviiie siècle*, vol.iii: *Catalogue*, Paris, 1922, pp.113–14, nos 270–1; Roux 1940, pp.619–20, nos 151–2.
3. C. M. Vogtherr, *Französische Gemälde I: Antoine Watteau und sein Kreis (Bestandskataloge der Kunstsammlungen. Stiftung Preußische Schlösser und Gärten Berlin-Brandenburg)*, Berlin, 2010 (B1 and B2).

Fig.14.1 Antoine Watteau, *Love in the Italian Theatre*, Gemäldegalerie, Berlin

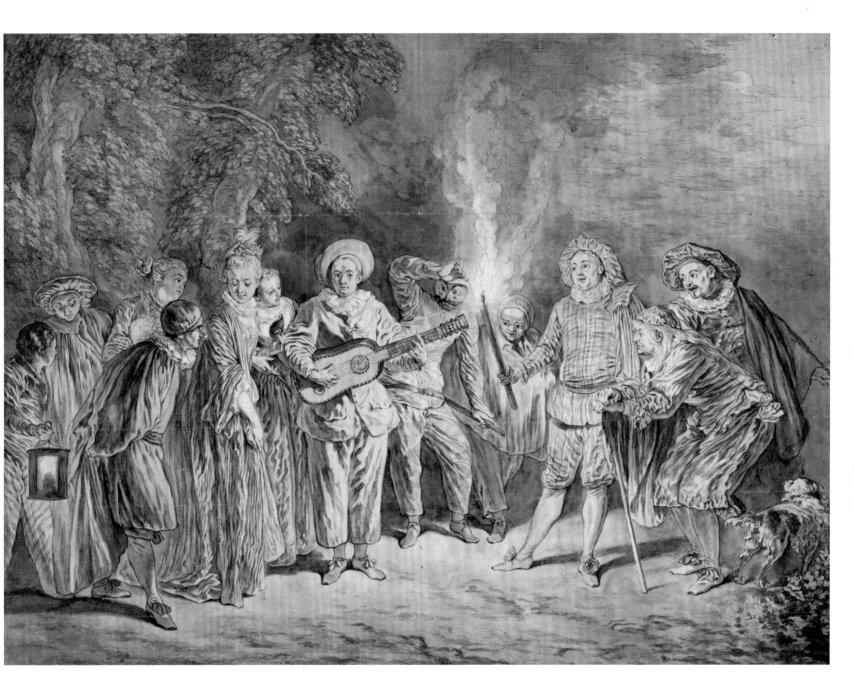

# Jean-Baptiste-Camille Corot
## *A Woman Writing*

PARIS 1796–1875 PARIS

In many respects Corot was the most important French landscape painter of the nineteenth century. In the course of his long career, he experienced both the triumph and decline of the neoclassical landscape and the rise of Impressionism. Born to relatively well-off and hardworking parents of the Parisian bourgeoisie (his mother was a successful milliner with premises in the rue du Bac), he studied under the short-lived but highly gifted Achille-Etna Michallon, and then Jean-Victor Bertin, before undertaking his crucial, and highly formative, first trip to Italy in 1825–8. Having inherited an annual allowance on the death of a sister, he had no financial need to compete for the quadrennial Grand Prix du Paysage Historique and remained financially independent throughout his career. Further trips to Italy ensued in 1834 and 1843. Corot's landscape oil sketches made in the open air are now rightly considered pre-eminent, but his finished Salon compositions, though greatly celebrated in their day, have fallen from critical favour, often unjustly.

Corot drew prolifically throughout his career so it is all the more regrettable that this aspect of his work has received little attention to date.[1] He himself frequently stressed the importance of drawing. As early as 1825 he observed, 'I see how much one must be *severe* after nature and not content oneself with a sketch made in haste. How many times have I regretted, when looking at my drawings, not having had the courage to have spent half an hour more on them!'[2] Later remarks by him also stress the primacy of drawing, though in these instances one should remember the dual meaning of the French *dessin* – 'drawing' or 'design' - and it may well be the latter that was intended by Corot in his stated hierarchy, which stressed first design (or drawing), then 'values' (for example, tones), and finally colour and execution.

Corot's early drawings in black lead show a keen observation and sense of structure of the terrain he chose to depict. In his mid-career he turned with increasing confidence to beautifully observed figure drawings that display great skill in the genre. His later drawings, with their use of pen and wash or stumped charcoal, mirror the poetic reverie of his later paintings and his involvement with the printmaking techniques of *cliché-verre* and lithography.

In this drawing, the sitter remains unidentified, but on grounds of style it seems reasonable to date it broadly to 1835–50 on comparison with two well-known figure studies of young women

included in Robaut's catalogue raisonné. The first is *Young Woman Seated with Arms Crossed* (Robaut IV no.2721, by whom dated 1835–45, fig.15.1),[3] one of the masterpieces of Corot's drawn œuvre, which shares a monumentality of pose with the Edinburgh drawing. The second is *Study of a Young Woman*, in which the model is seated facing the viewer, her right arm resting on the back of her chair (Robaut IV no.2778, by whom dated 1840–50, fig.15.2).[4] The cursory handling of drapery folds in this drawing is extremely close in manner to that of the Edinburgh sheet.

Over two-thirds of Corot's drawings featured figures and the finest of these studies reveal an original approach to the human form which is only equalled in his paintings in certain of the small and intimate portraits of friends and family of the 1830s and 1840s, and in the much larger, enigmatic fantasy 'portraits' of young women of the 1860s and 1870s. Degas, a great admirer of Corot, was probably not joking when he replied to the painter Gérôme's rhetorical question as to whether he [Degas] thought Corot knew how to draw a tree, 'Certainly … and I consider him even better in his figures.'[5]

D 5553
Pencil · 36 × 22
Corot Vente stamp (L 461), lower left

PROVENANCE
Jill Newhouse, New York; from whom purchased 2004.

NOTES
1. *Dessins de Corot (1796–1875)*, exh.cat., Louvre, Paris, 1962; F. Fossier, 'Corot dessinateur, Corot graveur', *Corot, un artiste et son temps*, Paris, 1998, pp.59–72.
2. *Corot raconté par lui-même et par ses amis*, vol.I, Geneva, 1946, p.87.
3. Black lead: 21.2 × 19.1, Louvre inv.no.RF3353. *Hommage à Corot*, Orangerie des Tuileries, Paris 1975 (151).
4. Black lead: 44.8 × 31, Louvre inv.no.RF8769. *Hommage à Corot* (154).
5. E. Moreau-Nélaton, *Corot raconté par lui-même*, vol.II, Paris, 1924, p.108.

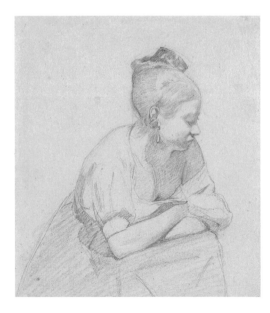

Fig.15.1 Camille Corot, *Young Woman Seated with Arms Crossed*, Musée du Louvre, Paris

Fig.15.2 Camille Corot, *Study of a Young Woman*, Musée du Louvre, Paris

VENTE
COROT

# Pascal-Adolphe-Jean Dagnan-Bouveret
## *Seated Breton Women*

PARIS 1852–1929 QUINCEY,
HAUTE-SAÔNE

A major exponent of naturalism in the later nineteenth century, Dagnan-Bouveret studied with Cabanel and then Gérôme. He exhibited at the Salon from 1875, at the Société nationale from its foundation in 1890 and, also from that year, with the Société des Pastellistes. In 1878 he travelled with his friend the genre painter Gustave Courtois to the latter's native Franche Comté and there developed a strong interest in the depiction of rural life which was reflected in his paintings of genre, landscape and still life. His *Horses at the Watering Place* (Musée des Beaux-Arts, Chambéry), exhibited at the 1885 Salon, established him as a major figure, renowned for his painstaking exactitude and photographic realism. From the 1890s he concentrated on portraiture and religious mysticism. He received the Légion d'honneur in 1885 and was elected a member of the Institut de France in 1900.

Dagnan-Bouveret began to concentrate on scenes from Brittany in around 1886, doubtless attracted by the exceptional natural light of the region and by the spirituality of the inhabitants as evidenced in their religious festivals, in particular the religious pardons which involved entire communities.[1] During his visits there he concentrated on gathering information on the regional dress, especially the women's headdresses. He even acquired a collection of costumes in which he could pose models in his preparatory studies for major compositions, which he undertook back home in Ormoy in the Haute-Saône. The first of his formal Breton compositions was *The Pardon in Brittany* (The Metropolitan Museum of Art, New York) of 1886. This was followed by *Bretons Praying* (fig.16.1) of 1888,[2] for which this pastel is a study. Given his painstaking procedure, there would have been many other preparatory drawings and photographs for the composition.[3] The painting was exhibited at both Mirliton and the Cercle des Arts and was bought by Goupil. His third major Breton composition, and in many ways the climax of the series, was the much-lauded *Breton Women at a Pardon* (Calouste Gulbenkian Foundation Museum, Lisbon), begun in 1887 but not completed until 1888 or 1889. Dagnan-Bouveret's Breton paintings, scrupulously realistic and commercially highly successful, form a stark contrast to those of the avant-garde working in Brittany at that time, most famously with Paul Gauguin's *Vision of the Sermon* (National Gallery of Scotland, Edinburgh) of 1888.

D 5541
Pastel on blue-green paper · 31.2 × 19.8
Verso, black and red chalk sketch of a standing female nude with right arm raised, and a diamond-shaped diagram.

PROVENANCE
Galerie Chantal Kiener, Paris; from whom purchased 2002.

EXHIBITED
*Gauguin's Vision*, National Gallery of Scotland, Edinburgh, 2005.

NOTES
1. On this and Dagnan-Bouveret in general see G.P. Weisberg, *Against the Modern. Dagnan-Bouveret and the Transformation of the Academic Tradition*, Dahesh Museum of Art, New York, 2002.
2. Oil on canvas: 123.5 × 68.9 signed and dated, lower right: *P.A.J. DAGNAN-B / 1888*.
3. P. Grisel, *P.A.J. Dagnan-Bouveret à travers sa correspondance*, D.E.A. d'Histoire de l'Art, Université Lumière, vol.II, Lyon, 1987, p.56 notes two preparatory photographs in the Archives Départementales, Vesoul, one showing a young woman holding a long stick.

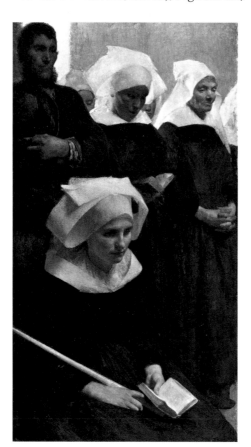

Fig.16.1 Pascal Dagnan-Bouveret, *Bretons Praying*, Montreal Museum of Fine Arts, William F. Angus Bequest

# 17

## Adrien Dauzats
### Portrait of a Spanish Guide

BORDEAUX 1804–1868 PARIS

One of the most travelled French artists of the Romantic generation, Dauzats was a major figure in the promotion of orientalist imagery in France. He was originally a painter of theatre scenery in Bordeaux but then travelled to Paris to study landscape painting under Michel-Julien Gué. At first he worked mainly in watercolours and produced designs for lithographs. His important association with baron Taylor began in 1828 with his participation in the ongoing production of the latter's *Voyages pittoresques et romantiques dans l'ancienne France*. In 1830 he accompanied Taylor on a journey to Egypt and his first orientalist pictures appeared at the 1831 Salon (he continued to exhibit there until 1867). Again, in the company of Taylor he travelled to Spain and Portugal (1833, 1835–7). In 1839 he accompanied the duc d'Orléans on the military expedition to Algeria led by Marshall Vallée. He also knew the duc d'Orléans's younger brother, the duc d'Aumale, who invited him to Twickenham and for whom he bought, in 1864, Delacroix's Moroccan album (Musée Condé, Chantilly).

Dauzats's first brief trip to Spain was in 1833, when he visited Barcelona and Madrid. It is more likely that this watercolour dates from his second, extended Iberian journey of 1835–7[1] during which, on account of the Carlist civil wars, he experienced multiple dangers and was robbed more than once. He would have needed the services of a local guide, such as the one portrayed in this watercolour. Dauzats's role on this voyage was to assist baron Taylor in his mission to acquire a representative cross section of paintings of the Spanish School, which would make up Louis-Philippe's Galerie Espagnole (installed in the Louvre in 1838 but later sold in London in 1852). During his various Spanish voyages Dauzats produced an impressive body of work detailing that country's architectural splendours, in particular its cathedrals.

D 5601

Watercolour and gouache · 26 × 19

Dauzat sale stamp (L 653), lower left

PROVENANCE

Vente Dauzats 1–4 February, Paris, 1869;[2] Galerie Normand, Paris; from whom purchased 2006.

NOTES

1. On which see P. Guinard, *Dauzats et Blanchard peintres de l'Espagne romantique*, Paris, 1967.

2. Although not specifically described in the sale catalogue, various lots consisted of unspecified groups of figure studies.

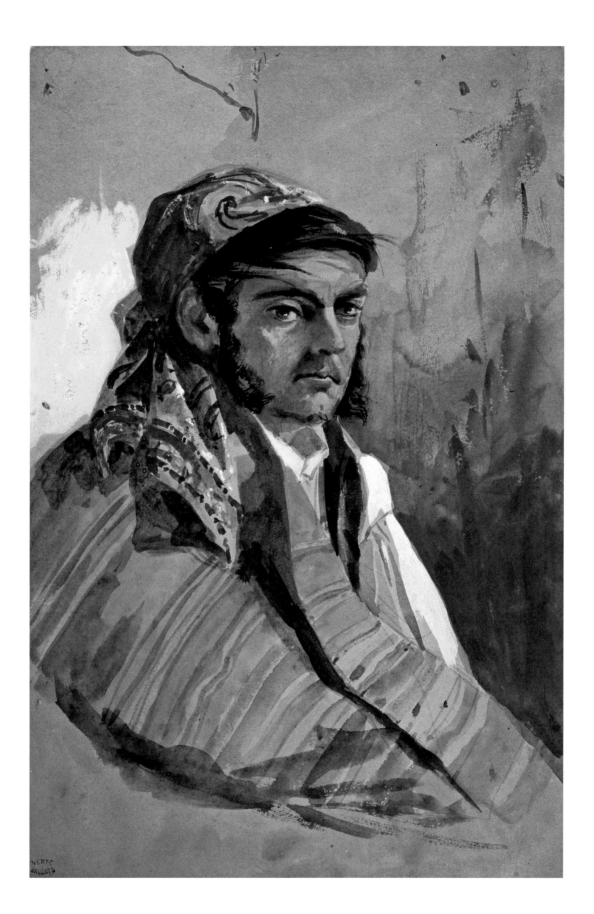

# 18 Alexandre-Gabriel Decamps
## *Landscape with a Town on a Hill*

PARIS 1803–1860 FONTAINEBLEAU

An artist who is primarily associated with Near Eastern scenes, Decamps spent his childhood years in Picardy, returning to Paris in 1816, where he trained with Etienne Buhot around 1816–17 and Abel de Pujol around 1818–19, and formed close friendships with the painters Jadin and Roqueplan. He also studied the collections in the Louvre, Paris, particularly the Dutch School. Decamps made his only trip to the Orient in 1828, accompanying Louis Garneray, who had been commissioned to paint the *Battle of Navarino* (Musée du Château, Versailles) and was researching the actual sites of French victories against the Ottoman Empire. The two men soon separated, with Decamps staying on for almost a year in Smyrna (now Izmir in modern Turkey) and proceeding on his own to Greece and North Africa. (He also visited Italy in 1835.) Oriental scenes became very much his stock-in-trade and critics remarked favourably on his painting *Turkish Patrol* (The Wallace Collection, London), exhibited at the 1831 Salon. His moment of triumph came with the *Retreat of the Cimbri* (Louvre, Paris), shown at the 1834 Salon. As a result of his travels Decamps became ardently pro-Turk, in contrast to many of his colleagues who were more fashionably pro-Greek. He continued to exhibit at the Salon until 1851. The Exposition universelle of 1855 included fifty-eight of his works. Decamps was made *chevalier* of the Légion d'honneur in 1839 and *officier* in 1851. He retired to Veyrier, near Barbizon, in 1853. He moved to Fontainebleau in 1857, where he later died as the result of a riding accident.

The subject matter of this heavily worked drawing with dramatic scratching-out remains unidentified. In the left foreground a Christ-like figure lies prostrate on a cross before an armoured knight. A dramatic, nocturnal scene, it is barely lit by a thin crescent moon as the wind, indicated by the sharply angled smoke from a chimney in the small town in the mid-distance, blows strongly to the right. The imaginary rocky and mountainous landscape was possibly inspired by the scenery Decamps had observed in the Near East. Its classical structure points to a date in the 1840s or 1850s.[1]

Drawing assumed increasing importance for Decamps as his career progressed. The popularity of Decamps's graphic work was attested by the landscape painter Paul Huet who recalled how, when he and Decamps both exhibited charcoal drawings at a dealer's in the rue Neuve-Vivienne in Paris, 'I have seen lovers of Decamps's works go into raptures in front of his drawings, in spite of everything, and not look at mine at all.'[2]

D 5340
Pen and grey and brown wash, black and brown chalk, heightened with white and red · 27 × 47.3
Signed, lower left: *DC*

PROVENANCE
Paul Prouté, Paris;[3] from whom purchased 1993.

NOTES
1. On Decamps's drawings see D.E. Mosby, 'Decamps dessinateur', *La donation Baderou au musée de Rouen: Etudes de la Revue du Louvre et des Musées de France*, Paris, 1980, pp.148–52.
2. R.P. Huet, *Paul Huet*, Paris, 1911, p.157.
3. Prouté catalogue 'Coypel', 1991 (43).

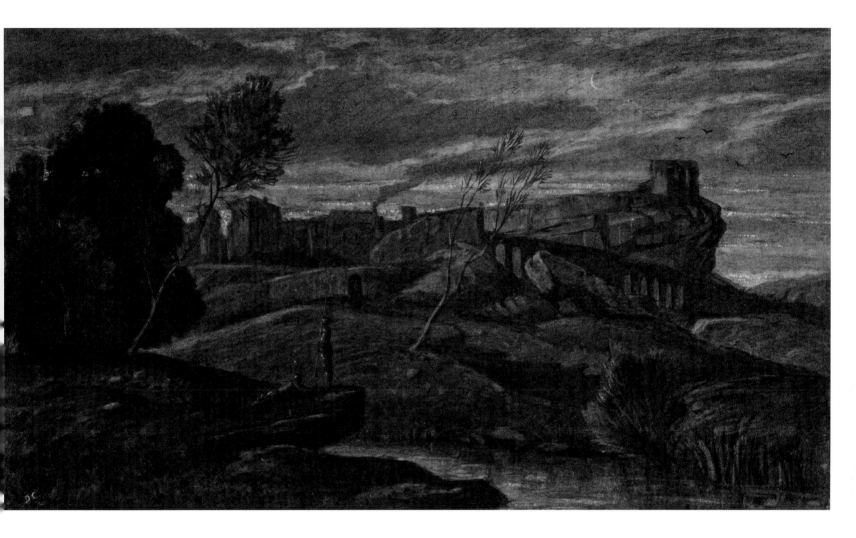

# 19

## Eugène Delacroix
### *Landscape Sketch with Two Trees*

CHARENTON-ST-MAURICE 1798–
1863 PARIS

The leading painter of the Romantic movement in France, Delacroix was born into a diplomatic family of high achievers. He trained in Guérin's studio and made his Salon debut in 1822 with his *Barque of Dante* (Louvre, Paris). In that same year he began his now celebrated *Journal*. A formative trip to England in 1825 was followed in 1826 by his participation in the pro-Greece exhibition held at the Galerie Lebrun in Paris. His political engagement was again demonstrated with his *The 28th July: Liberty leading the People* (Louvre, Paris) shown at the Salon in 1831, in which year he was appointed to the Légion d'honneur. In 1832 he accompanied the delegation of the comte de Mornay to Spain, Morocco and Algeria and oriental subject matter thereafter assumed an increasing prominence in his work. From 1849 to 1861 he was engaged on the decoration of the Chapelle des Saints Anges in the church of Saint-Sulpice in Paris and in 1850–1 he participated in the decoration of the Galerie d'Apollon in the Louvre. Elected on his eighth attempt to the Institut de France in 1857, he last exhibited at the Salon in 1859 with his *Ovid among the Scythians* (National Gallery, London).

Watercolour played a significant role in Delacroix's graphic work throughout his career. He would have been introduced to the technique by the example of the many English artists who visited or worked in France after the cessation of the Napoleonic Wars. Of particular importance in this respect were the Fielding brothers – Thales, Copley and Newton – contact with whom came initially via Delacroix's childhood friend Charles Soulier, who was himself a watercolourist and had been brought up in England. Also of great importance was Delacroix's friendship with the English artist Richard Parkes Bonington, whom he first met in 1816 or 1817 when the former was making watercolour copies in the Louvre of landscapes by the 'Flemish' masters there. Delacroix's appreciation of the medium is vividly expressed in an entry in his *Journal* for 6 October 1847:

*The special charm of water color painting, beside which any painting in oil will appear rusty and pissy, comes from that continual transparence of the paper; the proof is that it loses this quality when one employs any body color; it loses it entirely in a gouache.*[1]

This watercolour, both in its topography and its suggestion of a damp, rain-filled day with a passing shower to the right, suggests the landscape of northern France or the Loire valley. It has not proved possible to identify the exact location, nor to establish a dating with any certainty. However, on technical grounds it is tempting to group it with similarly diaphanous and thinly washed landscapes dating, for the most part, from the earlier part of Delacroix's career at a time when he was still strongly under the influence of the English tradition. A group of watercolours that affords certain parallels is that originating from his stay towards the end of 1828 in the apartment belonging to his elder brother General Charles-Henry Delacroix in the hôtel Papion in Tours.[2] Worthy of note from that time are two small watercolours now in the Louvre: *View of a Plain with Tours Cathedral* and *Landscape with a Plain*[3] in which, albeit with a different range of colours, similar effects of transparency are achieved. Later watercolours by Delacroix retain this ability to work with highly dilute washes, but the results are often more mannered as, for example, in a watercolour of 1839 sold at Christie's, New York in 1997.[4]

D 4316
Watercolour with some bodycolour · 13.8 × 21.2
Delacroix studio stamp (L 838), lower right

PROVENANCE
Delacroix sale; Kenneth Sanderson, Edinburgh; by whom bequeathed to the Gallery 1943.

EXHIBITED
London 1966 (94).

NOTES
1. *The Journal of Eugene Delacroix* (trans. W. Pach), New York (1937), 1980 edn, p.177.
2. See the exh.cat. *Delacroix en Touraine*, Musée des Beaux-Arts, Tours, 1998.
3. I. Berferol and A. Sérullaz, *Eugène Delacroix Aquarelles et lavis au pinceau*, Paris, 1998, pp.116–17, 171.
4. *A wooded River Landscape*, black lead and watercolour: 21.2 × 32.9, dated: *30 juille[t] 39*, Christie's, New York, 22 May 1997 (39).

# 20

## Paul Delaroche
### *The Girondins*

PARIS 1797–1856 PARIS

Wittily described by Heinrich Heine as 'the Court Painter to all the Beheaded Majesties',[1] Delaroche trained in the studios of Watelet and Gros and first exhibited at the Salon in 1822. He came to specialise in scenes from French and, more especially, English history (his best known painting in Britain is *The Execution of Lady Jane Grey* in the National Gallery, London).[2] In 1833 he was made professor at the Ecole des Beaux-Arts in Paris where his pupils included Couture and Gérôme. His major achievement was the large panorama (twenty-seven metres in length) of *The Hemicycle* for the Ecole des Beaux-Arts, executed between 1837 and 1841. It was painted with the aid of four assistants and depicts a total of over seventy artists in conversation, ranging in date from the thirteenth to seventeenth centuries. In the later part of his career portraiture and religious subjects assumed an increasing importance.

This drawing was one of those commissioned by the Orléans family for inclusion in an album of watercolours by leading French artists presented as a wedding album to Antoine, duc de Montpensier (the fifth son of Louis-Philippe) and Marie Louise Fernande of Bourbon (sister of Queen Isabel II) on their marriage on 10 October 1846 (see also cat.no.29, by Gudin, from the same album). The choice of artists reflected Louis-Philippe's close association with and promotion of leading artists of the day including Chassériau, Delacroix, Flandrin, Ingres, Scheffer and Vernet, as well as the taste of the duc d'Orléans, Louis-Philippe's eldest son, who had died as a result of falling from his carriage in 1842. All the artists who contributed to the album were apparently invited to a feast on 22 February 1847 at Vincennes to be presented to the duchesse d'Orléans.[3]

This drawing was made the same year that Delaroche began work on a closely related painting (fig.20.1), which he finally completed in 1856 (his last historical painting) and is now in the Conciergerie, Paris (on deposit from the Musée Carnavalet, Paris).[4] The subject is taken from the French Revolution and depicts the moment when the Girondin *députés*, imprisoned in a dark cell at the Conciergerie, learn of their death sentence from a member of the National Guard. They were executed just before midnight on 31 October 1793 on the orders of the Revolutionary Tribunal. The Girondins, originally founded in 1791 by a number of *députés* and their associates from the Gironde, had been denounced by Marat and others for their disquiet at the increasingly bloody course the Revolution was taking. 'Girondin' subsequently became a synonym for moderation and certain of Delaroche's contemporaries dubbed him the 'Girondin of painting'. According to Goddé, writing in 1858, Delaroche had first portrayed the episode of the Girondins in a drawing of 1838 made at Vichy which was purchased by the duchesse d'Orléans and was included in an album offered by the royal family to the princesse de Joinville as a wedding gift in 1843.[5] The marriage in question would have been that held in Rio de Janeiro of François, prince de Joinville, to the Brazilian princess, Francesca de Braganca. Six preparatory figure studies for the 1856 painting of *The Girondins* are in a Parisian private collection, a further group is in the collection of Christopher Forbes at Balleroi, Normandy.[6] In that latter group are also studies for other compositions, including one of an execution subject (Marie-Antoinette, or possibly Madame Elisabeth) which includes some lines transcribed by Delaroche from Alphonse Lamartine's *Histoire des Girondins*. Although that work was not published until 1847, Delaroche had met Lamartine in Rome in 1844 and his interest in the subject, and the expression he gave to it in the Edinburgh drawing and related painting, may well have been stimulated by discussions with the author.

D 5430

Pen and black ink, sepia wash and watercolour, heightened with white · 13.5 × 26

Signed and dated, lower left: *Paul Delaroche 1846*

PROVENANCE

Antoine, duc de Montpensier; his daughter, Isabelle d'Orléans; Amélie, Queen of Portugal; thence by descent to the comte and comtesse de Paris; Private Collection, Europe; Sotheby's, London, 11 June 1997 (37), where purchased by the Gallery.

EXHIBITED

Edinburgh 2001 (23).

NOTES

1. H. Heine,'Lutezia', *Historisch-kritische Gesamtausgabe der Werke*, 13 / 1, Volkmar Hansen (ed.), Hamburg, 1988, p.148.
2. On which see the recent exh.cat., *Painting History. Delaroche and Lady Jane Grey*, National Gallery, London, 2010, text by S. Bann, L. Whiteley *et al.*
3. An event referred to several times by P. Miquel, *Le Paysage français au XIXe siècle 1824–1874*, 3 vols, Maures-la-Jolie, 1975, p.376 and p.449.
4. Oil on canvas: 58 × 99. See the catalogue entry no.56 by Whiteley in *Painting History ...* , p.116.
5. H. Delaborde and J. Goddé, *Oeuvres de Paul Delaroche*, Paris, 1858, pl.79.
6. Information kindly communicated by L. Whiteley.

Fig.20.1 Paul Delaroche, *The Girondins*, Musée de La Conciergerie, on deposit from the Musée Carnavalet, Paris

# 21 Jean-Baptiste-Henri Deshays de Colleville
## *Apotheosis of a Female Figure*

COLLEVILLE, NEAR ROUEN 1729–
1765 PARIS

Deshays's early death at the age of thirty-five, probably from tuberculosis, brought to a premature close the brief period in which he had been regarded, not least by Diderot, as the most important religious painter in mid-eighteenth-century France. He had first trained with his father, Jean-Dominique Deshays, and then briefly at Jean-Baptiste Descamps's *Ecole Gratuite de Dessin* in Rouen. Around 1740 he entered the Parisian studio of Hyacinthe Collin de Vermont where he acquired a reputation for the excellence of his drawings. His next master, Jean Restout II, had, like Collin de Vermont, been a pupil of the great *Rouennais* history and religious painter, Jean Jouvenet. Deshays won the 1751 Prix de Rome with his *Job on the Dunghill* (untraced) and, prior to travelling to Rome, underwent the obligatory three years at the Ecole Royale des Elèves Protégés during which period he received a number of important religious commissions including that for a cycle on the life of Saint Andrew for the church of that name in Rouen. On his return from his four-year stay in Rome in 1758 he was *agréé* at the Academy and also married Jeanne-Elisabeth-Victoire Boucher, elder daughter of the painter François Boucher. The following year he was *reçu* and enjoyed great critical success at the Salon. His work was seen as continuing the seventeenth-century tradition of painters such as Domenichino, Reni and Poussin. At all the Salons to which he contributed he showed his *Caravanes*, journey scenes very much in the manner of Castiglione and (to Diderot's regret) Boucher. A number of his paintings were shown posthumously at the 1765 Salon, where a decline in his powers was noted.

This drawing is dated by Bancel, in his recently published monograph on the artist, to 1763–5.[1] A female figure is received in the heavens by two other women and a putto, on the ground below is a vanquished group, one of whom brandishes a torch and could conceivably represent Discord. According to Sandoz[2] the inspiration of the subject of this drawing may have been literary and perhaps drawn from the theatre, for example, the often violent tragedies made popular at that time by Baculard d'Arnaud and others. A drawing by Deshays based on d'Arnaud's *Le comte de Comminges* was among the works exhibited posthumously at the 1765 Salon. Bancel has suggested the allegory could be political or historical.[3] Although Cochin, in his memorial essay of 1765, claimed that Deshays's drawings were less well known than his paintings and small in number,[4] the plentiful evidence of Deshays's posthumous sale catalogue refutes the second part of that statement. The sale,[5] at which Cochin sought the permission of the marquis de Marigny to purchase four drawings for the *cabinet du roi*, consisted for the most part of drawings and provides ample evidence of Deshays's fecundity as a draughtsman. Many of the lots were multiple and unspecified and are described as in Deshays's most frequently used technique, as in this drawing, of pen, wash and white heightening. Today, however, relatively few of Deshays's drawings have been identified, probably because they bear attributions to other artists, notably Deshays's father-in-law, Boucher (of whom Deshays himself owned many examples).[6] This drawing, though characteristic of Deshays, also shows similarities to Fragonard in the dramatic use of brown pen and wash.

D 1564
Pen, brown ink and wash, heightened with bodycolour over black chalk laid down · 46.9 × 24.4
Inscribed in ink, upper left: *Deshays*
Collection stamps of Royal Scottish Academy (L 2188), lower centre, and National Gallery of Scotland (L 1969f), lower right.

PROVENANCE
Paignon-Dijonval;[7] Samuel Woodburn; David Laing Bequest to the Royal Scottish Academy; transferred 1910.

EXHIBITED
London, 1966 (71); *France in the Eighteenth Century*, Royal Academy, London, 1968 (191); Edinburgh / New York / Houston 1999–2001 (47).

NOTES
1. A. Bancel, *Jean-Baptiste Deshays 1729–1765*, Paris, 2008, no. D 99, illus. p.75.
2. M. Sandoz, *Jean-Baptiste Deshays 1729–1765*, Paris, 1977, no.110, fig.26.
3. Bancel 2008, *ibid*.
4. 'His drawings were less well known than his paintings. Those which have been found at his home, although very small in number, have created a very great impression.' C.-N. Cochin, *Essai sur la vie de M. Deshays*, 1765, reprinted in Sandoz 1977, pp.13–16.
5. 26 May 1765 and following days, Paris (Lugt 1440), also reproduced in Sandoz 1977, pp.149–54.
6. Nos 121–149 in the posthumous sale catalogue were '*esquisses et ebauches*' by Boucher. Bancel has considerably enlarged our knowledge of Deshays's drawn œuvre and his catalogue raisonné includes 121 drawings attributed to him.
7. *Catalogue de la collection de dessins et d'estampes de M. Morel de Vende, vicomte de Paignon-Dijonval*, Paris, 1810, no.3601 (lav. de b. et d'e ch., reh. de bl'; 18p. × 9p.). As Bancel has pointed out, the description in the Paignon-Dijonval catalogue accords exactly with the drawing: '*une femme est reçue dans le ciel par deux autres femmes; on voit dans le bas des personnages renversés par la foudre les uns sur les autres*'. The collection was bought en bloc by the dealer Samuel Woodburn in 1816.

# Gaspard Dughet
*Landscape with Fisherman*

ROME 1615–1675 ROME

Of Franco–Italian parentage, Dughet was one of the most important landscape painters working in seventeenth-century Rome. He painted major decorative cycles as well as many easel paintings for a distinguished circle of patrons, which included the Pamfili, Borghese and Colonna families. He was apprenticed to his brother-in-law Nicolas Poussin from 1631 to 1635 and this led to him being known as Gaspard Poussin. In addition to the influence of his brother-in-law, his work also shows a strong awareness of the Bolognese tradition of classical landscape. Emphasising the decorative nature of much of his work, many of Dughet's paintings are without a specific subject, though they frequently include staff-age. Storm scenes form a particular category within his œuvre. He was widely collected in Britain in the eighteenth and nineteenth centuries and his work influenced many artists there, in particular Thomas Gainsborough in his later landscapes.

The drawing in Edinburgh corresponds fairly closely to a print by Achille Parboni, one of a series of thirty-three after pictures by Dughet known to have been in the Colonna family collection in Rome in the nineteenth century. The engraving by Parboni is number seventeen in the series (fig.22.1). Two motifs in the drawing are different from the print: the figure of a man to the left of a foreground tree, and the fishing net held by the man to the right have both been touched out, perhaps by a later hand. As Anne French noted in the catalogue to the 1980 exhibition on Dughet, the relatively large size of this drawing suggests it may have been executed as a cartoon for a painting or as a drawing to be retained by the artist and submitted to prospective patrons for further commissions. Based on the Parboni engraving, Boisclair has dated the composition of the painting to which this drawing relates to 1671–3, a period during which miscellaneous documents from the Colonna archives attest to Dughet's employment by the family.[1] The finest collection of drawings by Dughet in this medium belongs to the Kunstmuseum, Düsseldorf.[2]

D 1730
Black chalk and gouache, heightened with white, on blue paper
40.6 × 55.6

PROVENANCE
David Laing Bequest to the Royal Scottish Academy; transferred 1910.

EXHIBITED
Edinburgh 1976 (23); *Gaspard Dughet called Gaspar Poussin 1615–75*, Iveagh Bequest, Kenwood, 1980 (36); Washington / Fort Worth 1990–1 (78).

NOTES
1. M.-N. Boisclair, *Gaspard Dughet. Sa vie et son oeuvre (1615–1675)*, Paris, 1986, p.355 G.72 (for the print) figs 602 and 456, and p.283, cat.no.368 for the painting. For a summary of the various proposed datings of Dughet's work for the Colonna see S.J. Bandes, 'Gaspard Dughet's frescoes in Palazzo Colonna, Rome' *The Burlington Magazine*, 1981, p.78 (20).
2. C. Klemm, *Gaspard Dughet und die ideale Landschaft: Kataloge des Kunstmuseum Düsseldorf Handzeichnungen*, Düsseldorf, 1981.

Fig.22.1 Achille Parboni, *Landscape with Fisherman Carrying a Net*, Calcografia Nazionale, Rome

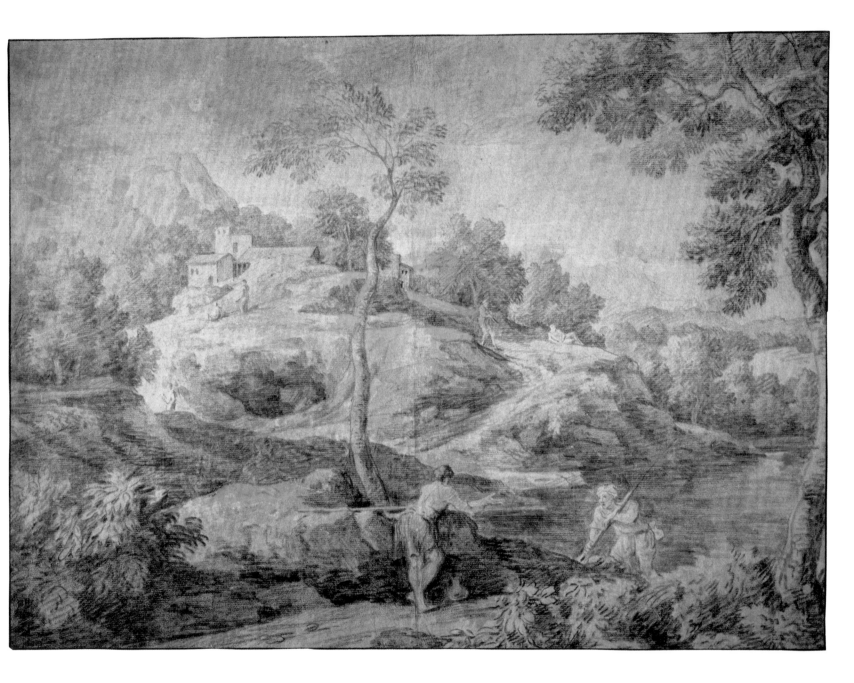

# Charles-Marie Dulac
## *Jesu Sol Justitiae*

PARIS 1865–1898 PARIS

A painter and lithographer,[1] Dulac began as a painter-decorator, but then trained in a number of Parisian studios and made his Salon debut in 1889. Around 1892, when seriously ill, he experienced a spiritual conversion and joined a religious society, the Third Order of Saint Francis, espousing the Franciscan ideals of piety and humility. He changed his name to Marie-Charles Dulac and thenceforth concentrated on colour lithography. Dulac's subject matter was pure landscape, without human figures, which he used in a symbolist manner to express his deep religious faith. His mystical landscapes were enthusiastically received in elite neo-Catholic circles where his work inspired hopes for the renewal of religious art and was admired by Catholic writers such as Maurice Denis and Joris Karl Husymans. A posthumous exhibition was organised by his friends in 1899 at the Galerie Vollard, the catalogue containing essays by Huysmans and Henri Cochin.

Dulac's first set of lithographs *Suite de paysages* was published in 1892–3. He expressed his intention as follows: ' … I seek to express the fugitive emotions produced by the various aspects of nature. To idealise as much as possible, nevertheless without distorting real forms, such is my aim.'[2]

In 1894 he began work on his second, more radically symbolist set of lithographs, the nine plates which make up *Le Cantique des créatures*. This was inspired by the verses of Saint Francis of Assisi's *Canticle of the Brother Sun*. As Huysmans later observed: 'The very idea of landscape representing with horizons and sites the passages of the Scriptures is a Franciscan idea …'.[3] The series includes both cosmic images and spiritualised landscapes that derive from compositions in the *Suite de paysages* and other earlier landscape sketches. The nine plates are entitled: *Le Commencement, Le Soleil, La Lune, Le Vent, Le Feu et l'Eau, La Terre, La Voie bénie, La Mort corporelle, Le Chant final*. In summary, the spiritual journey as evoked in these visionary and unpeopled compositions leads from the celestial sphere of sun and moon to the elements, then to the realm of human existence and Man's redemption through the Christian faith, his overcoming physical death and his return to the Eternal.

This drawing is the preparatory study for plate two, captioned *Jesu Sol Justitiae*. The image of a symmetrically ordered open landscape filled with the light of the rising sun constitutes a visual parallel of the Franciscan analogy of the sun and Christ. In notes related to the print Dulac cited a passage from Malachi: 'But unto you that fear my name shall the sun of righteousness arise with healing in its wings'.[4] This particular composition was eulogised by Huysmans in *La cathédrale* (1898) in which the character of 'Durtal' is based on Dulac:

*A light gold landscape, clear, transparent, receded to infinity, a peninsular landscape, with lonely stretches of water, criss-crossed with beaches, with tongues of earth planted with trees reflected by the hidden mirror of the lakes; in the distance the sun, whose orb, cut off by the horizon, shone forth, was reflected by the expanse of these waters; it was everything and a tranquility, a calm, an extraordinary plenitude spread from this site. The idea of Justice, to which replied like an inevitable echo the idea of Mercy, was symbolised in the serene gravity of these expanses which were lit by the glimmers of an indulgent season, of gentle weather.*[5]

D 5442

Black chalk, heightened with pastel and white gouache on buff paper · 32 × 48.5
Collection mark of A. Beurdeley (L 421), lower left signed and dated, lower right: *Ch.Dulac 93*

PROVENANCE
Alfred Beurdeley; Galerie Antoine Laurentin, Paris; from whom purchased 1998.

EXHIBITED
Edinburgh 2001 (25).

NOTES
1. The fundamental article on Dulac and his lithographs is T. Greenspan, 'The Sacred Landscape of Symbolism: Charles Dulac's La Terre and the Cantique des Créatures', *The Register of the Spencer Museum of Art*, vol.v, no.10, Spring 1982, pp.63–79.
2. Dulac, quoted by A. Marguillier 'Charles Dulac', *Gazette des Beaux-Arts*, April 1899, p.330.
3. J.K. Huysmans, *In Memoriam Marie-Charles Dulac*, Paris, 1899, p.15.
4. M.C. Dulac, *Lettres de Marie-Charles Dulac*, Paris, 1905, appendix, p.151.
5. J.K. Huysmans, *La cathédrale*, Paris 1898, 1986 edn, p.265.

# 24

# Eugène Fromentin
## Study of a Horse and Riders

LA ROCHELLE 1820–
1876 SAINT MAURICE

A painter and writer, Fromentin managed to combine the two disciplines throughout his career. His early poetry was in the style of Lamartine and Sainte-Beuve and his art criticism began with a review of the 1845 Salon. In painting, his first masters were Rémond and Cabat. His lasting enthusiasm for the landscape and customs of North Africa took root after his first visit to Algeria in 1846. From the 1847 Salon onwards, he became the leading exhibitor of such scenery, focusing particularly on its nomadic inhabitants. In his later years his work became somewhat repetitive. Today he is perhaps best known for his highly perceptive account of the art of the Low Countries, *Les Maîtres d'autrefois*, first published in 1876.

The recto is a preparatory study for the lost painting by Fromentin *An Arab Horseman Crossing a Stream with a Madman Sharing his Horse* dating from the 1860s. The composition of the painting, which last appeared on the art market in New York in 1903,[1] is known from an engraving by Paul Rajon, that appeared as an illustration to Fromentin's autobiographical account of his travels in Algeria in 1852–3, *Un été dans le Sahara* (1857).[2] The episode depicted by Fromentin is described as follows:

*I recall having met one day a tribal chieftain of the eastern Sahara, who was returning home, … followed by a fairly dazzling escort of horsemen, with a dervish riding pillion alongside him. This chieftain was an elegant young man, very handsome, and with the slightly feminine elegance particular to the Saharans of Constantine [one of Algeria's principal cities]. The dervish, a wasted old man disfigured by imbecility, was naked under a simple gandoura [a short, loose, sleeveless garment], deep red [sang de boeuf] in colour, without headgear, and swung his hideous head to the movement of the horse, topped by a long tuft of greying hair. He held on to the young man across his middle and seemed, with his two scrawny heels, to be directing the beast which was ill at ease with its double burden. I greeted the young man in passing: he bade me good evening and wished me the blessings of heaven. The old man made no reply whatsoever and set the horse to trot.[3]*

This comes from a passage in which Fromentin comments on the superiority in many respects of the Arabs to Westerners, in particular the straightforward manner in which they deal with those less fortunate. In the engraving of the painting there are no figures in the background as there are in some of the related drawings, including this one. Another drawing for the composition, similar in style, has separate studies of the horse and of the two riders and is in a private collection.[4] A further study, more finished, includes a second rider to the right of the composition.[5] A more linear drawing of the composition shows two further riders to the left.[6] Finally, there also exists a freely painted replica of the composition as recorded by Rajon, signed lower left by Fromentin.[7]

The study on the verso of our drawing is probably for a horse in Fromentin's painting of 1851, *An Arab Encampment in the Desert* (Private Collection).[8] A comparable study for the head of the horse is also in a private collection.[9]

D 5613

Verso: *Study of a Horse's Hindquarters*
Black chalk on grey-blue paper; verso: black chalk and blue and black ink · 29.7 × 33.1
Collection mark, lower right, of Fromentin's inheritors (not in L, but of similar design to Fromentin sale stamp L 957).

PROVENANCE
The artist's family, by descent; Jean-Luc Baroni, London; Galerie Jean-François Baroni, Paris; from whom purchased 2007.

EXHIBITED
*Master drawings and oil sketches*, Jean-Luc Baroni, New York / London, 2005 (42).

NOTES
1. Oil on canvas: 65 × 54. Provenance Fromentin vente, Paris, 1877 (14) ; Galerie Brame, Paris; G. Errington MP by 1879; Warren sale, New York, 8–9 January, 1903 (53).
2. The engraving first appeared in the 1879 edition of this work. It is illustrated in J. Thompson and B. Wright, *La vie et l'oeuvre d'Eugène Fromentin*, Paris, 1987, p.219.
3. E. Fromentin, *Sahara et Sahel 1. Un été dans le Sahara II. Une Année dans le Sahel. Edition illustrée*, Paris, 2004, reprint of 1887 edn, p.44. The print faces p.42.
4. Pencil on papier calque: 31 × 37. Thompson and Wright 1987, p.218 illus.
5. L. Gonse, *Eugène Fromentin, peintre et écrivain*, Paris, 1881, p.211 illus.
6. Location unknown, Musée d'Orsay files, photo 1995 / 2319.
7. Location unknown, Musée d'Orsay files, photo 1995 / 2276.
8. Oil on canvas: 46 × 108. Thompson and Wright 1987, pp.88–9 illus. Sotheby's, London, 25 March 1987 (141).
9. Ink over black lead: 20.2 × 12.2. Thompson and Wright 1987, p.141 illus.

# Marguerite Gérard
## *Drawing Lesson*

GRASSE 1761–1837 PARIS

Marguerite Gérard travelled to Paris around 1775 to join her elder sister Marie-Anne, who had married the painter Jean-Honoré Fragonard in 1768.[1] She became his pupil, though there is no real evidence to support later suggestions that their relations were improperly close, nor that they sometimes collaborated on works. In the course of a long and lucrative career she rapidly developed a personal style, less emotional and more realist than the flamboyant manner of her brother-in-law. Much of her work, which was frequently engraved, was inspired by the Dutch *petits-maîtres* of the seventeenth century, such as Metsu and Terborch, and her genre scenes were often devoted to depictions of familial piety and affection. After the Salons were opened to women in the 1790s she exhibited there until 1824, her patrons including Napoleon and Louis XVIII.

In this affectionate scene from family life the young mother gazes out at the viewer while the child, who is portrayed in a Greuze-like manner, earnestly copies a miniature portrait of his presumably deceased father. Gérard was herself an accomplished miniature painter.

D 5536

Pen, black ink and grey wash heightened with white
37.2 × 29.1

PROVENANCE
Fernand Weill, Paris; Galerie Moss, Geneva, 9 February 1935 (21); Hôtel Drouot, Paris, Rieunier, Bailly-Pommery, Mathias, Le Roux, 28 April 1995 (81);[2] Emmanuel Moatti, Paris; from whom purchased 2002.

NOTES
1. The most detailed biographical information on the artist, who is curiously absent from the major artist dictionaries, can be found in S. Wells-Robertson, 'Marguerite Gérard et les Fragonard', *Bulletin de la Société de l'Histoire de l'Art Français*, 1977, pp.179–89.
2. The sale catalogue entry mentions a letter of authentication dated 30 January 1970 from Alexandre Ananoff.

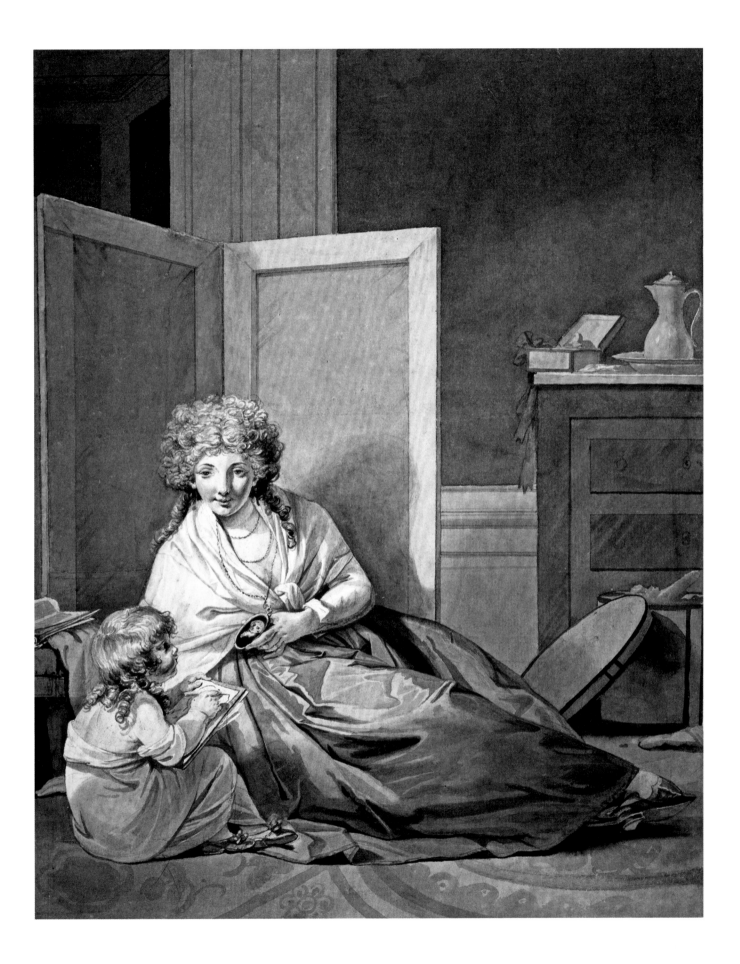

# Anne-Louis Girodet de Roussy-Trioson
## *Study for Racine's Phèdre*

MONTARGIS 1767–1824 PARIS

Possessed of a difficult personality, Girodet was nevertheless one of the most talented and individual of all David's major pupils. He entered his master's studio in 1784 and tried twice for the Prix de Rome before succeeding in 1789 with *Joseph Recognised by his Brothers* (Ecole des Beaux-Arts, Paris), sharing the prize with Charles Meynier. He left for Rome in 1790 and there painted *The Sleeping Endymion* (Louvre, Paris), shown to great acclaim both in Rome and at the Paris Salon of 1793. The treatment of the male nude in the *Endymion* is perhaps the most sensuous example of the homoerotic element often found in Girodet's art and, with its references to the grace of Correggio and the *sfumato* of Leonardo, constituted a deliberate rejection of the strict Neoclassicism advocated by David. Girodet was forced to leave Rome on account of anti-French feeling during the Revolution and spent time in Naples, Venice and Genoa, returning to Paris in 1795. He made his reputation with the *Portrait of Madame Lange as Danaë* (Institute of Arts, Minneapolis) and the *Deluge* (Louvre, Paris), shown at the Salons of 1799 and 1806 respectively. In the latter year he was adopted by Dr Benoit-François Trioson, his tutor and guardian, and probably his natural father. At the decennial competition of 1810, his contemporaries judged his *Deluge* superior to David's *Sabine Women* (Louvre, Paris). The fourteen works exhibited by Girodet at the 1814 Salon constituted a virtual retrospective of his career, and the following year he was *reçu* into the Academy. He was also a prolific writer. His collected works appeared in a two-volume posthumous edition published by P.-A. Coupin in Paris in 1829 and consisted of the epic didactic poem *Le Peintre*, its embryonic form *Les Veillées*, and his correspondence and discourses.[1]

The *Oeuvres de Racine* appeared in Paris in 1801–5 in a three-volume illustrated atlas folio edition published by Pierre Didot (for whom Girodet had worked since 1791).[2] Dedicated to Napoleon, it was sometimes called the *Racine du Louvre* because it was printed on the former Royal Press in the Louvre. A celebration of the master playwright of French classical tragedy, Jean Racine (1639–1699),[3] it fitted perfectly into the Consulate's grand design to reaffirm the hegemony of France in cultural and intellectual fields. When the first volume was exhibited in Paris in 1801 it was grandiloquently described as 'the most perfect production in the field of typography in any country or in any age'.[4] The fifty-seven engraved illustrations for the complete work were devised by eight artists chosen by David: Chaudet, Gérard, Girodet, Moitte, Peyron, Prud'hon, Sérangeli and Taunay. Gérard was commissioned to design fifteen in total, Girodet five each for *Andromache* (volume I) and *Phaedra* (volume II).[5]

The Edinburgh drawing is a preparatory nude study for the drawing to illustrate act IV, scene 2 of *Phaedra*, in which Oenone has just accused Hippolytus of his passion for Phaedra, his sister-in-law, and Theseus reproaches him, ordering him to leave his presence:

Thesus: *What! Has your anger lost all its restraint? For the last time, be gone from my sight! Be off, traitor. Do not wait for an enraged father to have you torn away from me in disgrace!* [6]

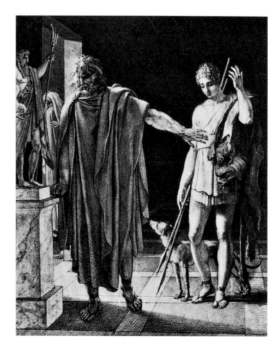

Fig.26.1 Anne-Louis Girodet de Roussy-Trioson, *Phaedra, Act IV, Scene 2*, Musée Dobrée, Nantes

Girodet's finished drawing, engraved by R.U. Massard, is now in the Musée Dobrée, Nantes (fig.26.1).[7] It has been suggested by Osborne that the head of Hippolytus may portray the well-known tragic actor Talma (1763–1826), whom Girodet could have seen in live performances of the play.[8] So highly did Girodet regard his final drawings for *Racine* that he exhibited them in the paintings sections of the 1800 and 1804 Salons. Those for *Phaedra* were shown at the 1804 Salon, mounted together in one frame (no.212). Apart from the Nantes drawing, four further finished drawings by Girodet for the *Racine* have been identified: *Phaedra Rejecting the Embraces of Theseus* (J. Paul Getty Museum, Malibu), *Phaedra Confesses her Love for Hippolytus to Oenone* and *Phaedra, having Declared her Passion, Attempts to Kiss Herself with the Sword of Hippolytus* (both with Brady / Bellinger 1997);[9] and for *Andromache*, the *Meeting of Hermione and Orestes* (Museum of Art, Cleveland).[10] The importance Girodet vested in these drawings extended to the preparatory process. Whereas Renaissance masters and, later, David had made nude studies for their paintings, Girodet also followed this procedure for his finished drawings, which he valued as highly as his history paintings:

*I ought to mention here the drawings which I made for the folio editions of Virgil (1798) and Racine printed by M. Didot. It is wrong that drawings should be nothing more than drawings, and yet, when one prides oneself on giving them some style and character, they require the same conception and almost the same preparatory studies as a picture; the only difference is in the method of execution. The artist who succeeds in this sort of drawing can only be a history painter or sculptor who has the right to expect recognition in his real field.* [11]

In addition to this drawing, only three other nude studies for the *Racine* illustrations are known: *The Suicide of Phaedra* (Louvre, Paris),[12] *Hermione and Oenone* (Musée Bonnat, Bayonne),[13] and *The Return of Orestes* (The Art Institute of Chicago). Interestingly, a rapidly sketched compositional drawing for *The Suicide of Phaedra*, now in the Musée des Beaux-Arts at Rouen,[14] provides the expected evidence that the extraordinarily beautiful and highly-finished nude studies and the completed drawings for the engraver would have been preceded by quickly sketched *premières*

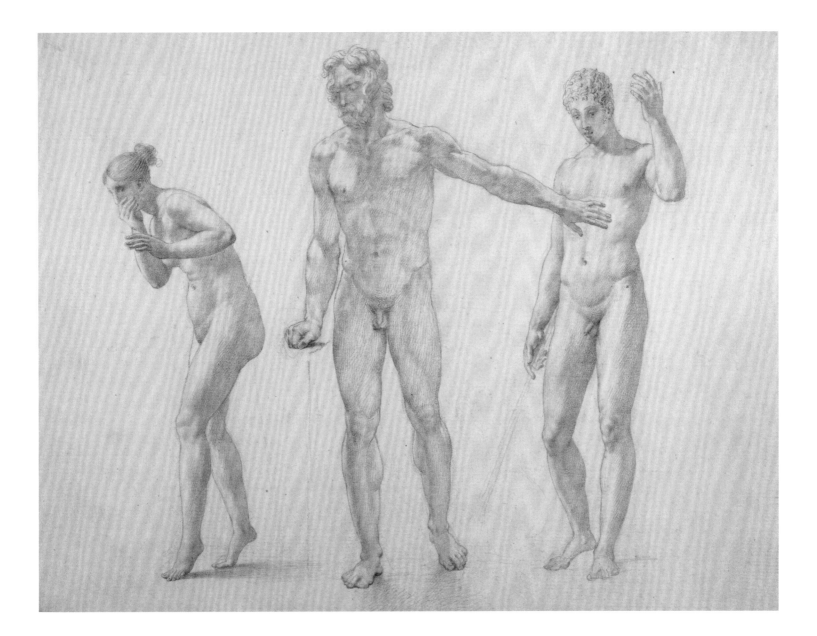

*pensées*. Both the *première pensée* and the nude studies are of horizontal format, the normal neoclassical stage on which to work out visual ideas for multi-figured compositions. The furnished drawings are vertical, however, as determined by the shape of Didot's grand publication.

D 5395
Black lead · 26 × 34.3
Inscribed in ink, verso, lower right: *Dessiné par Girodet*

PROVENANCE
Antoine César Becquerel (Girodet's cousin and executor);[15] Henri Becquerel; his wife, Louise Lorieux: her nephew, Pierre Deslandres; then by descent; Private Collection, Montreal; Sotheby's, New York, 16 February 1994 (2ff.); Richard L. Feigen & Co., New York; from whom purchased 1995.

EXHIBITED
*Girodet 1764–1824*, Musée de Montargis, Montargis, 1967 (70); *Neo-Classicism and Romanticism in French Painting 1774–1826*, Richard L. Feigen & Co., New York, 1994 (18); Edinburgh / New York / Houston 1999–2001

(52); *Girodet 1767–1824*, Paris / Chicago / New York / Montreal, 2005–7 (116).

NOTES
1. P.-A. Coupin, *Oeuvres posthumes d'Anne-Louis Girodet-Trioson peintre d'histoire, suivies par sa correspondance ...*, Paris, 1829.
2. C.M. Osborne, *Pierre Didot the Elder and French book illustration 1789–1822*, New York, 1985, in particular 'Didot's Racine', pp.113–40.
3. On the late-eighteenth-century revival of interest in Racine, see J.H. Rubin, 'Guérin's Painting of Phèdre and the Post-revolutionary Revival of Racine', *The Art Bulletin*, vol.LVIII, 1977, pp.601–18.
4. *Second Exposition publique des produits de l'industrie française*, Paris, 13 Ventose, An IX.
5. Prud'hon was the original choice for *Andromache*, but in the end he only produced the illustration for the frontispiece to the three-volume *Racine*.
6. Coupin 1829, vol.II, p.343.
7. *French Painting: The Revolutionary Decades 1760–1830*, exh.cat., Sydney / Melbourne, 1980–1 (62). The original drawings for Racine were mounted in the vellum copy of the *Oeuvres*, which Pierre presented to his brother Firmin in appreciation of his work. It was put up for auction in 1810 at the sale of Firmin Didot's

library but withdrawn because it failed to fetch the reserve of 3,200 francs. Around 1814, the drawings were bought by the Marquis de Château Géron who immediately sold them to the dealer Schrot, with the exception of Prud'hon's frontispiece and Gérard's drawing for *Bajazet*, act 2 scene 1, which he kept for himself.
8. Osborne 1985, pp.128–9.
9. Bellinger / Brady catalogue, 1997 (32, 33).
10. On the Cleveland drawing see *Visions of Antiquity: Neoclassical Figure Drawings*, exh.cat., Los Angeles / Philadelphia / Minneapolis, 1993–4 (55).
11. Coupin 1829, vol.II, p.243.
12. *Le beau idéal ou l'art du concept*, exh.cat., Louvre, Paris, 1989 (55).
13. *Dessins français du XIXe siècle du Musée Bonnat à Bayonne*, exh.cat., Louvre, Paris, 1979 (80).
14. *La donation Baderou au musée de Rouen, Peintures et dessins de l'Ecole Française: Etudes de la revue du Louvre et des Musées de France*, 1980, vol.I, p.115, fig.11.
15. The son of a cousin of Girodet's, Becquerel (1788–1878) was a distinguished soldier and scientist. He was given the task by his family of ensuring the posthumous publication of Girodet's literary works. His grandson, Henri, gave the family name to the unit by which radioactivity is measured.

# Auguste-Barthélémy Glaize
## *Head of a Bearded Man*

MONTPELLIER 1807–1893 PARIS

A student of Eugène and Achille Deveria, Glaize exhibited at the Salon from 1836 to 1880. In his native Montpellier he enjoyed the patronage of the well-known collector Alfred Bruyas (most notably in his *Interior of Bruyas's Study* of 1848, Musée Fabre, Montpellier). Although active as a genre and portrait painter, he is best known for his religious works, including mural paintings for the churches of Saint-Sulpice, Notre-Dame-de-Bercy and Saint-Gervais in Paris. Among his finest works is the decoration of the baptismal chapel in the church of Saint-Eustache, Paris.

This drawing is possibly a profile study for a head of Christ and has long borne an attribution to Glaize. The facial type is close to that found in a number of his paintings for the baptismal chapel at Saint-Eustache. Hardly any drawings by Glaize are known, though a signed study of the head of a man, possibly a self-portrait, is in the Art Institute of Chicago (fig.27.1).[1]

D 5470
Black chalk, with touches of brown chalk · 60.9 × 47

PROVENANCE
Marc Pagneux, Paris; Shepherd Gallery, New York in 1986; Frederick Cummings, New York; Colnaghi, London; from whom purchased 1999.

EXHIBITED
Colnaghi, New York / London 1992 (51); Colnaghi, New York 1995 (46); Edinburgh, 2001 (27).

NOTES
1. Black conté crayon, heightened with red-brown wash and white conté crayon: 39.1 × 29.4. Acc.no.1994.243

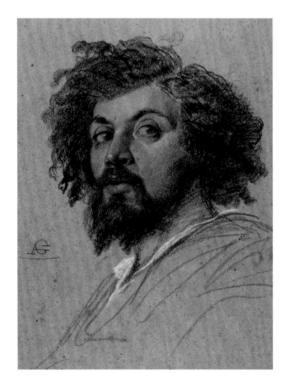

Fig.27.1 Auguste Barthélémy Glaize, *Self-portrait*, Mr and Mrs William O. Hunt Fund in honour of Harold Joachim, 1994.243, The Art Institute of Chicago

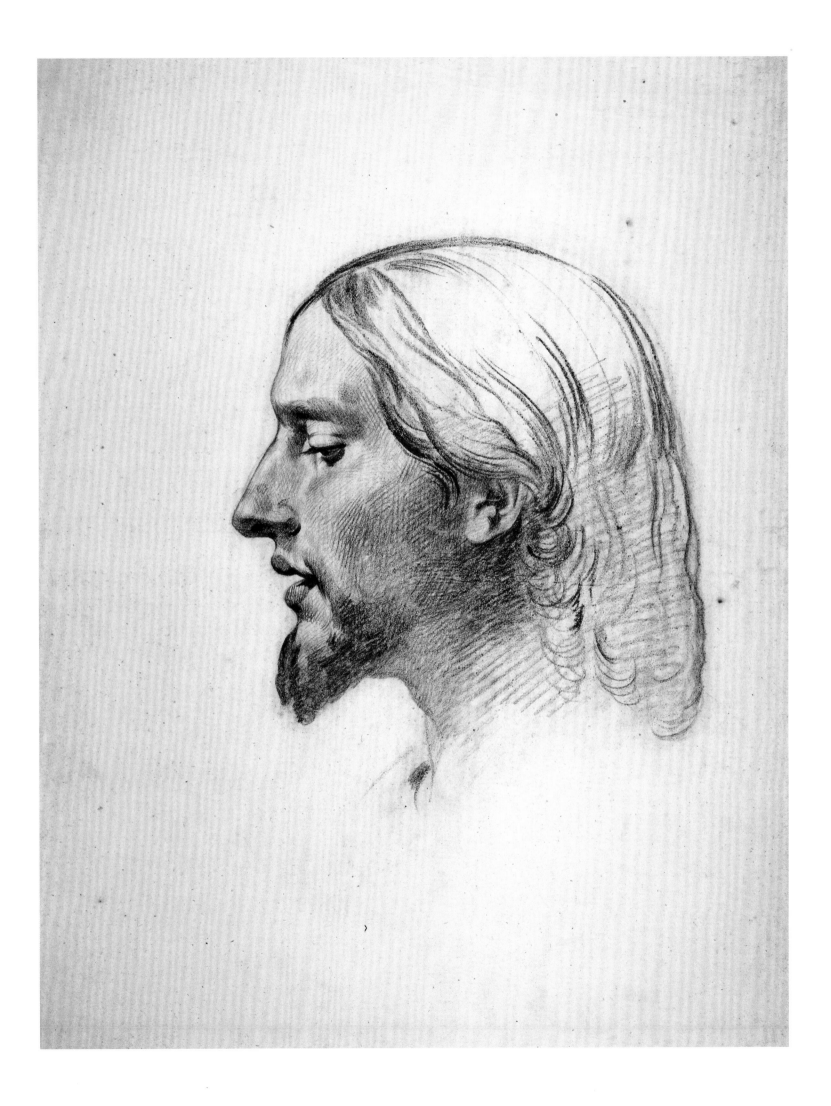

# Antoine-Jean, baron Gros
## Two Romantic Figures in an Embrace

PARIS 1771–1835 BAS-MEUDON

The son of a miniaturist, Gros entered the studio of Jacques-Louis David at the age of fifteen. His early failure to win the Prix de Rome and his father's declining health forced him to suspend his studies and give drawing lessons to supplement his income. On the intervention of David he was granted a passport in 1793 and left for Italy. In Genoa in 1796 he met Josephine. She introduced him to Napoleon who appointed him to work with the commission responsible for transporting works of art from Italy to France. He returned to France in 1799 having studied the colours of the Venetian masters as well as Rubens's work in Genoa. The success of his *Bonaparte at Arcola* of 1796 (Musée du Château, Versailles) greatly advanced his career and he soon became the chief chronicler of Napoleon's military progress in pictures such as *The Fighting at Nazareth*, 1800–1 (Musée des Beaux-Arts, Nantes), *The Plague Victims of Jaffa*, 1804 (Louvre, Paris), *The Battle of Aboukir*, 1806 (Musée du Château, Versailles) and *The Battle of Eylau*, 1808 (Louvre, Paris). At the Restoration of the monarchy, David left Paris for Brussels and handed over his studio to Gros, who received commissions to paint the cupola of the Panthéon and several ceilings of the Musée Charles X in the Louvre. In 1835 the critical failure of his *Hercules and Diomedes* (Musée des Beaux-Arts, Toulouse) drove Gros to commit suicide by drowning himself in the Seine at Bas-Meudon.

This is one of several sheets of similar subject, medium and size, which are preparatory studies for the main figures in a now lost composition, *Arcadian Shepherds*. The composition of the painting is known from a drawing reproduced in the catalogue of Gros's œuvre by his pupil Delestre.[1] Dating from about 1791, the painting is the work of a young artist struggling with the melancholy and Poussinesque theme of lovers in Arcadia. A drawing now in the Metropolitan Museum of Art, New York (fig.28.1) shows the lovers in a configuration similar to this drawing, with an interesting, thumbnail sketch in the upper right of the sheet relating to the complete version of the lost composition.[2] Gros's dissatisfaction with his figure grouping in this drawing is evident by his use of swirling pen lines over the figures and faces. Another drawing, of the two main figures turned in one to another, was with W.M. Brady, New York in 2003 (fig.28.2).[3] Our drawing, which is closely related, but with the clinging figures turned more outward in their pose toward the viewer, exhibits the same fluid use of brown wash and came from the same sale as the ex-Brady drawing. Both the Brady and the Edinburgh drawing represent more purposeful solutions to the main figure group. Distinct from these three drawings, which essentially explore the main figure group, are two that depict the composition as a whole and relate closely to its final formulation. One is in a private collection[4] and the second has come to light recently and was with Galerie Terrades, Paris

in early 2010 (fig.28.3).[5] Its recto is very close to the final composition, whereas the study on the verso concentrates on the main figure group, albeit in reverse.

D 5545
Brush and brown ink and brown wash over black chalk
26.7 × 18.5

PROVENANCE
Hôtel Drouot, Paris, Tajan, 25 March 2002 (122); W.M. Brady, New York; from whom purchased 2002.

NOTES
1. J.B. Delestre, *Gros: sa vie et ses oeuvres*, Paris, 1867, p.18, fig.10 (illustrated by a preparatory drawing for the composition). The painting was lot 24 in the artist's posthumous 1835 sale (23 November–1 December, Paris, Lugt 14144), where it was bought by his pupil Jean-Baptiste Delestre, together with several preparatory drawings. It was no.4 in Delestre's 1871 sale (13–14 October, Paris, Lugt 32649), but was lost thereafter.
2. Black chalk, pen and brown ink, brown wash: 20 × 14. Sold Christie's, New York, 30 January 1998 (330) illus.
3. *Master Drawings*, 22 January–14 February, 2003 (16) illus. Pen and brown ink with brown wash over black chalk: 26.7 × 18.5.
4. Black chalk, black lead, on brown paper: 27.5 × 22.
5. Pen and brown ink: 22.5 × 18. Signed, lower centre: *A.J. Gros*.

Fig.28.1 Antoine-Jean, baron Gros, *A Man and a Woman Embracing*, Gift of Mrs Gardner Cassatt, by exchange, 1988 (1988.52) The Metropolitan Museum of Art, New York

Fig.28.2 Antoine-Jean, baron Gros, *Study for the 'Arcadian Shepherds'*, W.M. Brady, New York

Fig.28.3 Antoine-Jean, baron Gros, *Arcadian Shepherds*, Galerie Terrades, Paris

# 29

## Jean-Antoine-Théodore, baron Gudin
### Arab Warriors by the Shore of Algeria

PARIS 1802–
1880 BOULOGNE-SUR-MER

A specialist in marine subjects, Gudin left home at an early age and joined the crew of an American ship, working for three years as a sailor and surviving a shipwreck. At the age of fifteen he decided to become a painter and trained under Girodet and Gros and became a disciple and friend of the Romantic painters Delacroix and Géricault. He first exhibited at the Salon in 1822 and came to be regarded as France's leading painter of sea battles. He participated in many military expeditions and was appointed official artist to the Algerian expedition of 1830 at the conclusion of which he was awarded the Légion d'honneur and later created baron. In the 1830s he was commissioned by Louis-Philippe to paint ninety-seven large scenes illustrating episodes of French naval history for the galleries at Versailles. His work suffered from over-production, however, and received increasingly hostile criticism from the 1840s onward. He married a Scottish woman of noble birth, Margaret Louis Hay, a god-daughter of the Duke of Wellington, and enjoyed the hospitality of his in-laws, Lord and Lady James Hay, at Seaton Castle, Aberdeenshire.[1] He retired for a while to Scotland after the Franco-Prussian War (1870–1).

Like the drawing by Delaroche (see cat.no.20), this comes from the marriage album of the duc Antoine de Montpensier which was commissioned by the Orléans family in 1846. The subject, in which Arab horsemen look out from the shore towards the French fleet, was doubtless chosen to reflect the Algerian campaign of 1845–6, in which the duc took part. The album was broken up and sold at Sotheby's, London, 11 June 1997 (1–46). Several such wedding albums were produced for the children of Louis-Philippe, though their present whereabouts are unknown. The choice of Gudin was particularly apposite as he had been extensively patronised by the Orléans family, was used to moving in elevated society, and was on familiar terms with Louis-Philippe.

D 5431
Watercolour, heightened with white, laid down · 29 × 44.5
Signed and dated, lower right: *T.Gudin.1846.*

PROVENANCE
Antoine, duc de Montpensier; his daughter, Isabelle d'Orléans; Amélie, Queen of Portugal; thence by descent to the comte and comtesse de Paris; Private Collection, Europe; Sotheby's, London, 11 June 1997 (32), where purchased by the Gallery.

EXHIBITED
Edinburgh 2001 (28).

NOTES
1. He was also on close terms with the Duke and Duchess of Sutherland and had visited the family at Dunrobin where, in his *Souvenirs*, he recalled a day's catch yielding 500 salmon (*Souvenirs du baron Gudin*, Paris, 1921, p.211).

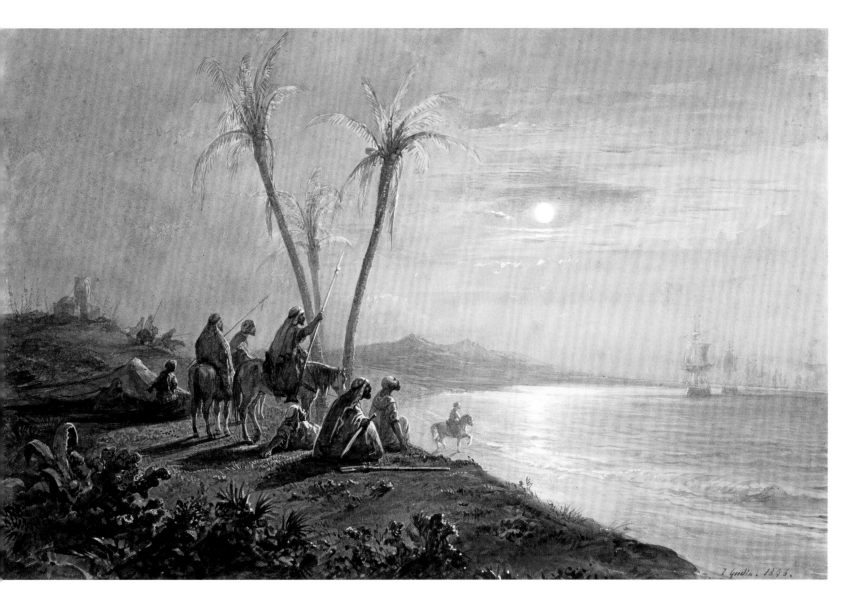

# 30 Pierre-Narcisse Guérin
## *Aurora and Cephalus*

PARIS 1774–1833 ROME

A pupil of Brenet, then of Regnault, Guérin won the Prix de Rome in 1797 and enjoyed his first success at the Salon two years later with his *Return of Marcus Sextus* (Louvre, Paris). He was in Rome 1803–5 and on his return to Paris, in response to criticism of his excessive reliance on subjects drawn from the classical theatre, in particular the works of Racine, he modified his subject matter to reflect the more lyrical classicism made popular by Girodet. He was director of the French Academy in Rome from 1822 to 1828. By remaining faithful to the dogmas of classicism throughout his career, he could be viewed as David's natural heir but, ironically, he was never his pupil. Guérin's own teaching was liberal, however, and his pupils included Delacroix, Géricault and the Scheffer brothers.

This drawing is related to two painted versions by Guérin of *Aurora and Cephalus*, both illustrating the classical myth, as told by Ovid, of Aurora, goddess of the dawn, and her love for the youthful Cephalus.[1] The first was painted in 1810 for the comte Giovanni-Battista de Sommariva[2] – a collector of Lombard origin whose collection of contemporary paintings and sculptures by Canova was well known in Paris – and is now in the Louvre, Paris (fig.30.1). There is a preliminary compositional drawing in Valenciennes,[3] and there was also an oil sketch, now lost.[4] A second version was commissioned in 1811 by Prince Nicolas Borissovitch Youssopov,[5] together with its pendant *Iris and Morpheus* (The State Hermitage Museum, St Petersburg), and is now in the Pushkin Museum, Moscow. Sommariva gave his permission that a second version be undertaken, but on condition that Guérin modify the position of the figure of Cephalus (to which he was particularly attached) in Youssopov's painting, in order to distinguish it from his own. In a letter written to Youssopov, shortly before his departure for Russia, Guérin thanked the prince for resolving any difficulties with Sommariva and stated he would be putting forward his suggestions on paper (in a drawing), rather than on canvas.[6] In this drawing Cephalus's right arm, held by Love

in the Sommariva version, rests across Cephalus. The light squaring-up and relatively finished appearance of this drawing suggest it was the final version of the composition, ready for transfer to canvas. But another drawing was used in which Guérin employed the stereotypical pose of antique sculptures of figures in repose with the arm raised above the head. A double-sided drawing at Lille[7] has on the verso a design for the Youssopov *Cephalus and Procris* and on the verso one for *Iris and Morpheus*.

D 5590
Pencil, heightened with white on brown paper · 25.4 × 18.7
PROVENANCE
Hôtel Drouot, Paris, 12 December 1924, salle 10 (59); Hôtel Drouot, Paris, 25 June 2003, salle 7, (3), as 'Ecole Française début XIXe siècle'; Galerie Terrades, Paris; from whom purchased 2005.

NOTES
1. J. Bottineau, 'Pierre Guérin et le merveilleux mythologique: L'Aurore et Céphale, Iris et Morphée', *Gazette des Beaux-Arts*, December 1999, pp.271–88. A short notice on this drawing appears in J. Bottineau et E. Foucart-Walter, *Pierre-Narcisse Guérin 1774–1833*, Cahiers du Dessin français, no.13, Galerie de Bayser, Paris, 2006, no.43.
2. F. Haskell, 'An Italian Patron of French Neo-Classic Art', *Past and Present in Art and Taste*, New Haven and London, 1957, pp.47–64.
3. Black and white chalk on tinted paper: 47.9 × 29.6, illus. Bottineau 1999, p.272, fig.1.
4. See Bottineau 1999, p.272, note 9.
5. On whom see P. Lang, 'Un collectionneur d'art contemporain à l'âge néo-classique: le prince Nicolas Borissovitch Youssopoff (1751–1831), *Actes du colloque L'Age Néoclassique*, Zurich, 2004, pp.125–36.
6. *J'ai l'honneur de presenter mes respects au Prince et suis enchanté qu'il ait levé les difficultés à l'égard de Mr. de Sommariva. Je vais de mon côté m'occuper de lever celles relatives à la composition. Cependant comme il vaut mieux chercher sur le papier que sur la toile, je ne responds pas que jeudi le Prince voye déjà le sujet tracé. Je le prie aussi de se rappeler que la peinture ne va pas aussi vite que la parole et surtout entre mes mains. Je prie le Prince de croire que je ferai tous mes efforts pour le satisfaire, car tel est mon désir.* Quoted by Bottineau 1999, p.278.
7. Black chalk and white heightening on oiled paper: 25 × 18, Musée des Beaux-Arts, Lille (H. Pluchart, *Musie Wicar, Notice des dessins*, Lille, 1889, p.320, no.1437).

Fig.30.1 Pierre-Narcisse Guérin, *Aurora and Cephalus*, Musée du Louvre, Paris

# Henri-Joseph Harpignies
## *View of a Distant Town*

VALENCIENNES 1819–
1916 SAINT-PRIVE, YONNE

In the course of a remarkably long career (he was still painting one week before his death at the age of ninety-seven),[1] Harpignies produced a vast body of work, landscapes of a fairly traditional nature, which found consistent popularity with collectors. He studied in Paris with the landscape painter Jean-Alexis Achard, a friend of Corot's, an artist whom Harpignies greatly admired and came to know well. He first visited Italy in 1850–2. Shortly after his return to Paris he began to exhibit at the Salon in 1853 and continued to do so until 1912. In the early 1860s he bought a house and garden in the village of Saint-Privé in the Yonne and stayed there frequently, painting the scenery of the region with its forests and views of the rivers Allier, Nièvre and Yonne. He was in Italy again, 1863–5, and in 1875 was awarded the Légion d'honneur. From 1885 onwards, he spent his winters on the Côte d'Azur where he was able to tutor wealthy pupils such as the princesse d'Arenberg. In 1913, at the age of ninety-four, he acquired a car which he drove around Paris.

This excellently preserved watercolour represents one of Harpignies's most striking compositions. He began to paint watercolours around 1850–1 and they often reveal a more delicate sensibility than his paintings in oils. Harpignies first exhibited watercolours at the Salon in 1864 (the year of this watercolour) where they were favourably commented on by the critic, Thoré.[2] Although in Italy at the time, he evidently had no difficulty composing 'French' scenes from memory.[3] He also exhibited regularly with both the Société d'Aquarellistes Français in Paris and the British Watercolour Society in London, his watercolours proving equally popular in England. On his death his achievements were acknowledged in both France and England. His obituarist in *The Burlington Magazine* over-generously credited him with the 'revival' of watercolour painting in France and touchingly quoted from Léon Bonnat's funeral oration for Harpignies, 'The Old Oak, as we used to call him informally, has just fallen'.[4]

D 5138

Watercolour over pencil · 28 × 37.5

Signed and dated, lower left: *H. Harpignies 64*

PROVENANCE
Hazlitt, Gooden & Fox Ltd, London; from whom purchased 1985.

EXHIBITED
Edinburgh / London 1994 (13); *Masterpieces from the National Galleries of Scotland*, Niigata / Bunkamura / Nara, 2005–6 (21).

NOTES
1. A particularly sympathetic account of Harpignies's career is given by A. Mongan, 'Henri-Joseph Harpignies', *Essays in Honor of Paul Mellon Collector and Benefactor*, Washington, 1986, pp.227–37, citing earlier literature including the biography, based on Harpignies's unpublished 'Mémoires', written by his friend L. Bénédite, 'Harpignies', *Gazette des Beaux-Arts*, vol.13, 1917, pp.207–35.
2. ' … ses deux aquarelles exposés dans la catégorie des dessins: on peut voir qu'il est presque aussi distingué de couleur et de dessin que Bonington.' quoted in P. Miquel, *Le Paysage français au XIXe siècle 1824–1874*, vol.III, Maurs-La-Jolie, 1975, p.754.
3. The two watercolours exhibited at the Salon were *Souvenir du Dauphiné* and *Marécage*.
4. 'H.V.S.', 'Henri-Joseph Harpignies', *The Burlington Magazine*, vol.XXIX, 1916, pp.267–71.

# Ernest Hébert
## *Study for the Woman of Cervara (Les Cervarolles)*

GRENOBLE 1817–
1908 LA TRONCHE, ISÈRE

After studying with Benjamin Rolland in Grenoble, Hébert left for Paris in 1834 and entered the Ecole des Beaux-Arts where he passed through the studios of Monvoisin, David d'Angers and Delaroche. In 1839 he was awarded the Prix de Rome and stayed in Italy from 1840 to 1847 (where he studied under Ingres and Schnetz amongst others). In Florence in 1844, he met and was befriended by Princess Mathilde, German cousin of the future Napoleon III. He was awarded a first-class medal at the 1850–1 Salon for his painting *La Mal'aria* (Musée d'Orsay, Paris) and this really marked the beginning of his official career: throughout the Second Empire and Third Republic his work alternated between scenes of Italian life and fashionable portraits, both suffused with a languid melancholy which was considered highly poetic. He belonged to a generation of late, academically trained, Romantics who anticipated, in certain respects, the Symbolists at the end of the century: Hébert's biographer, Joséphin Péladan, known as Sâr Péladan,[1] was an important member of the Symbolist movement. Between 1853 and 1858, Hébert made two long voyages in Italy preparatory to his submissions to the Salons of 1857 and 1859. He was appointed director of the French Academy in Rome in 1866.

This is a study for the main figure in the painting *Les Cervarolles (Etats romains)*,[2] which Hébert exhibited at the 1859 Salon (1420) where it was well received by most of the critics. It was purchased by the State for 15,000 francs (one of the highest sums ever paid by the Imperial Museums) and placed in the Musée du Luxembourg (it is now in the Musée d'Orsay, Paris, fig.32.1). It was essentially a reworking of the theme of Italian peasant women previously explored by Hébert in *The Girls of Alvito* (Musée Hébert, Paris) of 1857, and demonstrates his ambition to make genre painting aspire to the ambition of history painting. Studies of Italian women in costume had been made by French artists since the late eighteenth century and had featured prominently in the Italianate genre scenes of artists such as Léopold Robert. Many of these country models gravitated to Rome, where they were drawn and painted by the artists resident there. Hébert, on the other hand, wished to depict these peasant women at source in their native villages.

His biographer Péladan gives a somewhat melodramatic account of the execution of *Les Cervarolles*, claiming that the artist required six months in Cervara di Roma (high up in the Alban hills outside Rome) to persuade these 'fierce beauties'[3] to pose for him and that he was snowbound in dreadful conditions for eighteen months![4] Hébert stayed in Cervara from October 1856 to May 1858 and, such was the size of the canvas he had delivered from Rome for the painting of *Les Cervarolles*, the roof of his studio had to be raised.

In an article of 1897, Georges Lafenestre speculated that the three figures in the painting might symbolise the three ages of life.[5] A smaller painting by Hébert, *Going to the Well* (Walters Art Gallery, Baltimore),[6] reproduces the central figure of *Les Cervarolles*.

There are a number of related drawings. Two studies for the same figure are now in the Musée Hébert, Paris, one for the head of the central figure, the other showing her full length. One bears the date 1854 and the inscription *Adelaide;* in the other the model is referred to as *Adela.*[7] Another drawing of her, entitled *L'Orfanella*, is reproduced in a 1906 article by Jules Claretie.[8] A further drawing of the same model, dated 1859 but not in a pose directly related to *Les Cervarolles*, has recently come to light.[9] A drawing of the entire composition appeared at auction in Paris in 1990.[10]

D 5398
Coloured chalk on beige paper · 48 × 31.3

PROVENANCE
James Mackinnon, London; from whom purchased 1995.

EXHIBITED
Edinburgh / New York / Houston, 1999–2001 (58).

NOTES
1. J. Péladan, *Ernest Hébert. Son Oeuvre et son temps, d'après sa correspondence intime et des documents inédits*, Paris, 1910. For a recent appraisal of the artist, see P. Cooke, 'Ernest Hébert (1817–1908) and the Romantic Aftermath', *Apollo*, CXLVI, 1997, pp.32–6.
2. Oil on canvas: 288.5 × 176. See the very full entry on this picture by H. Loyrette in *Impressionnisme: Les origines 1859–1869*, exh.cat., Paris / New York, 1994–5 (79), more recently exhibited in *Italiennes modèles, Hébert et les paysans du Latium*, La Tronche / Paris, 2008–9 (13).
3. Péladan 1910, p.125.
4. For the most recent account of Hébert's stay in Cervara, see R. P. d'Uckermann, *Ernest Hébert 1817–1908*, Paris, 1983, pp.97–104.
5. G. Lafenestre, 'M. Ernest Hébert', *Gazette des Beaux-Arts*, 1897, pp.353–70, specifically p.360.
6. W.R. Johnston, *The Nineteenth Century Paintings in the Walters Art Gallery*, Baltimore, 1982, pp.56–7, no.28, fig.37.133.
7. *L'Italie romantique vue par Hébert*, exh.cat., Musée Hébert, Paris, 1977 (73, 72).
8. J. Claretie, 'Ernest Hébert, notes et impressions, artistes contemporains', *La Revue de l'art ancien et moderne*, 20, 1906, p.411.
9. *Le XIXe siècle*, Talabardon et Gautier, Paris, 2009 (22).
10. *Ruelle orientale*, black chalk with white heightening: 31 × 18, Hôtel Drouot, Paris, 7 November 1990 (41).

Fig.32.1 Ernest Hébert, *Les Cervarolles*, Musée d'Orsay, Paris

# Alexandre-Jean-Baptiste Hesse
## A Kneeling Shepherd

PARIS 1806–1879 PARIS

Nicknamed 'the last Venetian' because of the strong colouring in his work,[1] Hesse was initially trained by his father, the painter Henri-Joseph Hesse. Alexandre entered the studio of Jean-Victor Bertin in 1820, enrolling at the Ecole des Beaux-Arts the following year where he frequented the studio of baron Gros, who taught many history painters. He undertook the first of three trips to Italy in 1830, meeting Horace Vernet in Rome, then continuing on to Venice. He made his debut at the Salon in 1833 with his *Funeral Honours Rendered to Titian after his Death at Venice during the Plague of 1576* (Louvre, Paris), winning a first-class medal. In the same year he returned to Italy (he made a third trip 1843–7), making copies of Renaissance masterpieces in Florence and Venice. Three years later he was commissioned by the State to paint *Henry IV Brought Back to the Louvre after his Assassination* (Musée du Château, Versailles), destined for the Galerie d'Apollon in the Louvre. Like his uncle, the painter Nicolas-Auguste Hesse, he participated in the 1848 competition to provide an allegorical figure of the Republic. In addition to his Salon paintings (where he continued to exhibit until 1861), he worked on a number of major public commissions for church decorations in Paris,[2] including the chapels of Sainte-Geneviève at Saint-Séverin (1850–2), Saint-François-de-Sales at Saint-Sulpice (1854–60), and that of Saint-Gervais-Saint-Protais (1863–7) in the church of that name. Hesse was elected a member of the Académie des Beaux-Arts, in place of Ingres, in 1867, and was made *officier* of the Légion d'honneur the following year.

This beautiful drawing is a study for the figure of the kneeling shepherd in the lower right-hand corner of the *Nativity* (fig.33.1) which Hesse painted for the choir of the country church of Chevry-en-Sereine, near Nemours. A total of four other studies for the painting are known. Two are in the Ecole des Beaux-Arts, Paris – one of a *Standing Infant*, the other of a *Bearded Man* – both forming part of Hesse's bequest of the contents of his studio in 1879.[3] A drawing for the standing figure of *Saint Joseph* was with Stephen Ongpin Fine Art in 2010[4] and a further study, for the head of a donkey, was in the 1979 exhibition of drawings by Hesse held at the Galerie Pierre Gaubert, Paris in 1979.[5]

Hesse was commissioned in May 1861 by Mme Brisson, owner of the Château of Chevry-en-Sereine and whose family were already considerable patrons of the artist,[6] to decorate the choir and family chapel of the village church there. Of the four murals for the choir, two were in vertical format – *Christ in the Garden of Olives* and *Christ Tempted by the Devil*, and two were in horizontal format – *Mary Magdalen in the House of Simon* and *The Nativity*. In order to combat the harmful effects of humidity, the walls of the church were carefully resurfaced with slabs fixed with bronze tenons and were then coated with lead white and wax. The paintings were executed in a mixture of oil and wax. Despite these efforts, it was noted that substantial restoration was necessary only two years after the completion of the scheme in 1863.

The Edinburgh drawing was dedicated ('to his most kind friend') by Hesse to Victor Baltard (1805–1874), chief architect for the city of Paris and diocesan architect to the department of the Seine. According to the date, it was presented to him four years after the completion of the Chevry-en-Sereine decorations. Baltard was the main dispenser of important contracts to artists for the decoration of public interiors in Paris, both ecclesiastical and secular. Architect of Les Halles and restorer of a number of churches using metal structures, he worked in close collaboration with his friend, the painter Hippolyte Flandrin, on the decoration of a number of churches, most famously Saint-Germain-des-Prés. The presentation of such a drawing as this to Baltard, with its rather sycophantic inscription, is therefore comprehensible in the circumstances, and also indicates Hesse's own high opinion of this particular sheet. The gift may well have been made in connection with Hesse's work on the decorations for the chapel of Saint-Gervais-Saint-Protais which, as Baltard reported in an official communication of 9 October 1866, were nearing completion:[7] the project was jointly funded by the city of Paris and the State.

D 5392
Coloured chalks, with white heightening on tan paper
47.5 × 35.6
Signed, inscribed and dated, lower left: *Alexander Hesse / al suo garbatissimo amico / V. Baltard / 1867*

PROVENANCE
Victor Baltard: W. M. Brady, New York, from whom purchased 1994.

EXHIBITED
Edinburgh / New York / London 1999–2001 (59).

NOTES
1. P. Nicard, *Alexandre Hesse, sa vie et ses ouvrages*, Paris, 1882.
2. On this whole subject see B. Foucart, *Le renouveau de la peinture religieuse en France (1800–1860)*, Paris, 1987.
3. Nos 33 and 34 in *Les Dossiers du Musée d'Orsay 26: Dessins d'Alexandre Hesse conservés à l'Ecole supérieure des Beaux-Arts*, catalogue by E. Brugerolles and D. Guillet, Paris, 1988. This represents the most up-to-date publication on the artist.
4. *Master Drawings*, Stephen Ongpin Fine Art, New York / London / Paris, 2010 (23).
5. *Alexandre Hesse 1806–1879*, Galerie Pierre Gaubert, Paris, 1979 (32).
6. Portraits of *Mme Brisson* in 1835 and of *M. Adrien Brisson* in 1836 (both Private Collection) and the *Death of President Brisson 1591* (1840 Salon no.832), *Procession of the League 10 February 1593* (1850 Salon no.1517), *Henry IV Leaving for the Hunt*, 1852, Nicard, p.46, p.140, p.19, p.69, p.75.
7. Brugerolles and Guillet, pp.14–15, note 60.

Fig.33.1 Alexandre-Jean-Baptiste Hesse, *Nativity*, Church of Chevry-en-Seine

# Claude Hoin
## *Portrait of a Young Boy*

DIJON 1750–1817 DIJON

A painter, teacher and museum administrator, Hoin was the son of a prominent doctor in Dijon. After training in his native town at the drawing academy (where he was registered as a student of architecture) founded by François Devosge in the Palais des Etats, he moved to Paris in 1772 or 1773 and, under the tutelage of Greuze, copied portraits of young girls. Elected to the academies of Dijon and Toulouse, he exhibited miniatures, gouaches and pastels at the Salon de la Correspondance in 1779, 1782 and 1783. He was appointed professor of drawing at the Ecole Royale Militaire and in 1785 was named official painter to the comte de Provence (later Louis XVIII). At the outset of the French Revolution he returned to Dijon and in 1804 was appointed professor of drawing at the school there. In 1811 he became *conservateur* of Dijon's Musée des Beaux-Arts.

Although he painted miniatures, portraits, allegories and theatre scenes, Hoin was known particularly for his drawings and was considered by Edmond de Goncourt to be one of the most accomplished gouache artists of the eighteenth century.[1] His best studies of heads date from after his return to Dijon when he took up the use of blue paper, as practised by Devosge's pupils at the school of drawing there and, also, by one of the greatest Dijonnais artists, Prud'hon.[2] A number of his vigorously modelled heads on blue paper were included in the exhibition of his work held in Dijon in 1963, whose museum currently holds a total of seventy-three works by him.[3]

D 5488
Black and red chalk, charcoal and pastel · 34.2 × 25.5

PROVENANCE
Emmanuel Moatti, Paris; from whom purchased 1999.

EXHIBITED
Edinburgh 2001 (29).

NOTES
1. E. Launay, *Les Frères Goncourt collectionneurs de dessins*, Paris, 1991, pp.326–7, cat.no.135 *Mme Dugazon, in the role of Nina*, a signed and dated gouache by Hoin purchased by the Goncourts in 1865 with an attribution to Fragonard in the sale catalogue! The market's ignorance of Hoin was noted by Edmond de Goncourt (quoted by Launay), *un nom d'artiste complètement sombré, et que seulement depuis quelques années vient de réapprendre aux amateurs le passage, dans les ventes d'estampes, de deux ou trois gravures en couleur d'après ses compositions. Les experts avaient une telle defiance de l'inconnu de son nom, et cela encore à la vente Tondu, qu'ils livraient aux enchères ses gouaches, signees en toutes lettres, sous le nom de Fragonard.*
2. This point is made by Pierre Quarré in the catalogue of the exhibition, *Claude Hoin*, Musée des Beaux-Arts, Lyons, 1963, pp.10–11.
3. *Ibid.*, pls XVI, XIX, XX.

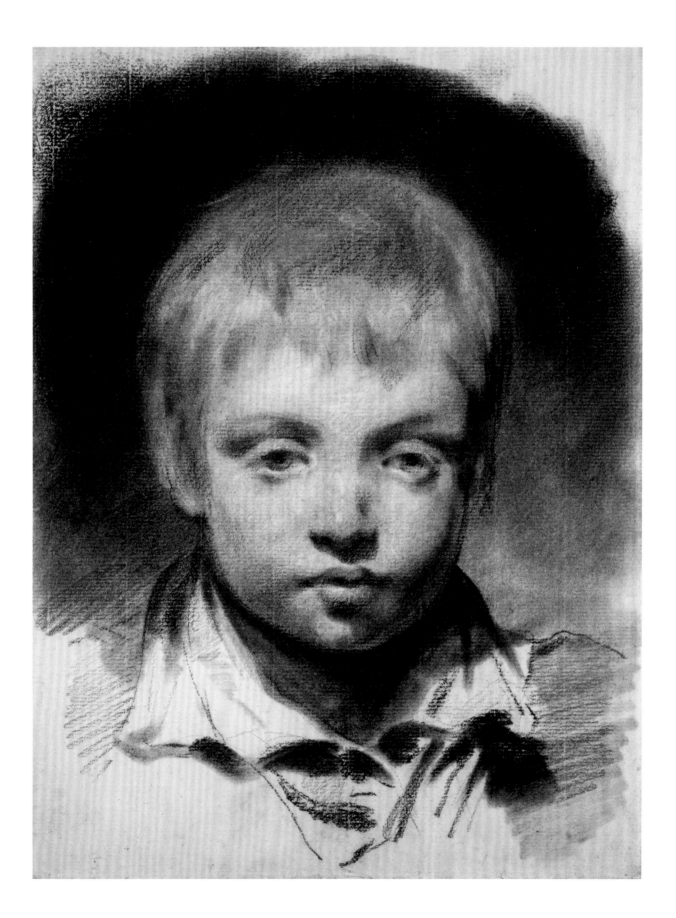

# Paul Huet
## *Toulon*

PARIS 1803–1869 PARIS

Huet studied in Gros's studio where he met the English painter Richard Parkes Bonington, with whom he sketched *en plein air* and from whom he learnt the English technique of watercolour painting. Around this time he also befriended Delacroix. He was profoundly influenced by the work of John Constable, which was shown at the 1824 Salon. Huet himself first exhibited at the 1827 Salon. In 1830 he accompanied Bonington on a sketching tour of Normandy. This was the first of his extensive travels round France: regions he particularly favoured included Normandy, the Auvergne, Provence and, nearer to Paris, Fontainebleau and Compiègne. He made his only trip to England in 1862, travelling as far west as Lands End, and visited the Low Countries in 1864. A cultivated man, his circle of acquaintances included Michelet, Sainte-Beuve and Victor Hugo.

This exceptionally well preserved watercolour comes from a set depicting towns of the Midi commissioned for 2,000 francs in March 1839 from Huet by his patron the duc d'Orléans through the agency of Monsieur Asseline, secretary to the duchesse. The artist was entrusted with all decisions regarding the number of scenes in the suite and the precise locations (the only town mentioned in the letter of commission was Avignon).[1] Huet was well known to the Orléans family and for the previous two years had held the post of art teacher to the duchesse. The commission also, as his patrons knew, would have aided his unfortunate personal circumstances at the time: his wife was suffering from a lingering illness, the (unsuccessful) prescription for which had been the warmer and drier air of the Midi. She died later that year on 12 December. As Asseline pointed out in the letter of commission, Huet already had numerous drawings of the towns of the Midi and the production of this set was not intended to involve him in extensive new labours. The finished watercolours would therefore have been based on extant designs. There were originally twelve watercolours in the Orléans album: others in the series included views of *Avignon* (The Art Institute of Chicago); *La Fontaine de Vaucluse* (Brooklyn Museum of Art); *Cannes, Les Gorges d'Ollioules, Marseilles, L' île Ste Marguerite* and *Cagnes*[2] (Private Collections); *Golfe Juan, Antibes, Hyères* and *St Laurent du Var* (all with James Mackinnon). In his monograph on the artist Pierre Miquel described these watercolours as amongst the most beautiful produced in the nineteenth century and noted particularly those of Marseille, Toulon and Avignon.[3]

D 5367
Watercolour · 28.3 × 47.5

PROVENANCE
James Mackinnon, London; from whom purchased in 1994.

EXHIBITED
Edinburgh / London 1994 (14).

NOTES
1. The letter of 14 March 1839 describing the commission is reprinted in R.P. Huet, *Paul Huet (1803–1869) d'après ses notes, sa correspondance, ses contemporains*, Paris, 1911, p.33.
2. A watercolour study for *Cagnes* was exhibited in *Paintings by Paul Huet*, Heim Gallery, London, 1969 (37).
3. P. Miquel, *Paul Huet, De l'aube romantique à l'aube impressionniste*, Sceaux, 1962, p.114.

# Jean-Auguste-Dominique Ingres
## *Portrait of Mlle Albertine Hayard*

MONTAUBAN 1780–1867 PARIS

Ingres can justly be claimed as the major French painter of the first half of the nineteenth century. He enrolled at the Toulouse Academy in 1791 and also showed a talent for music: in 1796 he was second violin in the orchestra of the Capitole at Toulouse. In 1797 he travelled to Paris to enter David's studio. He won first prize in the 1801 Prix de Rome for his *Ambassadors of Agamemnon* (Ecole des Beaux-Arts, Paris) but circumstances prevented his visit to Rome until September 1806 and he remained in Italy until 1824. His prolonged stay at the French Academy in Rome was a period of intense activity. There were major paintings for Napoleon such as *Ossian* (Musée Ingres, Montauban), his official *envoi* to the Institut de France of *Jupiter and Thetis* (Musée Granet, Aix-en-Provence), and numerous portraits of the French community in Rome. After the fall of the French Empire in 1814, Ingres suffered a temporary reversal but he soon began to receive official commissions again under the Bourbon monarchy, and in the period 1815–25 produced many works in his troubadour style such as *The Death of Leonardo da Vinci* (Musée du Petit Palais, Paris). In 1824 he returned to France where his *Vow of Louis XIII* (Cathedral, Montauban) was shown to great acclaim at the Salon. He was awarded the Légion d'honneur, made a member of the Institut de France and opened a flourishing studio where he taught many pupils. He returned to Rome as director of the French Academy 1835–41. Despite various disputes with the critics, the later part of Ingres's career was one of official success, even after he ceased exhibiting at the Salon and reserved his works for specific admirers. In 1853 he was appointed, along with Delacroix, to the imperial commission presided over by Prince Napoleon to direct and supervise the 1855 Exposition universelle, in which an entire gallery was devoted to his work.

Over 450 portrait drawings by Ingres are known,[1] the majority executed between 1806 and 1824. Some, as may have been the case here, were done out of friendship, others on commission. Albertine (1797–1833) was the eldest of the four daughters of Charles-Roch Hayard (1768–1839), who sold artists' materials from his shop in the Via dei Due Macelli off the Piazza di Spagna, just a short distance from the French Academy in the Villa Medici, Rome.[2] Hayard would, therefore, have been known by many of the *pensionnaires* at the Academy and Ingres was a faithful client and became a close friend. He drew a total of seven portraits of members of the Hayard family, the first in 1811 and the last in 1843.[3] This portrait of Albertine,[4] aged fourteen or fifteen, was probably made just before her marriage on 17 January 1812 in the church of San Andrea delle Fratte to the landscape painter Pierre-Athanase Chauvin (1774–1832). Naef has suggested that the profile format of this drawing, together with those of others dating from 1810 to 1811, may have been influenced by Ingres's friendship with the medallist Edouard Gatteaux, which began in 1809.[5] Two years later, Ingres drew a second portrait of Albertine, heavily pregnant (Musée Bonnat, Bayonne).[6] The Chauvins lived at Piazza Mignatelli, not far from the Via Gregorina, where Ingres had an apartment until his departure for Florence in 1820. Chauvin had been a witness to Ingres's 1813 marriage to Madeleine Chapelle. The Chauvins, who appear to have had four children, did not enjoy good fortune, however; as the painter Granet noted in a letter of 15 January 1830 from Rome to Ingres back in Paris: 'Our friend Chauvin is always ill, as is his wife. This household is not at all happy, without any rapport. They tell you a thousand things.'[7] Two years later Chauvin was dead from a heart attack and his wife died only thirteen months after him.

D 5100
Pencil · 21.5 × 15.1
Signed and dated, lower left: *Ingres a Rome / 1812*

PROVENANCE
Félix Duban (died 1870, brother-in-law of the sitter); his daughter, Mme Théodore Maillot (died 1898, born Félicie-Charlotte Duban); her cousin, Félix Flachéron (died 1927); Georges Bernheim, Paris, by 1921; purchased probably shortly thereafter by Maria Luisa Caturla, Madrid; Marianne Feilchenfeldt, Zurich; from whom purchased with the aid of The Art Fund 1981.

EXHIBITED
*Ingres*, Ecole des Beaux-Arts, Paris, 1867 (549) lent Duban; *Ingres*, Chambre Syndicale de la Curiosité et des Beaux-Arts, Paris, 1921 (72); Edinburgh 1984 (19); Edinburgh 1991 (83); Edinburgh / London 1994 (15); Edinburgh / New York / Houston 1999–2001 (53); Edinburgh / London 2003–4, p.46.

NOTES
1. H. Naef, *Die Bildniszeichnungen von J.-A.-D. Ingres*, Berne, 1977–80.
2. At some point Mme Hayard took over the running of the shop, and her husband was appointed *Inspecteur des Poudres et poudrières* to the Holy See (Naef, vol.I, p.460, letter of 11 November 1837 from Rome of the *liègois* painter Edmond Duvivier to his mother. Duvivier married the youngest Hayard daughter, Caroline).
3. Naef 1977–80, vol.I, pp.451–69.
4. Naef 1977–80, vol.IV, no.81.
5. H. Naef, 'Eighteen Portrait Drawings by Ingres' *Master Drawings*, IV, 1966, p.258.
6. Naef 1977–80, vol.IV, no.112.
7. Naef 1977–80, vol.I, pp.455.

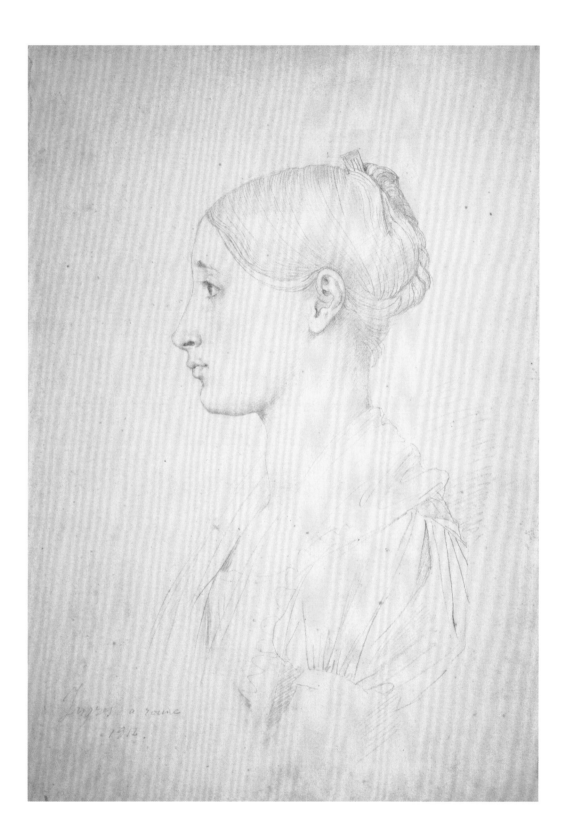

# Jean-Auguste-Dominique Ingres
## *The Dream of Ossian*

Fig.37.1 Jean-Auguste-Dominique Ingres, *The Dream of Ossian*, Musée Ingres, Montauban

This drawing is based on Ingres's large oval painting of this subject commissioned by Napoleon in 1811 for the ceiling of his bedroom in the Palazzo di Monte Cavallo on the Quirinal in Rome.[1] After Napoleon's downfall the palace was occupied by Pope Pius VII who removed all trace of Napoleon's decorative scheme. On his return to Rome in 1835 Ingres reclaimed his painting and, with his assistant Raymond Balze, reworked it to a rectangular format (fig.37.1). Eight drawings related to the complete composition have been identified (there are also studies of individual motifs),[2] though scholars have disputed the order in which they were made (at least five, including the Edinburgh drawing, post-date the initial painting).[3] Nearly all are agreed, however, that the ex-Gilbert watercolour (Private Collection, Montauban)[4] is the first in the sequence and probably predates the painting by a few years. Next, by fairly common consent, come two line drawings on tracing paper (Musée Ingres, Montauban)[5] which were probably done in connection with the painting. These are followed by a pen, ink and wash drawing, signed and dated 1813 (Private Collection, France).[6] Two later watercolours bear erroneous dates by Ingres of 1809 and 1812 (Fogg Art Museum, Cambridge, Mass. and Louvre, Paris).[7] This drawing bears an inscription stating that it was presented by Ingres to the architect Louis-Hippolyte Lebas (1782–1867). Although it has been suggested that it might have been made and presented to Lebas around 1825,[8] when both he and Ingres were elected to the Institut de France, in certain respects it is close to the 1851 print by Réveil,[9] from a publication created under Ingres's direction and reproducing his works up to that year, and in style it is also similar to the late signed and dated drawing of 1866 in the Musée Ingres, Montauban. In particular, the figure of Ossian's daughter-in-law, Malvina, has a comparable bound hairstyle. This whole series of drawings, and the later reworking of the original painting, bear witness to Ingres's continuing fascination with the subject of Ossian, even though the authenticity of the poems had come to be widely, and correctly, doubted.[10]

D 5369
Pencil, black chalk, white and cream heightening and grey wash on green-blue paper · 26 × 20.5
Inscribed in pencil below: *Ingres Pinx rome 1811; Songe d'Ossian* and *Don à son ami et cher confrere hippolite Lebas.*

PROVENANCE
Louis-Hippolyte Lebas; Monsieur Boulot; De Bayser, Paris; Private Collection, Switzerland; Christie's, New York, 11 January 1994 (343), where purchased.

EXHIBITED
Edinburgh / London 1994 (15); Edinburgh / New York / London, 1999–2001 (56); Edinburgh 2005 (122).

NOTES
1. Ossian, the 'Homer of the North', was a third-century Irish bard, son of Fingal, whose Gaelic poems were 'rediscovered' and 'collected' by James Macpherson, who 'relocated' them to Scotland and published them variously 1760–3 and in the complete *Works* of 1765. They enjoyed great popularity throughout Europe, inspiring both writers and painters (H. Okun, 'Ossian in Painting', *Journal of the Warburg and Courtauld Institutes*, vol.XXX, 1967, pp.327–56). Ingres's composition is generally inspired by the passage at the end of *The War of Inis-Thona*: *I see the heroes of Morven; I hear the songs of the bards; Oscar lifts the sword of Cormalo; a thousand youths admire its studded thongs. They look with wonder on my son. They admire the strength of his arm. They mark the joy of his father's eyes; they long for an equal fame … But sleep descends in the sound of the harp; pleasant dreams begin to rise. Ye sons of the chase stand far distant, not disturb my rest. The bard of other times holds discourse with his fathers, the chiefs of the days of old! Sons of the chase, stand far distant! Disturb not the dreams of Ossian!*, J. Macpherson (intro. W. Sharp), *The Poems of Ossian*, Edinburgh, 1926 edn, p.392.
2. See, for example, G. Vigne, *Dessins d'Ingres: catalogue raisonné des dessins du musée de Montauban*, Paris, 1995, nos 1277–99.
3. The most important discussions are D. Ternois, 'Ingres et le "Songe d'Ossian"', *Walter Friedlaender zum 90.Geburtstag*, Berlin, 1965, pp.185–92; H.Toussaint in *Ossian*, exh.cat., Paris / Hamburg, 1974, pp.102–6; R.A. Gross, 'Ingres' Celtic Fantasy "The Dream of Ossian"', *Rutgers Art Review*, vol.II, 1981, pp.43–58; P. Condon, *The Pursuit of Perfection: The Art of J.-A.-D. Ingres*, exh.cat., Louisville / Fort Worth, 1983–4, pp.46–51.
4. Condon 1983–4, no.8, colour illus., as c.1811–13.
5. Vigne 1995, nos.1279, 1280.
6. Condon 1983–4, p.46, fig.5.
7. Ingres later placed incorrect dates on many of these drawings, presumably a fault of memory.
8. H. Lapauze, *Les Dessins de J.-A.-D. Ingres au Musée de Montauban*, Paris, 1901, p.249 (dating the drawing to around 1824); Toussaint, p.103, no.VI, suggesting that *pinx.* refers to the painting, which Ingres mistakenly remembered as dating from 1811.
9. A. Magimel, *Oeuvre de J.-A.-D. Ingres … gravé au trait sur acier par A. Réveil, 1800–1851*, Paris, 1851, pl.22.
10. An investigation by the Highlands Society of Edinburgh, whose findings were published in 1805, proved inconclusive. The final debunking of Macpherson only took place from around 1850 onwards with the publication of much authentic Gaelic poetry.

Songe d'Ossian

# Etienne Jeaurat
## *Family in an Interior*

PARIS 1699–1789 VERSAILLES

The son of a wine merchant from Vermenton (Yonne), Jeaurat was placed by his brother, the engraver Edmé Jeaurat, in the Parisian studio of Nicolas Vleughels, whom he accompanied to Italy in 1724 when his master was appointed to the French Academy in Rome. He returned to France in 1728 and was *reçu* into the Royal Academy of painting and sculpture in 1733 as a history painter on presentation of his *Pyramus and Thisbe* (Musée de Roanne). He had a long and varied career, exhibiting irregularly at the Salon 1737–69 and producing history paintings, village scenes inspired by northern art, and scenes of Parisian life (for which he is probably best known) such as *The Carnaval of the Streets of Paris* and *Prostitutes being Taken to Hospital* (*Salpetière*), shown at the 1757 Salon and both now in the Musée Carnavalet, Paris. Jeaurat belonged to the literary circle, the *Société du Bout de Banc*, presided over by the actress Mlle Quinaut, which included the writers Piron and Vadé, both of whom shared an interest in the life of the common people. Indeed, Diderot later referred to Jeaurat as 'the Vadé of painting'. Jeaurat's own Parisian street scenes owed much to the influence of Hogarth, who visited Paris in 1743 and whose prints gained wide circulation there. During the reigns of Louis XV and XVI Jeaurat attained almost all available honours, being appointed rector of the French Academy in 1765, Guardian of the King's pictures at Versailles two years later and chancellor of the Academy in 1781.

Jeaurat's graphic masterpiece depicts a well-to-do bourgeois family in the spare, but elegant bedroom of the parents, which also functions, for the purposes of this image, as the father's office. The family has been rather improbably gathered together, however. In real life the father would have conducted his business in a separate office and certainly not in the bedroom. As he is shown in *profil perdu*, it is reasonable to assume this is not a specific family portrait, but rather a celebration of the virtues of a particular lifestyle and social class.

The room is half panelled, has a tile floor, and hung with what is probably damask. The clock on the chimneypiece is a Louise XV *pendule de cheminée* in the shape known as *forme violonée*. The time shown would appear to be twenty to eleven in the morning and the maid either sets down or picks up a jug from the hearth. Of the various pictures in the room, the overdoor is reminiscent of Boucher, while to the right there is a possibly Dutch landscape below two portraits. On the right the father works at his *bureau plat*, attended perhaps by a junior partner in the business or practice. The youngest of the three daughters of the family plays with the family dog, while her two elder sisters are engaged in sewing. On the far left sits the mother, possibly making tassel fringes, having temporarily abandoned her other work. In its highly finished state this sheet may have been intended as an exhibition drawing in its own right or as the basis for an engraving. Few of Jeaurat's drawings have been identified, the earliest being a number of delicate wash landscapes dating from 1725 during his stay in Rome.[1] No other grand, multi-figured works such as this are known, though there are studies for individual figures in various collections such as the Nationalmuseum, Stockholm; the Fitzwilliam Museum, Cambridge; and in private collections. The closest comparisons in terms of style and technique, however, can be drawn with a *Portrait of Seated Lady*, sold in Monaco in 1993,[2] and a *Woman Playing a Hurdy-gurdy* (Musée Lambinet, Versailles).[3]

A more modest sheet, with three protagonists (*The Convalescent*), was sold in New York in 1996[4] and formerly belonged to Philippe de Chennevières, the art administrator and collector who held the post of *directeur des Beaux-Arts* 1873–78 in succession to Charles Blanc. De Chennevières described Jeaurat as 'a Chardin

with a bourgeois palette'[5] and this disparaging comparison echoed earlier remarks made by those great collectors of the art of the *dix-huitième siècle*, the Goncourt brothers. Comparing the compositions of the two artists they observed, 'You look at that of Jeaurat, you enter into that of Chardin.'[6] They themselves owned drawings by Jeaurat, which were misattributed to Chardin at the time, so perhaps their judgement was rather harsh.

D 5360
Black and red chalk, heightened with white and pink touches of gouache, lightly squared up in graphite · 48 × 64

PROVENANCE
Hôtel Drouot, Paris, 4 December, 1992 (28); bought Emmanouel Moatti, Paris; from whom purchased 1994.

EXHIBITED
Edinburgh / London 1994 (16); Edinburgh / New York / Houston 1999–2001 (45); Edinburgh 2005 (70).

NOTES
1. For example, see *Maîtres Français 1550–1800: dessins de la donation Mathias Polakovits à l'Ecole des Beaux-Arts*, Paris, 1989 (80), *View of the Tiber*.
2. Black, red and white chalk: 42 × 31.8, Christie's, Monaco, 2 July 1993 (107), ex-collection Marcel Puech.
3. Black, red and white chalk: 42.5 × 29.7, Musée Lambinet, Versailles. inv.no.29989.
4. Christie's, London, 10 January 1996 (202).
5. P. de Chennevières, *Une collection de dessins d'artistes français*, Paris, 1893, p.183.
6. E. Launay, *Les frères Goncourt collectionneurs de dessins*, Paris, 1991, pp.335–6.

# Joseph-Ferdinand Lancrenon
## Study of Drapery

LODS[DOUBS] 1794–1874 LODS

Born in Lods, a small village near Besançon, Lancrenon was sent at the age of twelve to study in the studio of François Vincent, who was a friend of his older sister. The formative influence on his art came, however, with his entry in 1810 to the studio of Girodet, where he became that master's favourite and confidant, collaborating on a number of his major works. He remained there until 1818 and during that period competed unsuccessfully for the Prix de Rome on three occasions. In 1817, however, he won the *prix de concours* for the *tête d'expression* at the Ecole des Beaux-Arts and from that date he began to receive official commissions, thanks in part to the support of his patron the comte de Forbin, notable among which was that for a ceiling in the Tuileries *Oreithya Carried off by Boreas* (Musée Girodet, Montargis). He exhibited at the Salon between 1819 and 1845. He enjoyed his greatest success in the 1820s, practising an eroticised late Neoclassicism, Girodet-like in manner that was increasingly at odds with the rising tide of Romanticism. In 1834 he was appointed director of the Musée de Besançon and in 1840 director of the Ecole des Beaux-Arts there; at which point he largely gave up painting to devote himself to his administrative duties. In 1860 he became a member of the Institut de France and was awarded the Légion d'honneur, not as a painter but in recognition of his achievements in organising exhibitions in the French provinces.

Lancrenon's drawing ability was recognised from an early age. His style was strongly influenced by that of his master Girodet and a fair number of his drawings have appeared on the art market in recent years.[1] Many, in particular his drapery studies such as this example, are exceptionally beautiful and point to a talent that has been unjustly overlooked by posterity – as Girodet predicted it would be.[2] Drapery studies, of course, had formed an important part of the repertoire of artists since the early Italian Renaissance.

D 5563
Black and white chalk on brown paper · 49 × 31.8

PROVENANCE
Galerie Chantal Kiener, Paris; from whom purchased 2004.

NOTES
1. For example Groupe Gersaint, Clermont-Ferrand, *Atelier J.F. Lancrenon 1794–1874*, 30 June 1993 (1–30); Hôtel Drouot, Paris, salle 1, cat. Million et Associés, 23 and 25 March 2005 (333–54).
2. *Vous ne savez pas vous faire valoir et il vous arrivera d'être méconnu*, quoted in *Les années romantiques*, exh.cat., Nantes / Paris / Plaisance, 1995–6, p.410.

# Nicolas Alphonse Michel Mandevare
## *Mountainous Landscape*

ACTIVE 1786–1848

Little is known of Mandevare's career, most of which he seems to have spent in Paris.[1] He first exhibited at the Salon in 1793, where he showed two gouache landscapes, both now in the Musée des Beaux-Arts in Nantes. He continued to exhibit regularly at the Salon until 1848, showing mostly landscapes in black chalk or gouache. In 1804 he published a treatise, *Principes raisonnés du Paysage à l'usage des écoles des Départemens de l'Empire français, dessinés d'après nature*.[2] It consisted of twelve *cahiers*, each one including up to eight illustrations and an explanatory text at the front, and was intended as a guide to landscape painting for the amateur artist. It comprised mainly studies of trees with a limited number of landscapes and figures in landscapes. On the title page Mandevare was described as 'Membre de l'Athenée des Arts'. A number of Mandevare's tree studies were engraved by the Lambert brothers and he himself produced two landscape lithographs in 1822.

The style of this vigorous drawing is very typical of the artist and is related to that used for the lithographic illustrations to his 1804 treatise. It is more imaginative and daring, however, understandably so given that the illustrations to the treatise were intended for instruction. In the foreword to the treatise the publisher, Boudeville, explained that the drawing of landscape was as useful to young girls to assist them with the making of embroidery as it was to young men for military strategy. The sequence of plates took the reader through the study of increasingly complex leaves of trees, then branches, and it was only in the fourth *cahier* that whole trees were studied. Finally, the complete landscape was tackled, with its constituent elements of rocks and valleys. This drawing reveals Mandevare to have been an artist of considerable spirit and imagination. Its vertiginous viewpoint is combined with a semi-abstract approach to the form and structure of nature.

Many drawings by Mandevare were distributed on the art market in the early 1990s[3] and his work was acquired by a number of public collections including the British Museum, London, the Ashmolean Museum, Oxford, the Fondation Custodia (Institut Néerlandais), Paris and the National Gallery of Art, Washington. Other groups of drawings by him are in the museums at Nantes, Soissons and Schwerin.

D 5445
Black chalk · 44.7 × 58
Initialled, lower left: *M-M*

PROVENANCE
Galerie Chantal Kiener, Paris; from whom purchased 1998.

EXHIBITED
Edinburgh 2001 (30).

NOTES
1. A group of eight gouaches by Mandevare, *maroufl é* on canvas, was sold Hôtel Drouot, Paris, 12 June 1996 (26), of which three were dated 1786.
2. Copy in the Bibliothèque Nationale, Paris, BN Est. DC 50 / Fol. Published by Boudeville, rue Saint-Pierre-Montmartre, no.8 and dedicated jointly by Mandevare and Boudeville to A.M. Fourcroy, Directeur-Général de l'Instruction Publique.
3. For example Phillips, London, sales 11 December 1991 and 8 July 1992. See M. Joannides, 'Mandevare's Drawings: Le Rouge et le noire', *Phillips Preview*, London, autumn, 1992, pp.6–7.

# Charles Meynier
## *Terpsichore, the Muse of Dance*

PARIS 1768–1832 PARIS

Meynier, a pupil of Vincent, won the Prix de Rome in 1789, sharing the prize with Girodet. His stay in Rome was brief, due to the dispersal of the French Academy 'pensionnaires' during the Revolution, and he was back in Paris by 1793 when he entered a competition for works inspired by the Revolution, in which he won a prize and his reputation was rapidly established. He exhibited at the Salon from 1795 to 1827. During the Empire he enjoyed success as a painter of contemporary events, including *Marshal Ney and the Soldiers of the 76th Regiment Retrieving their Flags from the Arsenal of Inspruck* [sic], 1808 (Musée du Château, Versailles), one of eighteen works commissioned in 1806 to celebrate Napoleon's German campaign. He was also one of the great decorators of the neoclassical period and provided the drawings (Louvre, Paris) for the bas-reliefs and statues of the Arc de triomphe du Carrousel, the monumental entry to the gardens of the Tuileries. During the Restoration, Meynier was in great demand as a ceiling painter, including several for the Louvre. He was also a considerable collector, mainly of prints, but he also owned paintings by Annibale Carracci, Van Dyck, Simon Vouet and Jacques-Louis David.[1]

This drawing,[2] probably dating from 1800–1, is a study for the painting of *Terpsichore*, the Muse of Dance, the sixth of a series of nine paintings of Apollo and the Muses commissioned around 1795 by the Bordeaux-born industrialist François-Bernard Boyer-Fonfrède (1767–1845) for a gallery in his hôtel in the former Benedictine priory in Toulouse, where he had also installed a cotton mill.[3] Meynier probably obtained the commission, the most important in his career to date, through his former master, Vincent, who in turn had been entrusted with another cycle for the building, which was to be devoted to patriotic and educational subjects. Sadly, no doubt due to Boyer-Fonfrède's apparent bankruptcy at the turn of the century, neither cycle was completed. Of Vincent's, only *Agriculture* (Musée des Beaux-Arts, Bordeaux), shown at the Salon, was realised, whereas Meynier finished five of his projected cycle of nine works: *Apollo Accompanied by Urania, Calliope, Clio, Polymnia* and *Erato* (all now Cleveland Museum of Art),[4] of which the first three were shown at the 1798 Salon, the fourth and fifth at the 1808 Salon and the fifth again at the 1801 Salon. Fortunately, we can be fairly certain of the intended appearance of the installation of the cycle thanks to a surviving watercolour of the projected scheme by the architect Charles Norry (1757–1832),[5] from which

it can be seen that the canvas with Apollo and Urania was centred on an end wall, with four Muses ranged on each of the flanking side walls. According to Norry's projection, Terpsichore was placed furthest from Apollo on the right side (fig.41.1). However, that painting was never undertaken, but a preparatory oil sketch (Musée Magnin, Dijon)[6] and this drawing do survive. Norry probably had the oil sketch to hand when he painted the complete view of the gallery for it agrees in all details with the composition shown in his watercolour. This drawing, however, exhibits significant differences: in the drawing the nymph holds a tambourine in her left hand which is replaced by a lyre in the oil sketch, her hair is shorter in the drawing and in the oil sketch her shawl is simplified. There are differences, too, in the landscape backgrounds and in the placing of the stone plinth. The dimensions of the Edinburgh drawing are similar to those for Calliope and Clio.[7]

D 5419

Pen and ink, brown wash heightened in white with chalk underdrawing · 38.2 × 24.6

PROVENANCE
Private Collection, Paris; Hôtel Drouot, Paris, 13 November 1985 (76); Zangrilli and Brady, New York in 1986; Galerie Cailleux, Paris; from whom purchased 1996.

EXHIBITED
*French and English Drawings*, Zangrilli and Brady, New York, 1986 (18).

NOTES
1. For Meynier's biography and a catalogue raisonné of his work see I. Mayer-Michalon's recently published, *Charles Meynier 1763–1832*, Paris, 2008.
2. Mayer-Michalon 2008, no.D42.
3. On the commission, see Mayer-Michalon 2008, pp.30–8.
4. Mayer-Michalon 2008, pp.29, 31–3, 35.
5. Pen and watercolour: 42 × 54.4, on deposit in the Musée Paul Dupuy, Toulouse from the Musée du Vieux Toulouse. Illus. Mayer-Michalon, p.27, fig.2.
6. Oil on canvas: 38 × 25, Mayer-Michalon 2008, p.36.
7. Mayer-Michalon 2008, nos D37, D38.

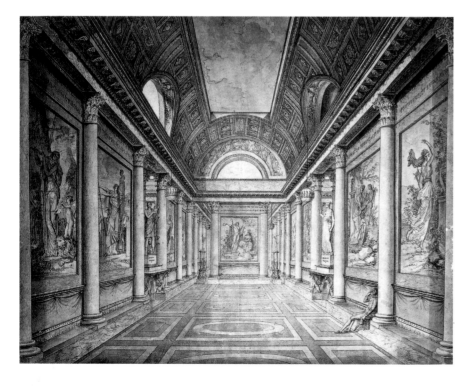

Fig. 41.1 Charles Norry, *Project for the Boyer-Fonfrède gallery*, Musée du Vieux Toulouse

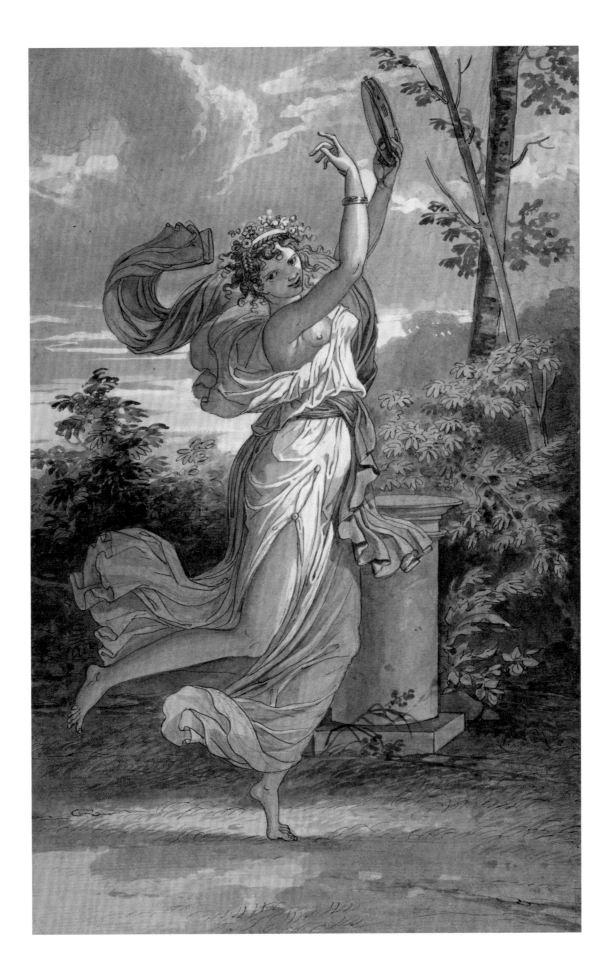

# Jean-François Millet
## *A Shepherdess*

GRUCHY, NEAR CHERBOURG
1814–1875 BARBIZON

Millet was the son of prosperous peasants, and after professional training in Cherbourg he was awarded a fellowship by the city and travelled to Paris in 1837 where he studied briefly with Paul Delaroche. He first exhibited at the Salon in 1840. He enjoyed success in the Revolutionary year of 1848 with his *Winnower* (later destroyed), purchased by the Republican minister Ledru-Rollin. The money earned from *Haymakers Resting* (Louvre, Paris) of 1848–9 enabled Millet to move to Barbizon, a village on the edge of the Forest of Fontainebleau to the south-east of Paris. By 1850 Millet had forged a close and enduring friendship with Théodore Rousseau. The two artists were closely associated with Barbizon for the rest of their careers and were the major figures in what would later be known as the 'Barbizon School', a loose grouping of artists which included Charles Jacque and Constant Troyon. Their subject matter embraced primarily rural and forest landscape and, particularly in Millet's case, the life and labours of the peasantry which he controversially elevated to heroic status in such celebrated compositions as *The Gleaners* 1857 and *The Angelus* 1855–7 (both Musée d'Orsay, Paris). He was awarded the Légion d'honneur in 1868.

This spirited preparatory drawing is one of two associated with the composition *A Shepherdess Knitting*, an oil of 1856, known in two versions. The first of the paintings was acquired from Millet by the American painter Edward Wheelwright, then living in Barbizon, and was later given to the Museum of Fine Arts, Boston, sold by them in 1939 and donated to the Cincinnati Art Museum in 1940.[1] The second was painted for Millet's friend, and pupil of Rousseau, the painter Charles Tillot and was donated to the Metropolitan Museum of Art, New York in 1984 (fig.42.1). Wheelwright, in his 1876 recollections of Millet published the year after the artist's death,[2] gives a detailed account of the progress of the two versions, which Millet considered of equal quality and of which he apparently offered Wheelwright first choice. The second related drawing was sold from the collection of Lord Clark in 1984. It is much more finished and its dimensions are almost identical to those of the painted versions.[3] Millet also made an etching of a similar subject, *La grande Bergère*,[4] in 1862, the preparatory drawing for which is now in the Museum of Fine Arts, Boston.[5]

D 3729
Black chalk with touches of blue chalk on pale buff paper
22.8 × 15.1
Signed, lower left: *J.F.M*
Millet sale stamp (L 1460), verso

PROVENANCE
Millet sale; A.E. Anderson,[6] by whom presented to the Gallery 1929.

EXHIBITED
*Drawings by Jean-François Millet*, London / Aldeburgh / Cardiff, 1956 (31); London, 1966 (82); *The Peasant in French 19th Century Art*, Douglas Hyde Gallery, Dublin, 1980 (57).

NOTES
1. Oil on canvas: 35.5 × 28, *Jean-François Millet*, exh.cat. Paris / London, 1975–6 (57).
2. E. Wheelwright, 'Personal recollections of Jean-François Millet', *Atlantic Monthly*, vol.38, September, 1876, pp.257–76.
3. Charcoal heightened with white chalk: 37.5 × 28, Sotheby's, London, 27 June 1984 (24).
4. Etching: 31.7 × 23.6, Lois Delteil, *Le peintre-graveur illustré*, Paris, 1906, I, Millet no.18.
5. Black conté crayon: 31.4 × 24.2. A. R. Murphy, *Jean-François Millet*, exh.cat., Museum of Fine Arts, Boston, 1984 (92).
6. On whom see M.Clarke, 'A.E.Anderson' in R.Thomson, *French 19th Century Drawings in the Whitworth Art Gallery*, Manchester, 1981, pp.2–3.

Fig.42.1 Jean-François Millet, *A Shepherdess Knitting*, The Metropolitan Museum of Art, New York

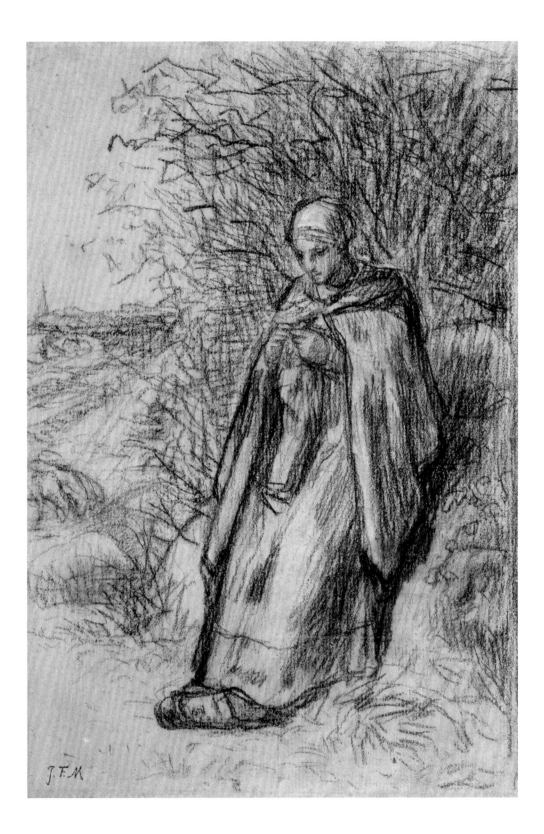

# Pierre-Antoine Patel (Patel the Younger)
## *January* and *August*

PARIS 1648–1707 PARIS

Relatively little is known of Patel's life and his surviving œuvre is not large.[1] He probably trained with his father the landscape painter Pierre Patel (1605–1676), whose distinguished career included the production of decorative paintings and designs for the Gobelins. Both father and son were independent of the French Academy, and in 1677, Pierre-Antoine was admitted to the Academy of Saint-Luc. His first known painting is the *Landscape with a Mounted Falconer* of 1673 (formerly in the Jacques Petitthory collection, now Musée Bonnat, Bayonne). In 1699 he was commissioned, probably as a result of his being recognised as a specialist in such subjects, to paint a series of twelve landscapes representing the months for the headquarters of the Jesuit order in Paris on the rue Saint-Antoine now known as Saint Paul-Saint Louis. These were confiscated during the French Revolution and dispersed (nine have since been identified including *January* in the Louvre, Paris; *October* in the Fine Arts Museum, San Francisco; and *December* in the Staatliches Museum, Schwerin). Patel's earlier works are often indistinguishable in manner from those of his father, though his later work became freer and more vigorous. He may have collaborated with his father on a group of landscape paintings intended to decorate the apartments of Anne of Austria in the Louvre. Patel *fils* was apparently killed in a duel in 1707.

Unlike his father, who does not appear to have worked extensively in gouache, Patel executed around eighty of these small, highly finished landscapes, doubtless intended for sale to collectors to adorn their cabinets.[2] All are roughly the same size and mostly date from the early 1690s. In style and context, they represent a combination of sixteenth-century fantastical Flemish landscape, Dutch seventeenth-century snow and winter scenes, and seventeenth-century classicism. As Coural has demonstrated, these two drawings can be identified as illustrating the months of *August* (D 5081)[3] and *January* (D 5082)[4] respectively, on account of the zodiacal signs they display. In *January*, on a snow-covered rock in the foreground, there is visible the sign of Aquarius, the water carrier, while in *August*, on the base of the ruined building to the left, is the sign of the lion. The human activities depicted in both gouaches also match those of the times of year: in January the open ruin has been transformed into a temporary dwelling with the two men on the right warming themselves by a fire, while in *August* two men mow a cornfield. Other gouaches identified by Coural as of similar dimensions and bearing zodiacal signs which enable them to be identified with specific months of the year are *March* (Christie's, New York, 1994)[5] and *December* (Art Museum, Princeton).[6] Patel also painted series of months in oils.

JANUARY · D 5082
Gouache on vellum · 16.1 × 27.4

AUGUST · D 5081
Gouache on vellum · 16.4 × 27.4
Both signed and dated: A P PATEL / 1693 (D 5081 lower left. D 5082 lower right).

PROVENANCE
Trafalgar Galleries, London, since at least 1968; from whom purchased 1979.

EXHIBITED
*Trafalgar Galleries at the Grand Palais*, Grand Palais, Paris, 1978 (14, 15). *Trafalgar Galleries at the Royal Academy II*, Royal Academy, London, 1979 (14, 15): Edinburgh, 1984 (4, 5); Edinburgh / New York / Houston 1999–2001 (42, 43).

NOTES
1. The most complete account can be found in N. Coural *Les Patel. Paysagistes du XVIIe siècle*, Paris, 2001, pp.115–30 and pp.205–340.
2. Coural 2001, nos PAP123–201.
3. *Ibid.*, no. PAP 168.
4. *Ibid.*, no. PAP 166.
5. *Ibid.*, no. PAP 167.
6. *Ibid.*, no. PAP 168.

# Attributed to Gabriel Pérelle
## *The Church of the Feuillants, Paris*

VERNON-SUR-SEINE *c*.1607–
1677 PARIS

It is difficult to distinguish between the various members of the Pérelle family who ran a very successful and productive print business in Paris during the seventeenth century: the father Gabriel, and his two sons, Nicolas (1631–1695) and Adam (1640–1695).[1] Nicolas, who is described as a painter in the contemporary documents, was less important than his father and brother who between them produced around 1,300 landscape engravings, which were republished without interruption until the end of the eighteenth century. Their topographical views of Paris and Rome are of the greatest historical interest and they also produced pure landscapes. Gabriel studied under Daniel Rabel and Simon Vouet and at the end of his career was appointed *directeur des plans et des cartes du cabinet du Roi*. The majority of his works are contained in two collections: *Délices de Paris et de ses environs* and *Délices de Versailles et de ses maisons royales*.

The influence of Callot is very apparent in this drawing, which was possibly done for the purpose of engraving and dates from around 1650–60. The church, attached to the monastery of the Feuillants (a Cistercian order) in rue Saint-Honoré, was designed by René Collin about 1601, and the main structure finished by 1608. The façade, by François Mansart, was built in 1623–4.[2] Bernini worshipped in the Feuillants when in Paris for the abortive Louvre project. The church was demolished in 1804.

D 5021

Pen and brown ink · 18.5 × 23.4

J. Beitscher collection mark (L 1409c) verso, lower right

PROVENANCE

J. Beitscher; Baskett & Day, London; from whom purchased in 1976.

EXHIBITED

Washington / Fort Worth 1990–1 (73).

NOTES

1. M. Roethlisberger ,'The Pérelles',*Master Drawings*, 5, 1967, pp.283–7; N. Avel, 'Les Pérelle graveurs de paysage du XVIIe siècle', *Bulletin de la Societé de l'Histoire de l'Art Français*, 1972, pp.145–153.
2. A. Braham and P. Smith, *François Mansart*, 2 vols, London, 1973, vol.I, pp.15–16, 191–2.

# 45 Antoine Pesne
## *Samson and Delilah*

PARIS 1683–1758 BERLIN

Born into a family of artists, Pesne trained in the workshop of his great uncle Charles de Lafosse. He won the Prix de Rome in 1703, and in 1705 set out for a prolonged stay in Italy. He spent most of his sojourn in Venice rather than in Rome – a choice which reflected the growing interest of French artists in Venetian (and Flemish) painters. In Venice Pesne's style was shaped by Andrea Celesti and by Jean Raoux. In 1711 Pesne was appointed court painter in Berlin to the Prussian King Frederick I who in 1696 had founded the Academy there. Pesne served under three consecutive Prussian Kings: Frederick I, Frederick William I, and Frederick II. Throughout his life, he stayed in touch with the Parisian art world and his friends in France. On 27 July 1720 he became a member of the Academy in Paris but only took his oath and attended his first Academy meetings on his way to London in 1723. The situation for artists in Prussia was difficult under Frederick William I (reigned 1713–40), and Pesne tried actively to obtain a position elsewhere (Dresden and London). His situation improved in 1736 when the young Crown Prince Frederick began to commission ceilings and easel paintings for his country house in Rheinsberg from him. Between Frederick's ascension to the throne in 1740 and the artist's death in 1757, Pesne enjoyed great success with numerous important royal commissions and an enormous production of portraits. Pesne is today regarded as a major figure in the history of painting in Berlin.

This drawing, dating from around 1719–20, is an unpublished compositional study for Pesne's reception piece for the Paris Academy.[1] The subject is from the Old Testament (Judges 14–16): Samson, the warrior hero of the Israelites in their battles against the Philistines, has been betrayed by his lover Delilah, who has cut off his hair, the source of his strength, while he slept.

The subject for the reception piece was chosen, as was customary, by the director of the Academy, at that time Antoine Coypel.[2] Pesne's first version is represented in a painting now in the Gemäldegalerie, Berlin (fig.45.1).[3] Probably in 1719 Pesne wrote to his friend Vleughels, then sharing a house in Paris with the painter Antoine Watteau, enclosing a drawing, now in the Louvre,[4] recording this composition. In his letter he asked Vleughels for his comments and to show the drawing to Watteau. The Edinburgh drawing probably represents Pesne's first reaction to Vleughels's untraced reply. This was followed by an oil sketch now in Rouen,[5] in which Delilah's right hand is no longer at her lips but outstretched. In the final painted version, a picture now in Carcassonne,[6] the composition has been simplified, perhaps reflecting Vleughels's suggestions. It was this second painting that was accepted as Pesne's reception piece.

Fig.45.1 Antoine Pesne, *Samson and Delilah*, Gemäldegalerie, Berlin

D 3264
Brown ink and wash, red chalk on blue paper · 32 × 43.5

PROVENANCE
William Findlay Watson, Edinburgh; by whom bequeathed to the Gallery 1881.

NOTES
1. The atttribution to Pesne was first suggested by Pierre Rosenberg (in pencil on the mount).
2. A. de Montaiglon, *Procès-verbaux de l'Académie Royale de peinture et de sculpture 1648–1793*, vol.IV, Paris, 1881, p.274.
3. Oil on canvas: 100 × 133.
4. Brown ink and wash, red chalk: 17 × 22.6.
5. Oil on canvas: 24.5 × 31, Musée des Beaux-Arts, Rouen.
6. Oil on canvas: 96 × 130, Musée des Beaux-Arts, Carcassonne.

# Jean-Baptiste Pillement
## *Chinoiserie Design with Two Figures on a See-saw*

LYONS 1728–1808 LYONS

One of the most widely travelled artists in eighteenth-century Europe, Pillement worked briefly as a designer at the Gobelins tapestry manufactory before leaving for Spain in 1745, aged seventeen. In the course of his career he would also visit Lisbon, London, Milan, Rome, Turin, Vienna, and Warsaw. It was in England in the 1750s that some of his ornamental designs were first engraved and published, and where he established himself as a fashionable decorative painter whose subject matter included pastoral scenes, seascapes and picturesque views. During the 1760s he received prestigious commissions from the Empress Maria Theresa and the Prince of Liechtenstein in Vienna and in Poland from King Staniska August Poniatowski. For much of the 1780s he worked in Portugal, where he established a school of drawing. His last years were spent back in his native Lyons (the heart of the eighteenth-century silk industry), where he was employed at the Manufacture de Soie et des Indiennes and gave lessons in decoration and design.

As an ornamental designer of chinoiseries, flower paintings and arabesques, Pillement created a repertory of designs that proved especially popular with tapestry weavers, furniture makers, fabric designers and porcelain manufacturers. More than fifty collections of his chinoiserie designs were published as engravings in England and France, and were widely disseminated throughout Europe.

This drawing is both signed and dated by Pillement, a practice to which he adhered from 1767 onwards. It relates to a series of chinoiserie designs of oriental figures perched on see-saws, published in Paris in 1773 as a set of six engravings entitled *Cahier de Balançoires Chinoises* published by Dalmon.[1] This drawing would appear to be a preparatory for plate two in the series.[2] Two other drawings for this set, for the title-page and plate four, are now at Waddesdon Manor, Aylesbury. The designs were reversed in the resulting prints.[3] An unsigned, and possibly reworked black chalk counter-proof of this drawing was at one time in the collection of the art historian and Daumier scholar K.E. Maison.

D 5539
Black chalk with some stumping · 32.3 × 21.4
Signed and dated, lower centre: *Jean Pillement / 1770*; traces of an erased signature and date, lower right.

PROVENANCE
Colnaghi, London; from whom purchased 2001.

EXHIBITED
*Old Master and 19th Century Drawings*, Colnaghi, London, 2001–2 (30).

NOTES
1. Engraved by Jean-Jacques Avril (1744–1831), illus. fig.197 in M. Gordon-Smith, *Pillement*, Cracow, 2006, the most recent study of the artist.
2. A complete, unbound set is in the Edmond de Rothschild Collection, Dépt des Arts Graphiques, Louvre, Paris, inv.nos 29.958–63 LR and the corresponding print to our drawing is second in the sequence. The title page is inscribed: *Cahier de Balançoires Chinoises / Inventés et Dessinés par J. Pillement / Premier Peintre du Roy de Pologne / Gravé par J.J. Avril / a Paris/ Chez Dalmon rue Fromenteau en face due Louvre* [nd].
3. A. Laing, *Drawings for Architecture Design and Ornament: The James A. de Rothschild Bequest at Waddesdon Manor, The National Trust*, Aylesbury, 2006, vol.I, pp.399–401, nos 280a and c, illus., each black chalk and stumping, laid down on mounts by François Renaud (L 1042). They are very slightly smaller than the Edinburgh drawing: 280a, 30 × 21.2; 280c, 31.3 × 20.3, but both have been slightly trimmed.

Jean Pillement
1770

# Isidore Alexandre Augustin Pils
## *Studies of Mohamed ben Su ...*

1813 PARIS–DOUARNENEZ 1875

After a brief period of study in the studio of Guillaume-Guillon Lethière, Pils enrolled in the studio of Picot. In 1838 he won the Prix de Rome and was in Italy until 1844. He exhibited at the Salon 1846–75 and his early submissions were of religious subjects, but after the Crimean War he specialised in military subjects. At the height of his fame he was made a professor at the Ecole des Beaux-Arts in 1864 and received the Légion d'honneur in 1867. His last commission was for the decoration of the ceiling of the main staircase at the Paris Opéra.

The visit of Napoleon III and the Empress Eugénie to Algeria took place in September 1860. In May 1861, Pils was commissioned to produce a commemorative painting of the voyage, *The Reception of the Arab Chieftains*, for the Musée du Château, Versailles. He left immediately for Algeria, where he remained until the end of 1862 staying at Fort Napoléon, built after the conquest of Kabylia in 1859. This sketch is one of the hundreds of preparatory drawings and sketches made during that visit. More specifically it can be identified as portraying a particular model on the basis of a comparison with the left-hand head in a painting *Two Studies of Kabyles*[1] (fig.47.1)[2] which bears an inscription on the lower right: *Mohamed ben Su ...* (illegible). This same model is also the subject of a portrait oil sketch in the Musée d'Art et d'Histoire, Narbonne.[3] From the evidence of a compositional sketch for the painting of *The Reception*,[4] Pils used the figure of Mohamed in a kneeling position as a link between the imperial couple and the Arab chiefs on the one side, and on the other the assembled crowd of mothers and children.

The fate of the final commemorative painting, which received a mixed reception at the Exposition universelle of 1867, is uncertain. According to some sources it was destroyed in the Tuileries fire of 1871, according to others it was recovered by Pils so that he could complete it.[5] The studies, however, were widely admired, for example by Bouguereau, who wrote of 'these physiognomies of Kabyles [which are] so fine, so intelligent, so expressive'.[6]

Fig.47.1 Isidore Pils, *Two Studies of Kabyles*, ex-Talabardon et Gautier, Paris

D 5577
Pencil, gouache and white chalk on brown paper · 31.4 × 47.6
Signed, dated and inscribed, lower left: *Fort Napoleon 2 De 1861. I Pils* . Inscribed lower centre: *Mohamed n ait âzzong(?) / de (?) n (?) (la fontaine des figures) / Zoua??a)*.
Pils atelier stamp (not in L) verso, lower left

PROVENANCE
David Daniels, his sale Sotheby's, New York, 29 October 2002 (26); Didier Aaron, New York; from whom purchased 2004.

NOTES
1. Inhabitants of Kabylia, a region in the north of Algeria.
2. Oil on canvas: 63.5 × 80.2, Talabardon et Gautier, *Le XIXe siècle*, Paris, 2004 (18).
3. Oil on canvas: 29 × 25.
4. Talabardon et Gautier, fig.3, *Fete given for their majesties the Emperor and Empress at Alger* 18 September 1860, collection of Kenneth Jay Lane, New York.
5. C. Bigot, *Peintres Français Contemporains*, Paris, 1888, p.145, states it was never finished.
6. W.Bouguereau, *Notice sur M.Pils*, Paris, 1887, p.9.

Mohammed *ait aggong*
*su lala n tazart (la fontaine du figuier)*
*(Zouaoua)*

Fort Napoléon 8 D.e 1861. *[signature]*

# Camille Pissarro
## *Figures at the Banks of the Marne, near Chennevières*

ST THOMAS, VIRGIN ISLANDS 1830–
1903 PARIS

Born of Jewish parents, Pissarro was perhaps the most left-wing of the Impressionists and in the 1880s adopted libertarian anarchist ideas. Although sent to a boarding school in Passy, he returned to the Virgin Islands and there entered the family business. He abandoned this for a career in art and moved to Paris in 1855. Encouraged to paint outdoors by Corot, his early range of acquaintances included Gustave Courbet and the anarchist philosopher Pierre-Joseph Proudhon. Pissarro first exhibited at the Salon in 1864, a practice he ceased after 1870. He was the only artist to participate in all eight Impressionist group shows between 1874 and 1886. In 1866 he settled his family at L'Hermitage, just north of Pontoise. Two years later, they moved to Louveciennes and then to London to escape the Franco-Prussian War (1870–1). On their return to France they re-established themselves at Pontoise. Their final move took place in 1886 when they settled in Eragny-sur-Epte, near Gisors, where they remained until Pissarro's death. In the 1880s he was strongly influenced by the dotted technique of the neo-Impressionists, though his late work witnessed a return to a more conventional Impressionist brushstroke.

From 1863 to 1865 Pissarro rented properties at La Varenne-Saint-Maur which is situated to the south-east of Paris on the river Marne, opposite Chennevières. At this point the river flows in a great loop beyond the Bois de Vincennes before it joins the river Seine. This is a highly-finished study loosely related to the right foreground area of the large picture which Pissarro exhibited at the 1865 Salon (1723) as *Chennevières au bord de la Marne* (fig.48.1).[1] The terrain depicted in the drawing is based on the right side of the Marne with the riverbank sloping sharply upwards. In the painting this area is obscured by rushes and islets situated further out in the river. It should also be noted that the exact topography of this part of the river has changed considerably since Pissarro's day on account of the actions of the river current. There is a more cursory drawing of the same view in the Ashmolean Museum, Oxford (fig.48.2).[2] Executed in pen and dark ink over black chalk with grey wash, and with no staffage, its relationship is much closer to the Edinburgh drawing than to the painting. Indeed, the status of the substantial Edinburgh drawing, given its high degree of finish and the Corot-like figure group in mid-distance, is more probably that of a fully independent composition than a preparatory study for the painting. No compositional *ébauche* for the picture survives, but a small oil sketch *Barges on the Seine* (Musée Camille Pissarro, Pontoise) of around 1863 depicts a fairly similar view, albeit from the left riverbank rather than from mid-stream as is probably the case in the Edinburgh picture. Many of Pissarro's works from this period may have been

lost due to the ransacking of his studio by Prussian soldiers during the Franco-Prussian War. Those that survive are described in the revised catalogue raisonné of his work which includes a particularly fine oil study *Strollers on a Country Road, La Varenne Saint-Hilaire* (Baltimore Museum of Art) of 1864, unknown to the compilers (Pissarro and Venturi) of the original 1939 edition and purchased by the Baltimore Museum in 1996.[3]

D 5621
Charcoal heightened with white chalk on grey paper
31 × 49
Initialled, lower right: *C. P*
Traces in outline of another drawing of a similar scene on the verso

PROVENANCE
Jill Newhouse, New York; from whom purchased 2008.

NOTES
1. J. Pissarro and C. Durand-Ruel Snollaerts, *Pissarro. Critical Catalogue of Paintings*, Paris, 2005, vol.II, no.103, illus.
2. Pen and ink over black chalk with grey wash on grey paper with a pink hue: 30.7 × 47.3. R. Brettell and C. Lloyd, *Catalogue of Drawings by Camille Pissarro in the Ashmolean Museum, Oxford*, Oxford, 1980, no.64 (recto), p.114, illus.
3. Pissarro and Durand-Ruel Snollaerts 2005, no.92.

Fig.48.1 Camille Pissarro, *The Marne at Chennevières*, National Gallery of Scotland, Edinburgh

Fig.48.2 Camille Pissarro, *Study of a River Landscape with Boats*, Ashmolean Museum, University of Oxford

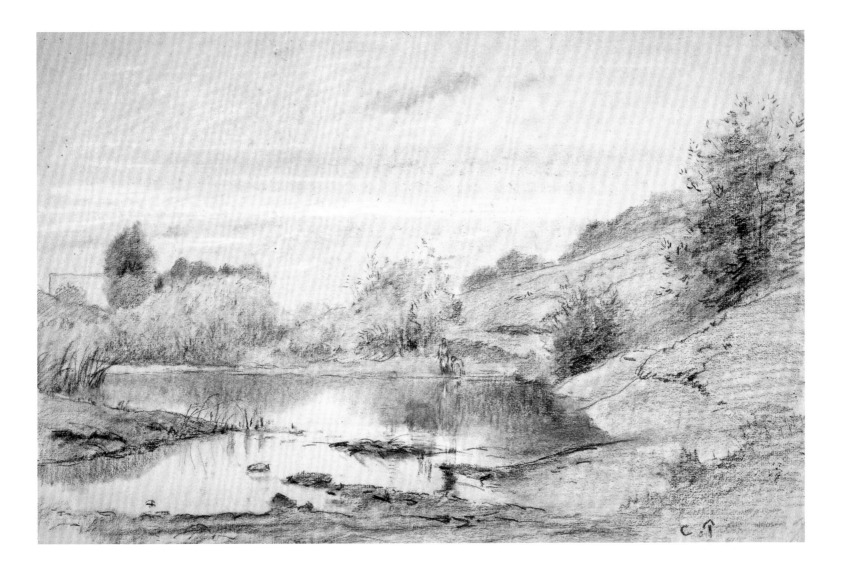

# Nicolas Poussin
*A Dance to the Music of Time*

LES ANDELYS 1594–1665 ROME

Poussin was widely admired for the intellectual rigour and enquiry which he brought to the process of picture making and has been acknowledged as the founder of the classical tradition in French art. After training in Rouen he went to Paris and worked briefly under Ferdinand Elle and Georges Lallemant. In 1624, after a stay in Venice, he arrived in Rome, which would remain his base for the rest of his career except for an unsuccessful return to Paris in 1640–2 at the behest of Louis XIII. His first major commission was from Cardinal Francesco Barberini in 1627 for the *Death of Germanicus* (Minneapolis Institute of Arts). From about 1630 he became involved in the intellectual circle round Barberini's secretary Cassiano dal Pozzo. Amongst his commissions for Dal Pozzo were the first set of the *Seven Sacraments*, 1636–42 ( five of which belong to the Duke of Rutland, Belvoir Castle, currently on loan to the National Gallery, London, and one to the National Gallery of Art, Washington). A second set was painted in 1644–8 for Paul Fréart de Chantelou, a civil servant in Paris, and is now on loan to the National Gallery of Scotland, Edinburgh from the Bridgewater Collection.

This is a fully worked up preparatory compositional study[1] for the painting in the Wallace Collection, London (fig.49.1)[2] of the same subject commissioned by Cardinal Giulio Rospigliosi, the future Pope Clement IX. Rospigliosi, who was greatly interested in allegory, probably dictated the subject. The dancing group represents the perpetual cycle of the human condition: from Poverty, Labour leads to Riches and thus Pleasure which, indulged to excess, reverts to Poverty. The dance is accompanied on the lyre by the figure of Saturn or Time. The bubbles and hourglass symbolise the brevity of life, while the two-headed Janus term on the left, looking backward and forward, refers to the passage of time. In the sky Apollo holds the ring of the Zodiac and his chariot is preceded by the figure of Aurora (Dawn); the dancing figures represent eight of the Hours.

The painting dates from around 1634–6. It differs from the drawing primarily in the scale of the figures in relation to the whole composition. More specifically, the palm tree has been left out, the clouds are less dramatic and the buildings in the distant landscape have been omitted.

D 5127

Pen and brown ink and wash · 14.8 × 19.8
Collection mark of P.J. Mariette (L 1852), lower left

PROVENANCE
Jacques Stella?; his niece, Claudine Bouzonnet-Stella, part of no.3 in her 1693 inventory 'Des Femmes qui dansent';[3] Pierre Crozat;[4] his sale, Paris, 10 April-13 May 1741 (967 part of); Pierre Jean Mariette; his sale, Paris, 15 November 1775–30 January 1776 (1325),[5] bt Boileau (drawn by Gabriel de Saint-Aubin in his example of the Mariette sale catalogue now in the Museum of Fine Arts, Boston); Prince de Conti; his sale 8 April 1777, Paris (1182), bt Desmarets; Abbé de Calonne (according to an inscription on verso of mount);[6] John Knight, his sale, 19 July 1841, Phillips, London (438) bt Stewart; Samuel Jones Loyd, Lord Overstone; by descent to Christopher L. Loyd, Lockinge House, Berks; purchased through Thomas Agnew, with the assistance of funds from The Art Fund, the Pilgrim Trust, the Edith M. Ferguson Bequest, and two private donations, 1984.

EXHIBITED
*Nicolas Poussin*, Louvre, Paris 1960 (159); *L'Ideale classico del Seicento in Italia e la pittura di paesaggio*, Palazzo dell'Archiginnasio, Bologna, 1962 (86); Washington / Fort Worth 1990–1 (68); Edinburgh 1991 (74); Edinburgh / London 1994 (18); Edinburgh / London 2003–4, p.26.

NOTES
1. P. Rosenberg and L.A. Prat, *Nicolas Poussin 1594–1665 catalogue raisonné des dessins*, Milan, 1994, vol.I, no.144.
2. Oil on canvas 82.5 × 104. A. Blunt, *The Paintings of Nicolas Poussin. A Critical Catalogue*, London, 1966, no.121, pp.81–2; J. Ingamells, *The Wallace Collection, Catalogue of Pictures*, vol. III, *French before 1815*, London, 1989, pp.307–13. For a more recent, and succinct, summary, see S. Duffy and J. Hedley, *The Wallace Collection's Pictures. A Complete Catalogue*, London, 2004, pp.334–5. The present title of the picture dates from 1913.
3. J. J. Guiffrey, 'Testament et inventaire des biens, tableaux, dessins etc ... de Claudine Bouzonnet-Stella, rédigés et écrits par elle-même, 1693–1697', *Nouvelles Archives de l'Art français*, 1877, pp.1–117, see p.49.
4. P.J. Mariette, *Description ... Du Cabinet de ... M. Crozat* [Paris, 1741], p.113, no. 967 'Sep. idem [Poussin] dont la Dance de la vie Humaine'
5. F. Basan, *Catalogue Raisonné du Cabinet de M. Mariette* [Paris, 1775], p.200 'L'Image de la vie humaine'.
6. Rosenberg and Prat suggest this may be identical with the drawing bought by the Abbé de Calonne at the Saint-Morys sale, 6 February 1786 (315). The subject corresponds, although the dimensions are larger, possibly indicating the drawing was measured in its frame.

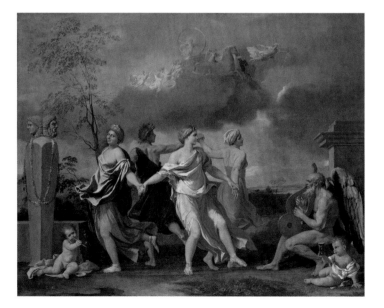

Fig.49.1 Nicolas Poussin, *A Dance to the Music of Time*, The Wallace Collection, London

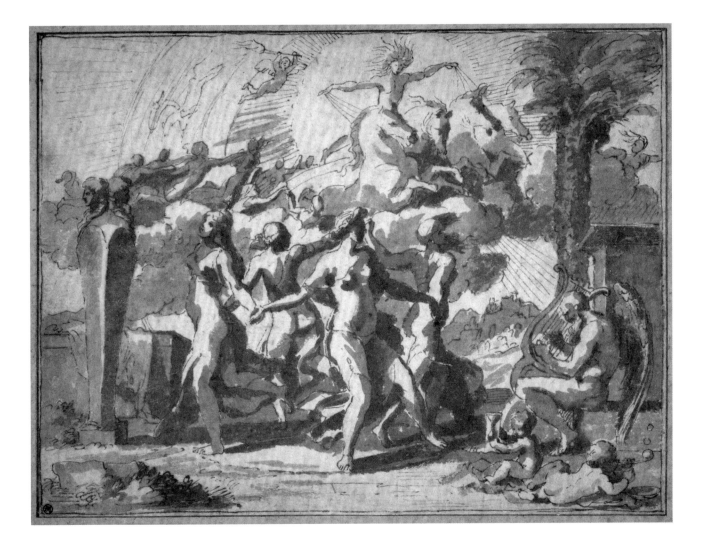

# Henri Alexandre Georges Regnault
## *Portrait of a Man in Spanish Costume*

PARIS 1843–1871 BUZENVAL

The son of the celebrated chemist, Victor Regnault, director of the Manufacture de Sèvres, Regnault studied with Lamothe and Cabanel before winning the Prix de Rome in 1866. In Italy he began several ambitious history paintings but was also permitted to travel to Spain on his Prix de Rome bursary. In Madrid he studied Velázquez and Goya in the Prado and in 1869 he completed the flamboyant portrait of the liberal revolutionary *General Juan Prim y Prats* (Musée d'Orsay, Paris), refused by the sitter but shown at the 1869 Salon. By 1870 he and his fellow artist Georges Clairin were established in Tangier where they constructed a house and studio for the execution of large pictures. Although exempt, Regnault volunteered for military service on the outbreak of the Franco-Prussian War and was killed shortly before the war ended in 1871. His immediate posthumous fame was great, with a memorial exhibition being held at the Ecole des Beaux-Arts in 1872, the erection by public subscription of a memorial bust by Chapu, and the publication of several commemorative monographs.[1]

After winning the Prix de Rome in 1866 with *Thetis Handing Vulcan's Arms to Achilles* (Ecole des Beaux-Arts, Paris) Regnault left for the Villa Medici in Rome the following year. He interrupted his Italian sojourn on numerous occasions for trips back to Paris and for many journeys to Spain, which he first visited in 1868, describing it as a 'new world'. Such was his enthusiasm that he learnt both the Spanish language and how to play the guitar. This vibrant watercolour possibly dates from this first visit. Although said to have been acquired by the dealer Brame in 1868 direct from the artist in Granada, there is no evidence to support this.[2] What is certain is that Regnault avidly drew both local scenery and costumes. On 8 January 1869 he wrote to his brother from Madrid:

*For several days we have been drawing studies in the studio of gitanos and gitanas, and if we had more time the whole of the gypsy tribe would pass through our hands … They all wanted to pose and quarrelled, each claiming to be more handsome than the others and wanting to be the first to be* retratar *(portrayed).*[3]

The fluid, rapid execution of this watercolour suggests it may have been executed in the street, rather than in the more formal confines of the studio.

D 5564
Watercolour · 45.7 × 35

PROVENANCE
Said to have been acquired from the artist by M.Brame *père*, in Granada 1868; Marmontel, Paris; M.A.Beurdeley, Paris; Galerie Georges Petit, Paris June 1920 (330); Jill Newhouse, New York; Bill Bloss; Emmanuel Moatti, Paris; from whom purchased 2004.

EXHIBITED
*Spain, Espagne, Spanien, Foreign Artists Discover Spain 1800–1900* The Equitable Gallery, New York, 1993.

NOTES
1. M. Gotlieb, 'Legends of the Painter Hero: Remembering Henri Regnault' *Nationalism and French Visual Culture, 1870–1914*, Studies in the History of Art, vol.68, Center for Advanced Study in the Visual Arts, Washington, 2005, pp.101–28.
2. Regnault was in Granada September-October 1869, but his main enthusiasm was reserved for the Alhambra.
3. H. Regnault, *Correspondance de Henri Regnault, recueillie et annotée par Arthur Duparc, suivie du catalogue complet de l'oeuvre de Henri Regnault*, Paris, 1872, p.232.

# Louis Roguin
## *Jewish Woman of Algiers*

ACTIVE 1843–1871

Apart from the works he exhibited at the 1848 Salon: *Jewish Women in an Interior; A Moorish Grocer's Shops*, little is known of Roguin's career.[1] The Salon *livret* gave his Parisian address as 'chez M.Mayer, 1, rue d'Enghien', but he mainly lived in Algeria. He was linked to Lizinka Guibal-Poirel, grand-daughter of the Nancy sculptor Barthélemy Guibal and wife of Victor Poirel, the chief engineer of the port of Algiers who, shortly after his appointment in 1832 to that post, had played host to Delacroix for several days. Mme Poirel, who had learnt Arabic, gathered round her a cultivated circle which included, among others, Théodore Leblanc, Captain of Engineers and a former artistic pupil of Charlet. Such a gathering would have provided a suitable cultural environment for Roguin.

In Algeria, Jewish women, with their costumes and their jewels, were the favoured models of Western artists, who were forbidden to meet Muslim women, still less to portray them. This highly distinctive drawing shows a young, pregnant Jewish woman who wears a *sarma* as her headdress: 'a metallic hairstyle in the shape of a *tulle à jours* placed horizontally on the head, decorated beforehand with a black scarf for Jewish women and a coloured one for Moorish women.'[2] Such tiaras were about sixty to eighty centimetres in length and were worn by married women. They could also, as here, be made of metal worked in filigree. The model in our drawing bears a look of resignation, doubtless caused by the weight of the *sarma* she is wearing. A contemporary account of the difficulties caused by the wearing of the *sarma* explained:

*It is a painful spectacle to behold these poor women obliged to lower their forehead, eyes fixed on the ground or raised with difficulty under the weight of what is loaded on their head; one cannot imagine the arkwardness of these long tubes which [ … ] force those who wear them to sit sideways on seats which run up against the wall.*[3]

Use of the *sarma* died out in Algeria and by the end of the nineteenth century it had become a collectors' item. It seems to have continued in Syria, however, where it was known as a *tantour*, and in Palestine where it was called a *chatweh*. The numbering of this drawing indicates it must have been intended for a series, perhaps a suite of studies of Algerian costume.

D 5614
Black and red chalk with white heightening · 58.3 × 41.5
Signed and dated lower right: *Roguin / 3 Janv. 43*
Inscription at lower left: *N° 6*

PROVENANCE
Galerie Laura Pecheur, Paris; Talabardon et Gautier, Paris; from whom purchased 2007.

EXHIBITED
*Le xixe siècle*, Talabardon et Gautier, Paris 2006 (16).

NOTES
1. E. Cazenave, *Les artistes de l'Algérie: Dictionnaire des peintres, sculpteurs, graveurs 1830–1962*, Maxéville, 2001, p.388, has an extremely short entry but does state he became a *membre correspondant* of the Société des Beaux-Arts d'Alger in 1871. She also notes the Bibliothèque municipale de Nancy has three works by him: *Rue de la Casbah; Café maure; Souvenir d'Alger*. A watercolour *Vue d'Alger* 32 × 46, signed and dated 13 August 1841, was sold at Drouot, Tajan, Paris, 18 May 2006 (166).
2. P. Eudel, *Dictionnaire des bijoux de l'Afrique du Nord, Maroc, Algérie, Tunisie, Tripolitaine*, Paris, 1906, pp.195–6. This and the following reference are taken from the informative entry in the Talabardon et Gautier catalogue.
3. H. Fisquet, *Histoire de l'Algérie, depuis les temps anciens jusqu'à nos jours*, Paris, 1942, pp.320–3.

N° 6

Beguin
4 Janv. 63

# 52      Gabriel de Saint-Aubin
## *Garden Fête at Saint-Cloud*

PARIS 1724–1780 PARIS

Best known as a draughtsman and etcher, Gabriel was a passionate and often unconventional observer of the city of Paris in the Age of Enlightenment. Amongst his many thousands of drawings – his contemporary Greuze remarked he 'had a priapic urge to draw' – should be noted his illustrated sale catalogues and his *livrets* of the Paris Salons which provide fascinating records of the hang of the exhibits and much valuable visual evidence on the individual works. He studied with the painters Etienne Jeaurat and Hyacinthe Collin de Vermont but failed three times to win the Prix de Rome, eventually breaking with the Académie Royale and preferring the Académie de St Luc. Something of the special character of Gabriel's work is captured in his elder brother Charles-Germain's recollection of him: 'Gabriel-Jacques de Saint-Aubin, born April 14, 1724, was a painter. Full of erudition, he failed to fulfil his talent, although he drew all the time and everywhere. Eccentric, unsociable and untidy, it was fortunate that he remained a bachelor.'[1] Posterity has rightly valued him highly and it would be hard to disagree with Pierre Rosenberg's recent estimation of his worth: 'He was an eccentric and especially inquisitive onlooker. But above all, he was the most endearing bystander in the history of art.'[2]

From around 1760 Gabriel exercised an increasing fascination with the fêtes galantes of Watteau and his followers (such as J.-B. Pater) from earlier in the century. Here he has set his fine ladies and gentlemen in front of the famous Grande Cascade in the Parc of Saint-Cloud, seven miles west of Paris. The cascade was constructed 1667–97, begun by Antoine Le Pautre (1621–1679) and completed by Jules Hardouin-Mansart (1646–1708). Lambert-Sigisbert Adam's sculpture of the union of the rivers Seine and Marne, installed in 1734, is visible at the top of the cascade. Gabriel's topographical observation is further borne out by his accurate depiction of the nine steps of the cascade. The September feast day of the Blessed Virgin brought many Parisians to the Château, primarily to watch the fountains in full operation. As Kim de Beaumont has pointed out in the excellent catalogue entry for this drawing in the New York / Paris exhibition catalogue,[3] there was a growing fashion for open-air *bals champêtres* held in the parks bordering Paris. Elegant society, so dramatically portrayed in the figures in the foreground of Gabriel's drawing, would mix with the poor – here illustrated by the figure of the walking vendor. A slightly later drawing (*c.*1765) by Gabriel of the Grande Cascade is in one of his sketchbooks – Groult album (fol.32 recto), Département des Arts Graphiques, Louvre, Paris.

D 2257
Pen and brown and black ink, brush, and brown and grey wash over black chalk · 21.3 × 30
Inscribed in graphite, lower right corner, in a later hand: *Pater*
Verso, a lightly sketched study of a dredger, inscribed by the artist: *machine a Tirer d'un (?) Sable*; and in a later hand: *Pater delin / French School.*

PROVENANCE
W.F. Watson, by whom bequeathed in 1881.

EXHIBITED
London, 1966 (68); *France in the Eighteenth Century*, Royal Academy, London, 1968 (635); Washington / Fort Worth 1990–1 (43); *Gabriel de Saint-Aubin 1724–1780*, New York / Paris, 2007–8 (40).

NOTES
1. E. Dacier, *Gabriel de Saint-Aubin, Peintre, dessinateur et graveur (1724–1780): L'Homme et l'oeuvre*, Paris and Brussels, 1929, p.14.
2. C.B. Bailey, K. de Beaumont *et al.*, *Gabriel de Saint-Aubin 1724–1780*, New York / Paris, 2007–8, p.17.
3. Bailey and de Beaumont 2007–8, pp.188–9.

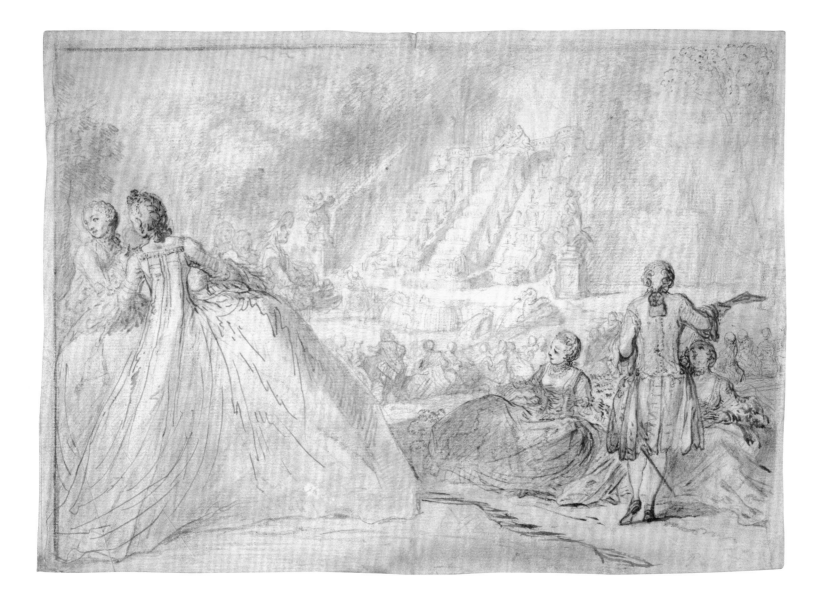

# George Sand
## *Landscape with Ruins and a Castle*

PARIS 1804–1876 NOHANT

George Sand was the pseudonym of Amandine Aurore Lucile Dudevant, née Dupin, the French Romantic writer noted for her rustic novels and numerous love affairs. She married Casimir Dudevant in 1822 but left him in 1831, adopting the nom de plume George Sand in 1832 for her authorship of the novel *Indiana*. Her more striking social habits included the wearing of men's clothing and smoking tobacco in public. Among her many lovers were Prosper de Mérimée, Alfred de Musset, Frédéric Chopin and Marie Dorval. She enjoyed a close friendship with Delacroix and knew many of the French painters of the Romantic generation.

George Sand recalled how, having left her husband, she wished to make her living from portrait drawings in chalk and watercolour, and also by producing small paintings to decorate snuff boxes, cigar cases and fans. She continued to paint and draw for her own pleasure, including small watercolour landscapes, both imaginary (as here) and from nature. According to her grand-daughter, Aurore Sand, she particularly concentrated on painting after she had retired to her property at Nohant. Her landscape watercolours, produced by a mixture of chance and intent, anticipate the frottages of the twentieth-century Surrealists such as Max Ernst.[1] She referred to them as her 'dendrites'[2] (literally 'branching, crystalline growths'), also known as *'l'aquarelle à l'écrasage'*,[3] and they were made in the following manner. A sheet of dampened Bristol board (used for visiting cards), flecked with gouache, was covered with a second sheet which, when it was pulled away, would reveal tree-like motifs comparable to the dendrites found in crystallography. The design produced by chance would then be worked up into a composition. Often produced with the aid of a collaborator, her first experiments date from the early 1860s, but she took up the technique again in 1870, working with her son Maurice, and gave it the aforesaid name in a letter of 1874. Henri Amic, writing in 1891, recalled her description of the process: 'You know how Maurice prepares these dendrites for me: he squeezes watercolours between two pieces of Bristol board. This squeezing produces veins, which are often curious. Giving rein to my imagination, I see woods, forests or lakes and I emphasize these vague forms produced by chance.'[4] In a famous passage in her autobiography, *Histoire de ma vie* (1855), Sand described her receptivity to suggested images and recalled her fascination as a child when, on winter evenings, her mother would read to her. She would be seated in front of the fire, but separated from it by an old screen lined with taffeta. As her mother read she would lose the thread of the story as she drifted into a reverie and images would appear on the screen: 'There were woods, meadows, rivers, towns with a strange and gigantic architecture, such as I often see in dreams … Finally, the whole fantastic world of my tales became tangible, self-evident, and I lost myself there with delight.'[5]

D 5500

Watercolour and gouache · 15.4 × 23.6

Signed and inscribed, lower left: *à A Proutet / George / Sand*

PROVENANCE

Harry Bailey, New York; John Richardson, New York; W.M. Brady, New York; from whom purchased 2000.

EXHIBITED

Edinburgh 2001 (31).

NOTES
1. For a broader survey of this subject, see S. Le Men, 'L'artiste et les hazards de la matière, de Cornelius à George Sand', *Revue de l'Art*, 137, 2002–3, pp.19–29.
2. N. Savy, 'La découverte des dendrites' in the exh.cat., *George Sand, une nature d'artiste: exposition du bicentenaire de sa naissance*, Musée de la Vie Romantique, Paris, 2004, pp.160–2.
3. Letter to Auguste Toulmouche, 5 December 1874, *Correspondance de George Sand*, Paris, 26 vols, 1964–95, vol.24, p.145.
4. H. Amic, *George Sand Mes souvenirs*, 1891.
5. G. Sand, *Histoire de ma vie*, 1855, deuxième partie, *Oeuvres complètes*, vol.41, Paris, 1879, pp.274–5.

# Ary Scheffer
## *The Retreat from Russia in 1812*

DORDRECHT 1795–
1858 ARGENTEUIL

The son of a German painter who had settled in Holland, Scheffer first enrolled at the Amsterdam Academy in 1806, but after his father's death in 1809 his mother sent him to Lille to improve his French. In 1811 he settled in Paris and entered Guérin's studio. He first exhibited at the Salon, aged seventeen, in 1812 and continued to exhibit there until 1846, submitting pictures with historical, literary or historical subject matter. He often represented themes taken from Romantic writers such as Goethe, Schiller and Byron. He was drawing master to the the duc d'Orléans (later Louis-Philippe), and after the 1830 Revolution supplied many works for Versailles. He enjoyed his greatest popularity from 1840 to 1858 and in his house in the rue Chaptal, Paris (now the Musée de la Vie Romantique) received many friends including Chopin, Gounod, Liszt and Rossini. His daughter donated many of his works to his native city of Dordrecht and they are now housed in the museum there.

This is a dramatic, unpublished, compositional study made in preparation for Scheffer's admired and controversial painting of 1826, *The Retreat from Russia*, now in a private collection and only rediscovered in 1997.[1] The use of brown wash is fully in accord with the contemporary practice of Romantic artists such as Gros, Delacroix and especially Géricault, but also harks back to the vigorous drawing style of Rubens. A drawing of similar style and type,[2] for the *Souliot Women* (Louvre, Paris), shown at the 1827 Salon, was, like the Edinburgh drawing, also formerly in the Coutan-Hauguet collection.[3] As Ewals has remarked, such drawings are rare in Scheffer's oeuvre and should not be regarded as *premières esquisses*, but rather as late stages in the compositional process, essentially concerned with the study of light and shade.[4] The final composition, as worked out in the painting, is more monumental and static than that in the drawing, with the figure of Marshal Ney having moved to the left of centre. Much closer to the final design is a signed watercolour, last recorded with Prouté in 1969.[5] Two closely related oil sketches are known, one for the entire composition,[6] and another for a group of four soldiers to the right of Ney: both are now in the Musée de la Vie Romantique, Paris. Scheffer's final design was reproduced in a lithograph by Garnier[7] and an engraving by Girardet.[8]

The subject of the French retreat from Moscow in the extraordinarily harsh winter of 1812 was treated many times by French artists, and Scheffer was particularly attracted by Napoleonic themes. The exact incident shown in the painting is the crossing of the river Dnieper. Ney had been placed in command of the third army corps acting as rear-guard to the retreat. When they reached the river they found the bridge destroyed and the river not fully frozen, making crossing impossible. By the time he rejoined the Grande Armée at Orcha, on the road to Minsk, Ney had lost 4,000 of his original complement of 7,000 men. In 1815, after Napoleon's final defeat at Waterloo, Ney, the 'bravest of the brave', was executed by firing squad.

Scheffer was on close terms with Ney's son, the duc d'Elchingen, and his sympathy for the subject of his painting is evident. Shortly after its completion he allowed it to be included in the exhibition at the Galerie Lebrun held in aid of the Greeks who had risen up against the Sultan,[9] and in 1832 it was included in an exhibition at the Galerie

Colbert in aid of the cholera epidemic then raging in Paris.[10] It was entirely typical of Scheffer that, with his liberal and Orléanist views, he should demonstrate his support for the suppressed and the stricken in this manner.

D 5581
Pencil, brown ink and wash · 19 × 25
Collection marks Pierre Olivier Dubaut (L 21036) and Coutan-Hauget, lower right and (L 464) verso

PROVENANCE
Coutan-Hauget:[11] Pierre Olivier Dubaut; Galerie Normand, Paris; from whom purchased 2005.

NOTES

1. The fundamental article on the painting and its related sketches is A. M. de Brem, 'La Retraite de Russie par Ary Scheffer', *Collections Parisiennes*, no.2, May 1998, pp.53–62. The painting of 1826 is oil on canvas: 129 × 164, signed lower right.
2. Pencil, brown ink and wash: 20.6 × 27.4, Dordrecht Museum. See the catalogue entry by L. Ewals, *Ary Scheffer 1795–1858. Dessins, aquarelles, esquisses à l'huile du Musée Scheffer à Dordrecht*, Institut Néerlandais, Paris, 1980 (52), illus.
3. On Coutan see note 9.
4. Ewals 1980, *ibid*.
5. Paul Prouté, Paris, catalogue 'Gavarni', 1969 (63) watercolour and gouache: 27.5 × 18.5, signed lower right. Repr. De Brem, p.55, fig.3.
6. Oil on canvas: 40.5 × 46. Dordrecht Museum, on deposit Musée de la Vie Romantique, Paris. De Brem, p.54, fig.2.
7. *Retraite de Russie*, signed and dated: *A.C.Garnier 1833*, published by Lemercier. De Brem, p.56, fig.4.
8. *Retraite de Russie pendant l'hiver de 1812*. Reproduced in the guide by Théodose Burette, *Musée de Versailles*, published by Furne et Cie, 1844. De Brem, p.56, fig.5. The picture was never at Versailles.
9. On this exhibition see the exh.cat., *La Grèce en révolte 1815–1848*, Musée Delacroix, Paris, 1996. Scheffer's painting was no.165 in the 1826 exhibition: *Explication des ouvrages de peinture exposés au profit des Grecs / Galerie Lebrun / rue du Gros-Chenet, no. 4 / le 17 mai 1826 / Prix I franc*, Firmin-Didot, Paris, 1826. The exhibition was reviewed in *Le Globe*, 2 September 1826, where Vitet terminated his description of *La Retraite* thus: *… puis enfin au-dessus de toutes les têtes cette figure héroïque du Maréchal Ney qui seul ose encore jeter un regard courageux sur cette scène de désastre.*
10. No.378. *Explication des ouvrages / de peinture, sculpture, architecture / gravure / exposés à la Galerie du Musée Colbert / le 6 mai 1832 / par MM les Artistes / au profit des indigens / des douze arrondissements de la Ville de Paris, / atteints de la maladie épidémique / Prix: 50 cent.* Dezauche, Paris, 1832.
11. Louis Joseph Auguste Coutan (1779–1830), one of the main Parisian picture dealers under the Restoration. He was friendly with many of his painter contemporaries who often gave him sketches. His descendants presented much of his collection to the Louvre in 1883: 'Collection Coutan. Don Hauguet, Schubert et Milliet'. The rest of his collection was dispersed at public sale 16–17 December 1889 (*Les donateurs du Louvre*, Paris, 1989, pp.179–80).

VERSAILLES 1878–1870 PARIS

Schnetz was a pupil of David and then of Regnault, Gros and Gérard. He exhibited at the Salon from 1808 to 1867 and was awarded a first-class medal in 1819 and another at the Exposition universelle of 1855. In the course of a long career he practised as a painter of history, genre and portraits and as a printmaker. The first of his numerous stays in Rome lasted from 1816 (after a journey he made on foot) until 1832. By the mid-1820s he had made an international reputation with his genre paintings with themes from popular Italian life,[1] and he was a friend of both Horace Vernet and Léopold Robert. His studio in the Via del Babuino became a fashionable stop for Grand Tourists and was included by Stendahl in his list of recommended Roman sites in his *Promenades dans Rome* of 1829. Schnetz was made a member of the Institut de France in 1827 and was director of the Ecole des Beaux-Arts, Paris from 1837 to 1841. He was appointed to the directorship of the French Academy in Rome 1840–7 and, such was his popularity with the students there, he was reappointed 1852–65. During this latter period, he did much to foster a revival of interest in depicting popular Italian life among the students at the Academy.[2] He worked in fresco in the Parisian churches of Notre-Dame de Lorette, Saint-Séverin and Ste-Marie-Madeleine. He was made a member of the Académie des Beaux-Arts in 1837 and of the Légion d'honneur in 1843. His work is widely represented in French museums.[3]

The subject matter of this drawing represents a continuation of the fashion for such military scenes during the Napoleonic era and may well be symptomatic of pro-Republican sympathies on Schnetz's part. His now lost submission to the 1808 Salon had depicted *The Bravery of a French Soldier*.

This belongs to a small group of highly distinctive chiaroscuro drawings with white gouache highlighting by Schnetz which date from his early years in Rome: these include *Homage to the Soldiers of the 45th Column* (Private Collection),[4] *The Little Drummer* (Private Collection),[5] *Wounded Antique Warrior* (Private Collection, New York),[6] *The Greek Hero*[7] and, a recent discovery, *A Grenadier Attacking* (Talabardon et Gautier, Paris).[8] Other French artists in Rome at this period, many of the first-generation pupils of David, also employed this technique, indicative of a then widespread interest in drawing as a finished art form.[9]

This drawing is remarkably similar in style and technique to a number of gouaches produced by Géricault in Rome around this time and Schnetz may have influenced Géricault in this respect. As Wheelock Whitney has pointed out, there is documentary evidence that the two artists knew each other well and were in close touch in Italy,[10] and Géricault, and his painting *Cain's Remorse* (Academia di San Luca, Rome) won the Premio dell'Anonimo for painting at the Academia di San Luca in 1817, the year of this drawing. Géricault complained to his father some years later that he was unable to track down 'les blancs de Schnetz',[11] and he may well have been referring to the passages of pure white gouache found in drawings such as this one.

D 5416
Pen and brown ink and brown wash over black chalk, heightened with white gouache on brown tinted paper
24.5 × 20.8
Signed, dated and inscribed in pencil, lower left (partially cut through at the corner): *Schnetz 1817 Rome*

PROVENANCE
Private Collection, France; from which purchased 1994 by Paul Prouté, Paris;[12] from whom bought by Hazlitt, Gooden and Fox, London: from whom purchased 1996.

EXHIBITED
*Nineteenth Century French Drawings and some Sculpture*, Hazlitt, Gooden and Fox, London 1996(6); Edinburgh / New York / Houston, 1999–2001 (54).

NOTES
1. See *Jean-Victor Schnetz, Couleurs d'Italie*, Musée du Château de Flers, 2000.
2. L. Bénédite, *Gazette des Beaux-Arts*, 1908, pp.49–50.
3. See *Les années romantiques: La peinture française de 1815 à 1850*, exh.cat., Nantes / Paris / Plaisance, 1995–6, p.482.
4. On this drawing see L.A. Prat and L. Lhinares, *La collection Chennevières, Quatre siècles de dessins français*, Louvre, Paris, 2007, no.447. G.Bazin, *Théodore Géricault*, Paris, 1993, vol.v, no.1641. The episode referred to was the execution of four Republican sergeants at La Rochelle, whose heroism is commemorated in the stele depicted in the countryside.
5. Bazin 1993, no.1642. Bazin p.63 discusses nos 1641–2 and also *Une autre gouache dont j'ai vu la photographie – non reproduite ici – s'apparente aux deux précédentes. On y voit un lancier se pencher sur un jeune soldat blessé, en présence d'un grenadier embrassant un soldat nu-tête.*
6. W. Whitney, *Géricault in Italy*, New Haven and London, 1997, p.21, fig.16.
7. *Dessins Anciens*, Galerie de Bayser, Paris, 1984 (44).
8. Black chalk, brown ink and wash, white heightening: 27.6 × 21.4. Inscribed verso, in brown ink: *De Schnetz, un grenadier à l'assaut*. Information kindly supplied by Bertrand Gautier.
9. See V. Carlson's entry for Henri-Joseph de Forestier's *The Wrath of Saul c.1817* (Baltimore Museum of Fine Art) in *Visions of Antiquity: Neoclassical Figure Drawings*, exh.cat., Los Angeles / Philadelphia / Minneapolis, 1993–4, no.76. This drawing was later exhibited in *The Essence of Line*, Baltimore Museum of Art, 2005–6 (55).
10. Whitney 1997, p.20.
11. C. Clément, *Géricault*, Paris, 1973 edn, pp.198–9.
12. Prouté catalogue, no.106, December 1995 (55), illus.

# Georges Seurat
## *Study of a Boy*

PARIS 1859–1891 PARIS

For a brief period of five years between 1886, when he exhibited *Sunday on the Grande-Jatte* (The Art Institute of Chicago) and his early death at the age of thirty-one, Seurat dominated avant-garde painting in Paris and forged a new visual language, based on the use of dots of pure colour, which the critic Félix Fénéon dubbed neo-Impressionism. In 1878 Seurat entered the studio of Henri Lehmann, a former pupil of Ingres. After military service in 1879–80 he returned to his artistic career, concentrating particularly on drawing. He exhibited for the first time at the Salon in 1883 and began work later in the year on *Bathers at Asnières* (National Gallery, London), shown at the Salon des Indépendants the following year. There he made the acquaintance of artists such as Signac, Angrand, Redon and Schuffenecker and with them created the Société des Artistes Indépendants, successor to the Groupe des Artistes Indépendants. In 1885 he was befriended by Camille Pissarro, who was much influenced by his divisionist technique, and in the following year participated in the eighth and last Impressionist exhibition, to which he contributed the *Grande Jatte*. From 1887 he began to turn his attention to the significance of line painting, believing that certain directions of line could express specific emotions – horizontal lines represented calmness, upward-and downward-sloping lines represented happiness and sadness respectively. Such ideas found expression in paintings such as *Le Chahut* (Rijksmuseum Kröller-Müller, Otterlo) of 1890. Seurat died suddenly in late March the following year, probably of malignant diphtheria.

This study is for the central figure on the bank in *Bathers at Asnières* now in the National Gallery, London (fig.56.1). The painting was begun in 1883, submitted in early spring to the 1884 Salon, where it was rejected, and then shown at the newly formed Groupe des Artistes Indépendants, whose exhibition opened in May. Critics compared the monumental, frieze-like, figured design of the painting both to the work of Puvis de Chavannes and to that of the Renaissance masters. It was certainly the result of careful preparation, for no fewer than thirteen related oil sketches (*croquetons* 'sketchettes')[2] and up to eleven drawings are known.[3] The latter are all drawn on the Michallet brand of 'Ingres' paper which Seurat favoured. It is a heavy-textured, high-quality rag paper which is milky-white after long exposure to light. The black conté crayon which Seurat used was a solid, greasy medium which does not crumble or smudge like charcoal and allows the artist to apply differing degrees of pressure, particularly effective in achieving the penumbral effects Seurat sought.[4] This study, which would have been made from a studio model (very much in the Beaux-Arts tradition), was translated with only a few alterations into the finished figure painting. Relatively well-groomed in the drawing, the boy is less slumped in the painting and has acquired a bathing suit. He has become the central participant in an allegory of suburban summertime played out by working-class males. Asnières, on the Seine to the west of the centre of Paris, was not a smart area. Some of the earlier oil sketches, such as that in the National Gallery of Scotland (fig.56.2) illustrate the plainness of this industrial site, where horses and dogs were bathed: in the final picture the horses have been removed, though the factories of Clichy remain.

D 5110
Conté crayon · 32 × 24.5
Verso: inscribed in blue and red crayon respectively: *G. Seurat L. Baignade* and *368*[5]

PROVENANCE
Georges Lecomte, Paris;[6] Dr Alfred Gold, Berlin, until 1928; sold to Reid and Lefevre, London, in 1928; with Etienne Bignou, Paris; Simon A. Morrison, London; purchased by private treaty through Christie's from a private owner in London 1982.

EXHIBITED
*Les dessins de Georges Seurat* (1859–1891), Bernheim-Jeune, Paris, 1926, (148 suppl.); *Seurat: Paintings and Drawings*, David Carritt Limited, London, 1978, (16): Edinburgh, 1984, no.6; *Georges Seurat 1859–1891*, Paris / New York, 1991–2, (113); *Seurat and the Bathers*, National Gallery, London, 1997, (7); Edinburgh / New York / Houston 1999–2001 (60); *Georges Seurat, The Drawings*, Museum of Modern Art, New York, 2007–8 (99).

NOTES
1. The context and creation of this masterpiece have been exhaustively studied by J. Leighton and R. Thomson in the catalogue of the 1997 London exhibition.
2. All were reassembled for the 1997 London exhibition, nos 2–14.
3. Until relatively recently ten related drawings were known: see C.M. de Hauke, *Seurat et son Oeuvre*, New York, 1961, nos 589–98 (but no.592's connection to the painting is doubted by many authorities). A further drawing for the so-called 'echo boy' was included in the London 1997 exhibition, no.18, though its attribution to Seurat has been questioned.
4. On Seurat's drawing materials see K. Buchberg, 'Seurat: Materials and Techniques', in the 2007–8 exh.cat., pp.31–41.
5. The first inscription is possibly in the hand of Maximilian Luce (one of the compilers of Seurat's studio inventory), the second can be linked to the numbered inventory in the Signac archives where, under the category 'Croquis et Dessins', Signac noted '366–372' (deduction based on information from R.L. Herbert, quoted in *Seurat and the Bathers*, exh.cat., National Gallery, London, 1997, p.65, no.3).
6. Lecomte (1867–1958) was a writer and close friend of the critic Fénéon, with whom he shared anarchist sympathies, and he would have met Seurat many times. He ran the Cravache review for eighteen months as an avant-garde Symbolist newspaper and commissioned many important articles on modern art.

Fig.56.1 Georges Seurat, *Bathers at Asnières*, The National Gallery, London

Fig.56.2 Georges Seurat, *Study for 'Bathers at Asnières'*, National Gallery of Scotland, Edinburgh

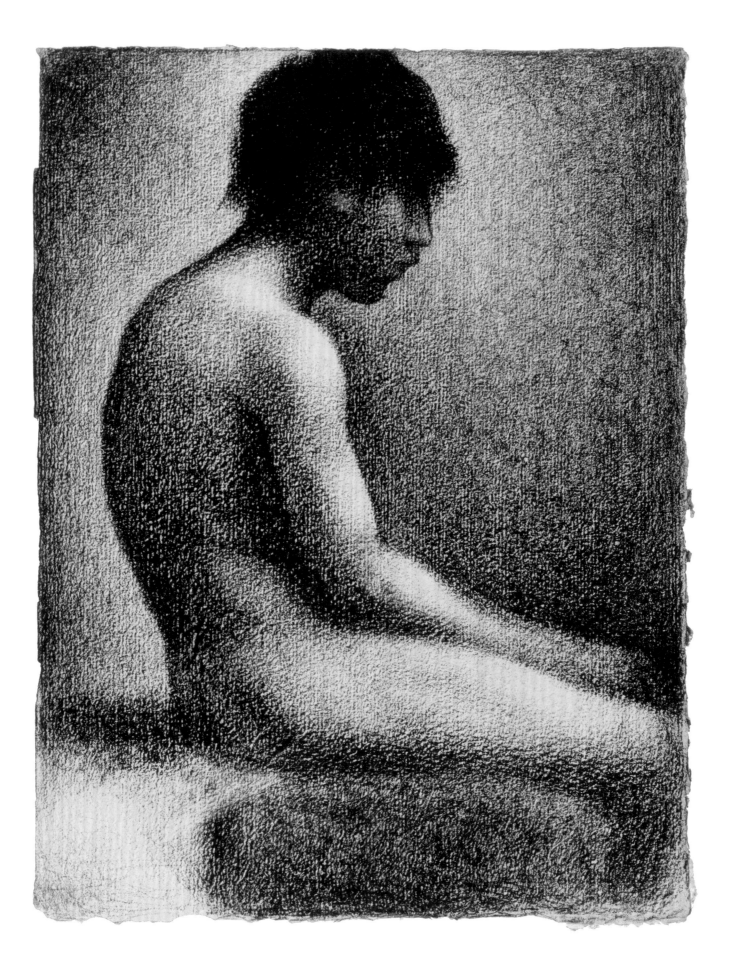

# Pierre-Henri de Valenciennes
## *Classical Landscape with a Monument*

TOULOUSE 1750–1819 PARIS

Valenciennes first trained at the Toulouse Academy, studying with the history painter Jean-Baptiste Despax and the miniaturist Guillaume-Gabriel Bouton. He visited Rome in 1769 and arrived in Paris in 1771 where he entered the studio of Gabriel-François Doyen in 1773. Four years later, he was back in Rome, where he remained until 1781. On a brief return to Paris in 1782 he met the landscape painter Claude-Joseph Vernet from whom he may have learnt the technique of outdoor landscape sketches in oil on paper. Valenciennes's advocacy of the practice created widespread interest. His exact movements during this period are uncertain. He claimed to have visited Asia Minor, Greece, Syria and Egypt, though Geneviève Lacambre has maintained that his travels were confined to France and Italy.[1] After returning to Paris by 1785, he was made a member of the Academy in 1787. In his studio he taught a wide variety of artists, his pupils included Jean-Victor Bertin and Achille-Etna Michallon. Known as the 'David of landscape', he taught perspective at the Ecole des Beaux-Arts from 1796 to 1800 and in 1812 was appointed professor of perspective. He played a prominent role in the foundation of the quadrennial Prix de Rome for Paysage Historique the first winner of which was Michallon in 1817. His treatise, *Elémens de perspective pratique à l'usage des artistes …* was published in 1800. It became the basic manual for a whole generation of neoclassical landscape painters.[2]

Valenciennes appears to have first developed this detailed and highly finished style of chalk landscape drawing in the 1790s;[3] comparable examples include a pair of drawings[4] of 1790 related to the 1793 Salon painting of *Biblis* (Musée des Beaux-Arts, Quimper), *A Classical Landscape with Figures near a Lake* of 1796 (Christie's, London, 8 July 1980, no.94), and *Landscape with a Statue of Alexander Carved into Mount Athos* of 1799 (Hôtel Drouot, Paris, 5 December 1983, no.155). This drawing should be considered as a finished work of art in its own right, intended for display or exhibition. In that context it is worth noting that some of Valenciennes's now celebrated plein air oil sketches may have been exhibited at the Paris Salon in the late eighteenth and early nineteenth century. In the artist's posthumous sale catalogue these oil paintings after nature were described as 'having served as models to the pupils of the late M. Valenciennes'. Charles Paillet, the author of the *Notice* at the beginning of the catalogue, described Valenciennes thus:

*One of the restorers of good taste and style among French landscape painters, he trained skilled pupils who, through his advice, have today become the honour of our school; his treatise on perspective is an esteemed work and the dictionary of all the students; this useful monument confirms this principle with regard to its author* [Valenciennes]: *'Art wins fame through science, science is perpetuated through art.'*[5]

There were apparently no finished drawings in the sale, from which one can conclude that works such as ours sold well during Valenciennes's lifetime.

D 5148
Black and white chalk on grey paper · 35 × 51.1
Signed and dated, lower left: *P. Valenciennes an 7* [1798]

PROVENANCE
Hazlitt, Gooden and Fox, London; from whom purchased 1987.

EXHIBITED
*French Drawings of the Nineteenth Century*, Hazlitt, Gooden and Fox, London, 1980 (2): *French Drawings*, Hazlitt, Gooden and Fox, London, 1986 (1): Edinburgh / London 1994 (19); Edinburgh / New York / Houston 1999–2001 (51).

NOTES
1. G. Lacambre, 'Pierre-Henri de Valenciennes en Italie: un journal de voyage inedit', *Bulletin de la Société de l'Histoire de l'Art français*, 1978, pp.139–72.
2. P. Conisbee, 'Pre-Romantic Plein-Air Painting', *Art History*, 2, no.4, 1979, pp.413–28; P. Radisch, 'Eighteenth-Century Plein-Air Painting and the Sketches of Pierre Henri de Valenciennes', *The Art Bulletin*, vol.LXIV, 1982, pp.98–104. The most recent study on the artist is the catalogue to the exhibition, *La nature l'avait créé peintre. Pierre-Henri de Valenciennes 1750–1819*, Musée Paul Dupuy, Toulouse, 2003.
3. Comparable examples include *Paysage classique avec une femme puisant de l'eau à une fontaine et une lavandière*, 1796, Paul Prouté, Paris, exh.cat., 1983 (33); *A Classical Landscape with Figures near a Lake*, 1796, Christie's, London, 8 July 1980 (94).
4. Christie's, London, 25 March 1969 (170). For further discussion, see *De David à Delacroix, la peinture française de 1774 à 1830*, exh.cat., Grand Palais, Paris, 1974–5, p.629.
5. Valenciennes's posthumous sale catalogue (Lugt 9578), Paris, 26 April 1819 and following days, p.4. Valenciennes himself was deeply interested in natural history and the second part of his sale included sections devoted to shells, reptiles, insects and minerals.

# Antoine Watteau
## Sketches of Individual Figures

VALENCIENNES 1684–
1721 NOGENT-SUR-SEINE

Watteau, the quintessential Régence artist, came from the predominantly Flemish town of Valenciennes. The years between his arrival in Paris around 1702 and 1712, when he became a candidate at the Academy, represented a prolonged period of training. After copying Netherlandish paintings in a workshop on Pont Notre-Dame, he worked with Claude Gillot and Claude III Audran. From Gillot, Watteau discovered the theatre as a subject for his paintings. Audran was the outstanding painter of the arabesque, the principle of which came to inform Watteau's art. Around 1710, he developed his most important contribution to European eighteenth-century painting, the fête galante, which depicted outdoor gatherings of mainly well-off city dwellers, mingling with actors, musicians and occasional countryfolk. Watteau was *agréé* at the Academy in 1712. He was given a choice of subject and the Academy waited until 1717 for him to produce his required reception piece, *The Pilgrimage to the Island of Cythera* (versions in Paris and Berlin). Although the Academy classed this painting as a fête galante, it has recently been shown that Watteau was actually accepted as a history painter. In spite of academic recognition and enormous financial and social success as a painter, Watteau never established his own workshop and lodged with various friends and supporters. A stay in London in 1719–20, officially to get medical advice from Dr Mead, might have been an attempt to give his career a new direction. Although he was apparently impressed by London, Watteau returned to Paris in the spring of 1720 and immediately painted the celebrated *Shopsign* (Schloss Charlottenburg, Berlin) for the art dealer Edmé Gersaint, which since the late nineteenth century has been regarded as his most famous work.

Watteau died at the relatively early age of thirty-seven. Shortly after his death both his paintings and drawings were published by Jean de Jullienne, a unique project at the time which secured his international fame and influence.

This double-sided drawing has recently entered the collection of the National Gallery of Scotland. Both sides of the sheet are densely filled with sketches of individual figures. Certain groups of studies were obviously made during a single sitting as they show the same model. Other sketches might have been added at different times.

Watteau probably began the recto with the quickly sketched head of a woman in the lower right-hand corner which is upside down relative to the larger and more finished figures that fill most of the sheet. He then turned the sheet around and sketched the seated woman. She was clearly drawn before the man in the centre was added, because his right hand is not fully outlined in order to avoid cutting into the female figure. The male figure on the right was added last. The outline of the plinth on which he is resting his right arm stops short of touching the man in the centre and the seam of his coat carefully avoids the sword of the central figure.

It is much harder to establish a relative sequence for the figures on the verso. Clearly, the two horsemen were drawn first because the drummer on the upper right is drawn around the head of one man on horseback, whereas a leg of the horse in the centre continues under the rifle of one of the soldiers. The figures on foot were sketched later but it is impossible to say in which order.

The original sheet was at some point slightly cut. A counter-proof of the verso in the Nationalmuseum, Stockholm, shows the head of the drummer, no longer on the Edinburgh sheet, and it also extends further to the right which implies that more of the arm of the seated woman on the recto was originally visible.

Recto and verso are not that similar in character. Prat and Rosenberg have proposed that the soldiers were sketched one or two years before the recto.[1] This seems unlikely as the differences can easily be explained by the choice of subjects and degree of finish. Also, the single head of a woman was apparently sketched before the sheet was turned around. More often than not, Watteau's drawings are oriented in the same direction on both sides which would then mean that the verso was drawn after the recto. There is no adequate reason to date the two sides years apart.[2]

The recto is closely linked to known works by Watteau. The figure of the sitting woman appears with modifications in his painting *Pierrot content*

in the Museo Thyssen-Bornemisza, Madrid (inv. no.432).[3] Another comparison is particularly useful for the dating of the drawing: the central figure of the standing man on the recto was etched with slight variations by Watteau himself for his *Figures de mode*, a series of engravings by the artist, later finished in burin by Henri-Simon Thomassin, fils.[4] The head of the man is turned further in the print and his hand rests on a walking stick, while the angle of the sword is slightly different. However, the overall figure is the same. The *Figures de modes* were dated to 1710 or earlier by Dacier and Vuaflart for external reasons and thus provide a reliable *terminus ante quem* for the drawing in Edinburgh. The same figure was engraved much later by Jean Audran and included in Jean de Jullienne's *Figures de différents caractères* but the plate was obviously copied from Watteau's engraving and not from the original drawing.[5] The proposed date of 1709–10 for the drawing accords with its style.

The figures on the verso are also closely related to one of Watteau's rare etchings, *Recrue allant joindre le regiment*, which was also worked over by Thomassin.[6] In this case, no figure is wholly taken from the Edinburgh sheet, but several of them are very close and reappear with slight modifications or are seen from a different angle. It seems safe to assume that Watteau used a similar and contemporary sheet of studies of soldiers for the drawing on which this etching was based. The parallels between the drawing in Edinburgh and the etching are much closer than those between the drawing and some of Watteau's paintings of military scenes which also have been suggested as comparisons.

D 5631

RECTO: *Two Men standing, a Seated Woman and the Head of a Woman*
VERSO: *Footsoldiers, a Drummer and two Cavaliers*
Red chalk · 16 × 19.5

PROVENANCE
J.D. Lempereur; Collection Villeboeuf, Paris, in 1935; P. & D. Colnaghi, London, in 1951; from whom acquired by Mrs Eliot Hodgkin; accepted by HM Government in Lieu of Inheritance Tax and allocated to the National Gallery of Scotland 2010.

EXHIBITED
*French and Italian Drawings*, Castle Museum, Norwich, 1954; *France in the eighteenth century*, Royal Academy, London, 1968 (738); *Watteau 1684–1721*, Washington / Paris / Berlin, 1984–5 (6); *Eliot Hodgkin, 1905–1987, Painter and Collector*, Hazlitt, Gooden and Fox, London, 1990 (108).

NOTES
1. P. Rosenberg, L.A. Prat, *Antoine Watteau 1684–1721. Catalogue raisonné des dessins*, 3 vols, Milan, 1996, vol.1, pp.148–9, no.94. Parker and Mathey do not explicitly date the drawing but list only the recto under the drawings from Watteau's youth: K.T. Parker and J. Mathey, *Antoine Watteau. Catalogue complet de son œuvre dessiné*, 2 vols, Paris, 1957, vol.1, p.10, no.61 (recto), p.36, no.246 (verso).
2. See in particular: *Watteau 1684–1721*, exh.cat., Washington / Paris / Berlin, 1984 / 5, Washington edn (6); M. Morgan Grasselli, *The Drawings of Antoine Watteau: Stylistic Development and Problems of Chronology*, Ph.D. Harvard University 1987, pp.81–5, pp.93–5, pp.104–7.
3. *Watteau 1684–1721*, 1984 / 5 (pl.13).
4. On Watteau's own etchings and the *Figures de mode* in particular: E. Dacier and A. Vuaflart, *Jean de Jullienne et les graveurs de Watteau au XVIIIe siecle*, vol.III: Catalogue, Paris, 1922, pp.70–6; on the relevant etching: *Watteau*, 1984–5, (E3).
5. See Dacier and Vuaflart 1922, p.27, no.49.
6. Dacier and Vuaflart 1922, no.178; *Watteau 1684–1721*, 1984 / 5 (E7).

# Antoine Watteau
## Two Couples Getting on a Boat

This is a rare example of an oil counter-proof by Watteau. In the seventeenth and eighteenth centuries oil counter-proofs were made in two different ways: a sheet of paper was either put on a painting while it was being painted, or on an already varnished painting after its outlines had been redrawn in oil. The first method was usually undertaken by the artist himself or by his workshop, while the second technique could be used long after the painting had been finished. Oil counter-proofs are mentioned in contemporary sources and must have been more common than the small number of extant examples suggests. They were not considered 'proper' drawings and thus less eagerly collected.

Quite remarkably, a handful of counter-proofs by Watteau have survived, and several others are recorded in etchings for the early publication of Watteau's drawings by Jean de Jullienne, the *Figures de différents caractères* (1726–8).[1] The known examples are related to a small group of Watteau's paintings: *The Pilgrimage to the Island of Cythera*, *Peaceful Love* and *The Adventuress*.[2] Even a cursory comparison with the paintings immediately reveals that the counter-proofs were not taken from the finished paintings for they differ in important details. The counter-proofs are usually closer to the figure drawings which Watteau used as the basis for his compositions. He obviously recorded his first rough outline of the figures on the primed canvas before they were further developed and the colours were introduced.

The Edinburgh counter-proof records the first sketch for a group on the left of the *Pilgrimage to the Island of Cythera* (fig.59.1) – like all counter-proofs, it is in reverse. A man in the centre to the left is about to help his partner into the boat, while another couple is just approaching the vessel. The two figures in the front plane are rendered in much more detail than their partners, who have just been sketched in. Two more figures are indicated behind the nude boatswains of the finished painting. They were omitted from the later version of the painting in Berlin, a clear indication that the counter-proof was taken from the earlier version in Paris. Watteau had laid out some of the figures in more detail than others when the counter-proof was taken. The man on the right is taken with the slightest of variation from a drawing in a private collection in Paris.[3] A

similarly detailed drawing must have existed for the woman on the left, but is not known today. The partners of these two figures were only developed in more detail at a later stage.

Surprisingly, however, the counter-proof does not record the original stage of Watteau's first *ébauche*. In the Louvre canvas the skirt of the woman on the left covers the figure of a putto which, over the centuries, has become visible again. The counter-proof was taken at a moment when Watteau had covered this first composition and tried to create a new group of couples about to embark.

The Edinburgh counter-proof – and not the finished painting in Paris – later served as the starting point for the version in Berlin (fig.59.2). The outlines of the areas which are highly developed on the counter-proof were not changed on the Berlin painting, but major modifications were introduced in the more sketchy figures: the skirt of the woman on the right was entirely changed as was the position of the man on the left.[4] This can easily be explained because the counter-proof was probably kept by Watteau while the actual painting became property of the Academy in late 1717.

It is harder to explain why Watteau made these counter-proofs in the first place. It is striking that both *The Pilgrimage to the Island of Cythera* and *The Adventuress* are compositions of which two autograph versions in the same scale exist. The counter-proofs seem to have been made by the artist as a basis for a second version. The same seems to be true for the counter-proofs from *Peaceful Love* in Berlin: while only one version of the painting is known today, it has recently been determined that the two related counter-proofs in the British Museum, London, and the Fitzwilliam Museum, Cambridge, were not taken from the Berlin version, but apparently from a lost first version of the same composition.[5] The oil counter-proofs played a role in the transfer of the composition from one version to another, probably primarily serving the artist as a record of the actual size of the figures on the canvas. Watteau's original drawings showed the figures in considerably varying scales. Once the size of the figures on the canvas was determined with the help of the oil counter-proofs, he could then return to his own more detailed drawings of the figures.

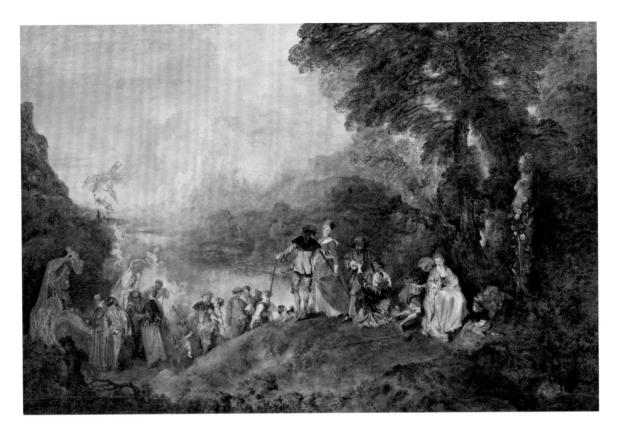

Fig.59.1 Antoine Watteau, *The Pilgrimage to the Island of Cythera*,
Musée du Louvre, Paris

Fig.59.2 Antoine Watteau, *The Pilgrimage to the Island of Cythera*,
Schloss Charlottenburg, Berlin

This interpretation implies that Watteau had already planned a second version when he took the counter-proofs from the painting. In other words, *The Pilgrimage to the Island of Cythera* in Berlin was apparently already planned when Watteau painted the first version in the Louvre. The Paris version was made by Watteau as a reception piece for the Academy. He had been *agréé* by 1712 and was urged by the Academy in 1714, 1715, 1716 and on 9 January 1717 to submit his reception piece, which he eventually did in August, seven months after the last reminder. By Watteau's standards, it was apparently painted in a short span of time. The date of the version in Paris (between January and August of 1717) also provides the date for the counter-proof in Edinburgh which must have been taken while Watteau was working on his reception piece. The later painting in Berlin has all the characteristics of an improved and revised version. The application of colours is more solid, the colour scheme brighter, but most importantly Watteau added figures after Raphael and Francesco Albani and additional ones after Rubens.[6] The Berlin version was meant to compete with the great masters of the past and to further develop the composition of the Paris painting.

D 1289
Brown oil · 36.5 × 26.9

PROVENANCE
David Laing Bequest to the Royal Scottish Academy; transferred 1910.

NOTES
1. The first in-depth discussion of Watteau's oil counter-proofs goes back to Martin Eidelberg who examined the evidence and discussed the extant examples: M.P. Eidelberg, *Watteau's Drawings. Their Use and Significance*, Ph.D. Princeton University, 1965, New York / London, 1977 (Outstanding Dissertations in the Fine Arts), pp.173–204. Only recently were Watteau's oil counter-proofs discussed again: C.M. Vogtherr, *Französische Gemälde I: Antoine Watteau und sein Kreis (Bestandskataloge der Kunstsammlungen. Stiftung Preußische Schlösser und Gärten Berlin-Brandenburg)*, Berlin, 2010, cat.nos 5 and 6. This also gives references to contemporary sources.
2. Eidelberg mentions another oil counter-proof of the head of a black boy which cannot be linked to any known painting: Eidelberg 1965, pp.179–80. He relates the counter-proof to a drawing which has been correctly rejected by Rosenberg and Prat. It is, therefore, best to omit this counter-proof from the list.
3. P. Rosenberg, L.A. Prat, *Antoine Watteau 1684–1721. Catalogue raisonné des dessins*, 3 vols, Milan, 1996, vol.2, pp.522–3, no.325. Watteau has extended the outline of the cloak. The arm of his partner, not present on the Paris drawing, is now cutting across the man's arm.
4. A drawing in a private collection in New York might have served to re-examine the two female heads, only indicated on the counter-proof, in more detail for the Berlin version: Rosenberg, Prat, vol.2, pp.974–5 (574).
5. Vogtherr 2010 (5).
6. *Ibid.* (6).

# Pierre-Alexandre Wille
## *A Tavern Brawl*

PARIS 1748–1837 PARIS

Wille was the son of the German draughtsman and engraver Jean Georges Wille (1715–1808) and his French wife Marie-Louise Desforges (1722–1785). From the age of thirteen to fifteen he studied with his father's friend Greuze and then with Vien. He was *agréé* by the French Academy in 1774 as a painter *dans le genre des sujets familiers*, but never *reçu*. He exhibited at all the Salons held from 1775 to 1787. His reputation, however, rests primarily on his activities as a draughtsman. In his early years, he drew sentimental Germanic subjects and pretty interiors, but his major achievement lay in his numerous portrait drawings, including those of the Revolutionary figures of Charlotte Corday and Danton.[1] Wille himself was an ardent revolutionary, serving in the Garde Nationale 1789–92 and holding the post of *Commandant du Bataillon de la Section du Théâtre Français*. His last years were evidently spent in straitened circumstances and in 1819 he petitioned the duchesse d'Angoulême, daughter of Louis XVI, for assistance towards the maintenance of his wife, who was confined to a madhouse at Charenton. In 1834 he sold his father's *Journal*, one of the more important sources on artistic life in eighteenth-century France, for forty francs to the Cabinet des Estampes of the Bibliothèque Nationale in Paris.[2]

This is a typical and fine example of the highly finished pen drawings in the manner of engraving that Wille drew from the 1780s onwards and which were intended for sale and gift. Wille's father recalled in January 1785, 'Our son has presented me for my New Year gifts two beautiful drawings, devilishly done in pen. One represents angry drunks; the other, gamblers dressed in ancient costume who are furious with each other.'[3]

Many of them were clever pastiches of Caravaggesque subjects. This drawing would appear to be most closely based on the example of Valentin de Boulogne (1594–1632), whose work had been avidly collected by Cardinal Mazarin and was therefore well represented in the Royal Collection. The costumes are contemporary, however, and there are Greuzian overtones to many of the figures, for example, the face of the small boy on the far side of the table, the awkwardly posed figure of the old woman to the left, or the outstretched arms of the younger male drinker she holds back.

A number of comparable drawings by Wille have appeared on the art market in recent years, of which the closest to ours is the *Cardplayers* of 1784, of identical size and signature, which was with De Bayser in 1975.[4] However, perhaps the greatest of these pastiche drawings is *The Concert* of 1801 in the Polakovits Collection, bequeathed to the Ecole des Beaux-Arts, Paris.[5] In his discussion of that drawing Jean-Pierre Cuzin rightly identified three topics worthy of further research in connection with such drawings: the apparent revival of interest in Caravaggism at the end of the eighteenth century;[6] the vogue for drawings which imitate engravings; and the links in the late eighteenth century between Parisian and Germanic art in the fields of painting, drawing and engraving.

D 5377
Pen and brown ink · 34 × 50.2
Signed and dated on the table in the centre: *P.A. Wille filius / del.1784*
Unidentified collection mark (L 74a, *AB*, blind stamp in a circle), on mount lower left, partly cut away. Lugt suggests it belongs to an unknown French drawings mounter of the late eighteenth or early nineteenth century.

PROVENANCE
Galerie de Bayser, Paris by 1991; from whom purchased 1994.

EXHIBITED
*De Robert à Guérin*, Galerie de Bayser, Paris, 1991 (10);
Edinburgh / New York / Houston 1999–2001 (50)

NOTES
1. K.E. Maison, 'Pierre-Alexandre Wille and the French Revolution', *Master Drawings*, vol.X, no.1, 1972, pp.34–5. On Wille's biography see C. Clark, 'Pierre-Alexandre Wille: The Later Years', *Master Drawings*, vol.XVIII, no.3, 1980, pp.268–9.
2. G. Duplessis, *Mémoires et journal de J.-G. Wille graveur de roi publiés d'après les manuscrits autographes de la Bibliothèque impériale avec une préface par Edmond et Jules de Goncourt*, Paris, 1857.
3. Duplessis, vol.II, p.109. I am grateful to my colleague Helen Smailes for drawing my attention to this intriguing reference.
4. De Bayser catalogue 1975 (40), pen and brown ink, 34 × 50.5, signed and dated: *P.A. Wille Filius/del. 1784*.
5. *Maîtres Français 1550–1800: Dessins de la donation Mathias Polakovits a l'Ecole des Beaux-Arts*, exh.cat., Paris, 1989 (118).
6. The young J.-L. David, in Rome 1775–80, had expressed his admiration for the 'brutal' though 'excellent' work of Caravaggio, Ribera and Valentin (whose *Last Supper* he copied). See E.J. Delécluze, *Louis David son école et son temps*, Paris, 1855 (1983 edn), pp.112–14.

# 61

## Benjamin Zix
### *Two Scenes of Military Life under the Consulate*

STRASBOURG 1772–1811 PEROUSE

Zix's principal fame derives from his association in 1805–11 with the baron Dominique-Vivant Denon (1747–1825), Napoleon's *Directeur général des musées*.[1] Noted as possessing a precocious gift for drawing from an early age, Zix studied under Joseph Melling and Christophe Guérin. In 1792 he volunteered for the Army of the Rhine and recorded its exploits. Back in the Vosges he produced a series of engraved views of medieval châteaux and also illustrated the works of a number of now largely forgotten local authors. After his decisive meeting with Denon in 1805 he accompanied him on his journeys across Europe in the wake of Napoleon's victories as Denon conducted his own enormous campaign of acquisition of art and artefacts for the Musée Napoleon (the present-day Louvre). Many of the most telling images of Denon at work, both real and imaginary, are due to Zix's rapid and acute observation. He died in Denon's arms having caught a fever on the way to Italy to research the illustration of Napoleon's victories of 1796.

These enjoyably raucous images recreate the boisterous nature of Dutch and Flemish tavern scenes of the seventeenth century transposed to the Consulate. Zix could aptly be described as a *peintre-soldat* and he would have been extremely familiar with the social life of Napoleon's soldiers. His œuvre constitutes a drawn chronicle of Napoleon's military campaigns and his wash drawings served as visual reportage for official painters such as Gros and Taunay when they came to compose their large commemorative history paintings. These two drawings are finished studies for the watercolours listed in the catalogue of the 1961 Zix exhibition held in Strasbourg in 1961.[2] Their modest dimensions are in stark contrast to what was perhaps Zix's most ambitious commission. This was for an enormous watercolour of *The Marriage Procession of Napoleon and Marie-Louise*[3] which was intended to be reproduced by Etienne-Charles Leguay, official painter at the Manufacture de Sèvres, on a colossal Sèvres porcelain vase which was never made.

D 5498A / B
Pen and brown ink, grey and brown wash, heightened with
white · 14 × 12
Inscriptions in black and blue chalk on verso of D 5498 B

PROVENANCE
Galerie Arnoldi-Livie, Munich; from whom purchased 2000.

EXHIBITED
Edinburgh 2001 (35A & B)

NOTES
1. For Zix's extensive activity in this sphere see the catalogue
to the exhibition *Dominique-Vivant Denon, l'oeil de Napoléon*,
Louvre, Paris, 1999–2000, in particular R. Spiegel, 'Benjamin
Zix, ami et collaborateur de Vivant Denon', p.272. A more
comprehensive study is R. Spiegel, *Dominique-Vivant Denon
et Benjamin Zix. Acteurs et témoins de l'épopée napoléonienne,
1805–1812*, Paris, 2000.
2. *Benjamin Zix 1772–1811*, Musée des Beaux-Arts, Strasbourg,
1961 (91, 92).
3. Pen, wash and watercolour: 24 × 172, (Dépôt de la
Manufacture Nationale de Sèvres, Louvre, Paris).